ANDY
WARHOL

ANDY WARHOL

A BIOGRAPHY

WAYNE KOESTENBAUM

OPEN ROAD

INTEGRATED MEDIA

NEW YORK

Grateful acknowledgment is made for permission to use the following copyrighted works: Correspondence from Andy Warhol to Julia Warhola and from Andy Warhol to Tommy Jackson from Correspondence files, Archives of The Andy Warhol Museum. Founding collection, The Andy Warhol Foundation for the Visual Arts, Inc.

Cover design by Neil Alexander Heacox

978-1-4976-9989-2

This edition published in 2015 by Open Road Integrated Media, Inc.
345 Hudson Street
New York, NY 10014
www.openroadmedia.com

for Steven Marchetti

CONTENTS

ANDY
WARHOL

And when the crowd bent over him at the edge of the coffin, it saw a thin, pale, slightly green face, doubtless the very face of death, but so commonplace in its fixity that I wonder why Death, movie stars, touring virtuosi, queens in exile, and banished kings have a body, face, and hands. Their fascination is owing to something other than a human charm, and, without betraying the enthusiasm of the peasant women trying to catch a glimpse of her at the door of her train, Sarah Bernhardt could have appeared in the form of a small box of safety matches.

—JEAN GENET, *Funeral Rites*

INTRODUCTION:

MEET ANDY PAPERBAG

WORDS TROUBLED AND FAILED ANDY WARHOL, although he wrote, with ghostly assistance, many books, and had a speaking style that everyone can recognize because it has become the voice of the United States—halting, empty, breathy, like Jackie's or Marilyn's, whose silent faces sealed his fame. Warhol distrusted language; he didn't understand how grammar unfolded episodically in linear time, rather than in one violent atemporal explosion. Like the rest of us, he advanced chronologically from birth to death; meanwhile, through pictures, he schemed to kill, tease, and rearrange time.

Early in his career, he experimented with the sobriquet "Andy Paperbag"—a reference to his tendency to carry drawings around in a paper bag. In imaginary conversations with him, as I try to reconstruct his life, I greet him as "Andy Paperbag"—Andy, my bag lady, a sack over his head, concealing the

features he disliked; Andy, stuffing a world's refuse into tatty, woebegone containers.

Andy Paperbag didn't want to humble himself before words or time. As interpreter, I must make him submit to both. It is paradoxical to write a brief account of a person who pretended never to edit or condense. Every effort in his career as artist and whirlwind, as impresario and irritant, was to give the public too much, more than it wanted. Monumental, the pile of stuff—films, videos, paintings, photographs, prints, drawings, tapes, books—he left behind for his mad widows to sort and comprehend; archivists and scholars will devote decades to unpacking, preserving, analyzing, selling, and quarreling over the mess. He left us too many hypotheses, too many images. Only a maniac or a masochist will want to absorb them all. His world is claustrophobically jam-packed—with people, artworks, collectibles, junk—and so every visit to his sanctum hyperstimulates and exhausts the traveler: possibilities open to the point of electrical short circuit. Compared with Warhol, the other exhausting modern figures (Picasso, Stein, Proust) are manicured miniaturists.

Warhol's self—his paper bag—had an odd shape, color, and consistency. It was slippery, elastic. It liked confusing itself with other bags, female and male, elderly and infantile. It had an imperial sense of domain: anything it saw, it conquered—by copying. It ignored everybody else's puling, tame ideas of normal behavior.

The story of Andy Warhol is the story of his friends, surrogates, and associates. It would be easy to narrate his life

without saying much about him at all, for he tried to fade into his entourage. He had a peculiar style of treating people as if they were amoebic emanations of his own watchfulness. In practice, his friends or collaborators often found themselves erased—zapped into nonbeing, crossed off the historical record, their signatures effaced, their experiences absorbed into Warhol's corpus. To work for Warhol was to lose one's name. Nathan Gluck, Warhol's most important assistant from the 1950s, often forged the boss's signature—when the artist's mother, Julia Warhola, wasn't in the mood to do it. Andy liked to entrust others with the task of embodying Andy.

Some members of Warhol's circle were erased; others were given animation, charisma, and a possible immortality by their connection with this near-albino fairy godmother, who sprinkled diamond dust on their foreheads. Other people were the messy experimental material whose din and plumage filled Warhol's empty canvas, screen, and page. He demanded collaborators; for every artistic or social act, he aggressively used other people as instruments and buffers. His work's major theme was interpersonal manipulation, sociability's modules at war; without accomplices to co-opt and hide behind, he would have had no art. Many of the people I've interviewed, who knew or worked with Warhol, seemed damaged or traumatized by the experience. Or so I surmise: they might have been damaged before Warhol got to them. But he had a way of casting light on the ruin—a way of making it spectacular, visible, audible. He didn't consciously harm people, but his presence became the proscenium for traumatic theater. Pain, in his vicinity, rarely

proceeded linearly from aggressor to victim; trauma, without instigator, was simply the air everyone around him breathed. To borrow a religious vocabulary, often useful in Warhol's case: he understood that people were fallen. Standing beside him, they appeared more deeply fallen, even if his proximity, the legitimacy he lent, the spark he borrowed and returned, promised them the temporary paradise of renown.

Despite the loyalty, infatuation, and transference that Warhol's associates felt, few seem to have entirely loved him. *Love* may be a vague, rabble-rousing word, but it is impossible to weigh a life without using it. I first understood the loveless vacuum surrounding Andy—a blankness that was his creation, though he was also its victim—when I read some letters written to him in June 1968, while he was convalescing in the hospital from gunshots. (The letters are at the Andy Warhol Museum Archives in Pittsburgh, along with the rest of his papers.) If I had been critically wounded, I would have wanted warmer commiserations; it seems that even his friends imagined Andy to be a bank momentarily closed because of a flood, the account holders congregated grumpily outside. Andy had friends, and many said they loved Andy, but no one (with the possible exception of his mother) could look after him. (Here I fall into sentimentality—the kitschy land where Andy dwelled, despite his reputed coldness and his dread of the corny.) Stars are often isolated; as a consequence of his stardom, Warhol was cut off from reciprocity, like an autistic, or a pet in a box. Abjection suited him; he knew the weirdo's experience of being insulted, rebuffed, and disliked. Nothing overcame this trampled sensation, not

even the worldly power he acquired. In fact, his trauma back-log grew. Although his rise to fame in the early 1960s as a Pop artist gave him a lasting notoriety that gratified him, the subsequent decline of his artistic reputation, and the instabilities of his private life, reinforced his fundamental experience of being hated, and ensured that he would leave the earth—prematurely, in 1987—with a conviction that he had never belonged to it.

One mother-lode Warhol managed to acquire was money. Zeal for money dominated his work habits and aesthetics, and led to criticisms that his art was morally compromised, corrupt. More than most artists, he made no secret of his hunger for lucre; procedurally and thematically, it drove his productions.

Art, for Warhol, was not just a means of making money. It was also a means of having sex. The word *sublimation* reductively describes such a practice—implying that sex is the real thing, and art the inferior by-product. Freud claimed that sublimation abetted civilization, and in this sense Warhol, sometimes considered a naive artist, surprises us by epitomizing civilization, since he channeled every impulse, sexual and otherwise, into work. But sublimation fails to explain his method. Warhol didn't sublimate sex; he simply extended its jurisdiction, allowing it to dominate every process and pastime. For Warhol, everything is sexual. Contemplation is sexual. Movement is sexual. Stillness is sexual. Looking and being looked at are sexual. Time is sexual: that is why it must be stopped. Warhol's art was the sexualized body his actual body largely refused to be.

He was frequently called a voyeur. But the word gives me pause, and I don't want to apply it, like a scarlet letter, to Warhol. Pejorative to speak of his aesthetic and erotic tastes as voyeuristic: it presumes a pecking order of concupiscences, and it ignores gazing's mutuality, the sweet interaction between beholder and beheld. The word *voyeurism* stigmatizes sight, declares it a way station where only the immature stop to rest.

Voyeur or not, Warhol was torn between bashfulness and bravado. Indeed, like many in his gang, he liked to flaunt and to conceal. He sought people who performed, who broadcast their sexualities in monologues and unsolicited intimacies. To certain observers, Warhol seemed quiet, passive, catatonic— as if he were holding back his true personality; on the other hand, he made sport of excessive revelation (through the mediation of accomplices). I found, in interviewing Warhol's associates, a consistent contrast between diffidence and exhibitionism, and I began to imagine that this duality reflected Andy's own character. One former Factory member, who sidestepped my questions about Warhol's sexual practices, urinated with the bathroom door open and left a porn magazine lying out in his kitchen; I was puzzled that he couldn't remember seeing physique magazines at Warhol's atelier (I found many in Andy's archives, including porn catalogs addressed to this particular associate, c/o the Factory). Another Warhol collaborator began the interview by showing me a nude photo of himself, but didn't look me in the eye, and typed on the computer and talked on the telephone throughout our conversation, and rather piously denied that Warhol had ever watched

him screwing (contra a previous biographer's claim). A puta-
tively heterosexual associate who has sex with men in Warhol
films claimed never to have been bisexual. Two other Warhol
associates, whom everyone calls gay, won't use that word to
refer to themselves. A reluctance to be intimate (as well as,
often, a reluctance to admit homosexuality, as if it were tacky)
is the sometime undersong to the Warholian love of display
and performance. Much of Warhol's work, in fact, turns away
from performance, or it makes a spectacle of backing off, avoid-
ing frontal relation.

Asexuality is a common way of describing Warhol's pur-
ported evasions of physical intimacy. Even people with whom
Warhol had dalliances call him asexual. It is his middle name,
another of those *a* words (*art, Andy,* and *a: a novel*) that, like
beads on an abacus, account him Andy. I don't know how
someone who turned thinking into sex, and sex back again into
thinking, could be called asexual. If anything he was ur-sexual:
lust was the bottom of his being, and yet he valued the horny
realm because it decomposed him, transplanted him out of his
body, through sight, into someone else (Marlon Brando, Hedy
Lamarr).

Andy is often called asexual as a way to avoid calling him
queer. He referred to homosexuality as a "problem": "Does
so-and-so have a problem?" he would ask his friends, hoping
the answer would be yes. According to Bob Colacello, editor
of *Interview,* Andy was convinced that every married man on
Park Avenue had a "problem." Andy was delighted by hang-
ups: problems, he said, made good tapes. He was until recently

a sticky subject for gay libbers; the most celebrated part of his career predates the movement's official birth, the Stonewall riots of June 1969, and even though he seems to have coined a "swish" identity as soon as he moved to New York in the late 1940s, neither his pictures nor his oblique manifestos fitted neatly with the radical urgencies of the gay liberation movement and its successors. Indeed, though we may now think of Warhol as the twentieth century's quintessential "queer" artist, during his lifetime his work was deemed irrelevant to the movement. He alienated activists by showing no interest in politics (he voted only once, and never marched), by flaunting conservative affiliations (*Interview* magazine put Nancy Reagan on its cover in December 1981), and by courting the rich and the royal. The men who surrounded him in his studios, many of whom had sex with other men, kept a distance from queer thoroughfares. (There are exceptions, such as Victor Hugo, the designer Halston's muse, though until Andy's Polaroids of hirsute Hugo having sex in the 1970s are exhibited, he will remain a shadowy figure in the Warhol pantheon.) Warhol's Catholicism is often cited as a reason for his reluctance to stand staunchly behind a gay party line, but piety or guilt seem beside the point of Andy's indifference to gay liberation, which many now credit him as helping, with his films and Factory, to invent.

How gay was Warhol? As gay as you can get. He dispersed gleefully offbeat sexuality over every human accomplishment, including sleeping, talking on the phone, and shoplifting lip gloss. More interesting than any earnest attempt to prove that

Warhol's art or life was good for gays is to notice, first, the ethical value he placed on male nudity as the one redemption available to him on this meager earth; and, second, to notice that, like another wig artist, Mae West, he infused sex into every sigh, allowing his emulators to understand that nongenital indulgences—gossiping, painting, photographing, dictating, shopping, collecting, filing, remembering—emit their own rude erotic charge.

Some of Warhol's best work skirts the borders of pornography, at least by 1960s standards; he trafficked with unblushing gusto in sexual imagery and content. That his art approaches porn doesn't stop it from being sublime. As a lifelong endeavor, from the time he took photos with a Brownie camera at age nine, to his appearance as fashion-show model a few days before his death, he reconfigured the pornographic impulse into a sage, serious quest for the essence of matter—to approach, more and more closely, the miraculous core of the material world by watching (and reproducing) other people's bodies, especially those of attractive men, in motion and at rest. It's hard to say which Warhol preferred, action or stillness. Perhaps, given his childhood bouts of St. Vitus' Dance (an affliction of uncontrolled shaking), and given the traumatic expatriation of his parents from what was then Czechoslovakia (before his birth), he preferred motionlessness, for the unmoving body, beautifully quiescent, could surrender to slack American immanence: he was comforted by the spectacle of the body going nowhere and therefore generously open to the searching eye. The puritanical moralism that surrounds the contemporary debate

over pornography overlooks the honest, near-religious motive for sexually explicit images: curiosity, or the laudable hunger to see more than the eye can hold. Philosophers and saints seek the Good. For Warhol, the Good was male flesh. He wanted to see and draw and film its ends and emissions. He wanted a style of seeing that could get to the bottom of flesh and comprehend its limit. There was no end to the patience of his eye, when confronted with the obdurate material body.

Patience was the keystone of his temperament. He had the diligence (let me steal Elizabeth Bishop's phrase) to look and look his infant sight away. And he had the patience to listen—never to interrupt, never to exclaim, after the third hour of a superstar's monologue, "I've had enough!" ("Superstar" is shorthand: fit synonyms for this indispensable other in Warhol's life are "talker," "baby," "muse," "subject," "object," or B.) Andy—A—had the patience never to be bored; or else he'd learned to plumb boredom's erotics. His movies, many viewers claim, are boring; he admitted to a fondness for dull things. Deciding to love boredom gave him an advantage: he overcame the repugnance that prevents the wary from delving into the unknown. Warhol's ability to enjoy boredom is a secular artistic translation of saintly patience, of stoicism—the willingness to wait for the Messiah. Warhol's tolerance for boredom is a spiritual virtue; so is his willingness to relinquish control, to shelve his own momentary idea of what is amusing, to cede control to the other, the superstar, the narcissistic monolith. Warhol teaches changelessness—how a motionless face grows metamorphic and articulate, if you pay attention.

One can see at a glance that Warhol's work is based on repetitions. *Ethel Scull Thirty Six Times. Sixteen Jackies. Triple Elvis. Two Hundred Campbell's Soup Cans.* Objects or individuals repeat within the artwork, and the single piece spawns copies. But images also multiply across media, across the decades of his career. Chairs, for instance: originally, the electric chair, murderous, vacant, in silk-screen paintings from the early 1960s. Then, in *Paul Swan,* a Warhol film from 1965, the camera keeps running while the film's star, an aging dancer, has left to change his costume, and all we see onscreen is an empty chair—which seems pointless, until, after a few minutes of staring, we remember the electric chair, and remember Warhol's final Last Supper paintings, with Elijah's vacated Passover seat their necessary shadow. . . . Warhol's images can seem stupid, mute, until you stare at them long enough to travel through stupefaction to illumination, to understand that a chair, too, conveys the ominousness of a body's premature departure from earth.

Such repetitions—the leitmotiv of the chair is one of hundreds—reveal his obsessive iconographic consistency, and such consistency, I'll wager, is the mark of a major artist, not the con artist some would still like to consider him. In every work and medium, he tries to solve one conundrum: what does it mean to exist in a body, next to another person, who also exists in a body? Will these two bodies ever join? Are they the same or different? Warhol was curious about doubles; he could stand, an alien, outside himself, and he could stare at other people as if they were his own thrown echoes. Everywhere

in his work, two bodies appear side by side, and the bodies are identical or they are slightly different, and it is sometimes impossible to tell. If you've been lucky enough to see his 1965 film *My Hustler,* remember the second reel's tableau of two hustlers standing together in a small Fire Island bathroom—a long dialogue between handsome Paul America (a blond hunk primping in the mirror) and his older simulacrum, Joe Campbell, who wants the evasive Paul to admit that he, too, is a call boy. Minute after minute of two hustler bodies, and the viewer begins to dream that male doubleness itself is the film's subject. If you haven't seen *My Hustler,* think of any two side-by-side Warhol images: two Marilyns, two Elvises, two Coke bottles; or the two screens of *The Chelsea Girls'* double projection, sometimes Mary Woronov as Hanoi Hannah, a Sadean figment, occupying both screens simultaneously; or forlorn Edie Sedgwick speaking to her own TV image in *Outer and Inner Space.* Everywhere in Warhol you'll find two bodies, whose twinship asks: will we two remain unlike, or will our proximity infect us with resemblance?

As Arthur Danto has argued, Warhol was a philosopher. He used his art to think through problems of space, time, and embodiment, and the center of his metaphysical investigations was the aroused or indifferent body, through which he asked, *How can I bear to exist inside my body, and how do other people exist inside theirs, and what happens to one body when it abuts another? Will it disappear, or alter its constitution? Does time speed up when two bodies are joined, and does time slow down when a body is alone? Are bodies motionless only when dead?*

Can the dead move, through haunting and replication? Is a boy like a boy? Is a girl like a girl? How do categories—mother, hustler, star, maniac—overlap? Is love a movement, and am I part of it? These are abstract questions, but to Warhol, and to sympathetic viewers of his films and artworks, they are as palpable as eight hours' sleep, eight hours' insomnia.

Eight hours. Nine months. Three minutes. All of Warhol's work condenses—or sublimes—into one preoccupation: time, and what time feels like when you are turned on. His art ponders what it feels like to wait for sex; to wait, during sex, for it to end; to wait, during sex's prelude, for the "real" sex to begin; to desire a man you are looking at; to endure postponement, perhaps for a lifetime, as you wait for the man to turn around and look back at you.

Warhol's art, complex, can't be reduced to axioms; and yet I reserve the right, on prose's death row, to suggest one. I say to myself, in moments of empathy with his shade: sex—and time—tortured Andy Paperbag.

BEFORE

1. TRAUMAS

ON AUGUST 6, 1945, the United States dropped the A-bomb on Hiroshima. That day, Andrew Warhola celebrated his seventeenth birthday. Asexual albino Andy, author of *a: a novel,* was born Andrew Warhola, but eventually he dropped the ultimate *a* in his last name. The extra *a* was clunky, ethnic. Dropped objects incite curiosity and dread; repressed from sight, they reappear. He may have dropped the *a* because it allowed his name to symbolize more belligerently: Andy War Hole. In any case, he retained a fondness for the letter *a*; its dialectical opposite, as far as he was concerned, was the letter *b*.

No trauma in Andy's early life compares to a dropped atomic bomb. And yet it's apt that America should have dropped the A-bomb on Andy's birthday, though he had not yet, in 1945, entered popular consciousness or climbed art's A-list. Critics would later fault him for caring about A-lists to the exclusion of the human catastrophes inflicted and suffered by the United States, the country he adored (he titled his last book *America*).

He grew up during the Depression, in a bone-poor immigrant family, and his art is an American response to American deprivation. He took symbolism seriously; he believed that a puny kid whose mother bought him a movie projector when he was eight might impersonate a monument, that little Andrew Warhola might ripen into a representative man, the archetypal anti-artist.

In 1965 he would commemorate the bomb and, indirectly, his birth, in a silkscreen painting, *Atomic Bomb,* an explosive self-portrait—an image of Andy as international trauma. Trauma was the motor of his life, and speech the first wound: painful for him to speak, to write, to be interviewed. One way he could mobilize words was to employ lists and repetitions. At the end of an interview in John Hallowell's book *The Truth Game* (1969), Andy launches one of his lists. Its repetitions lubricate impeded speech and forestall rapport with the interlocutor. Screening out Hallowell's nosy questions, Andy says, "Favorite tie, favorite pickle, favorite ring, favorite Dixie cup, favorite ice cream, favorite hippie, favorite record, favorite song, favorite movie, favorite Indian, favorite penny, favorite feet, favorite fish, favorite saint, favorite sin, favorite Beatle . . . " Traumas repeat. Being male was traumatic. Being unbeautiful was traumatic. Being sick was traumatic. Being operated on was traumatic. Being snubbed was traumatic. Moving was traumatic. Standing still was traumatic. To invoke his never-disappearing traumas is not to assert that a villain wounded him. After all, the earth is a traumatic place. It was rough for Eve, for Jesus, for Joan of Arc, and for Julia Warhola, Andy's mother.

Julia Warhola was born Julia Zavacky on November 17, 1892, in Mikova, in the former Czechoslovakia. Initially, she didn't want to marry Andy's father, the first Andy—Andrej, born November 28, 1889, also in Mikova. Her father beat her into accepting the proposal; she was further persuaded by candy that Andrej offered. When interviewed by *Esquire* in the late 1960s, she said, "My Daddy beat me, beat me to marry him. . . . I cry. I no know. Andy visit again. He brings me candy. I no have candy. He brings me candy, wonderful candy. And for this candy, I marry him." Candy, trauma: these were the alpha of Julia's marriage and the omega of her son's art. Julia loved candy, and so did little Andy. No wonder that the greatest drag queen in his eventual orbit should have named herself Candy Darling, in coincidental homage to his favorite drug. In his fanciful *The Philosophy of Andy Warhol (From A to B and Back Again)* (ghostwritten by Pat Hackett and others, and called on its original title page *THE Philosophy*, the definite article—like the indefinite—a source of mystery to Andy), he recounts that his mother gave him candy bars as reward for every page completed in a coloring book. As an adult, he continued to dote on sweets. Tom Wolfe reports Andy refusing food at society dinner parties and declaring, "Oh, I only eat candy"; after he was shot in 1968, and could, for a time, only tolerate liquids, he would retreat to the restaurant Serendipity 3 on East Sixtieth Street and nurse a Frozen Hot Chocolate.

Beaten into marriage, bribed by candy, Julia suffered a second trauma: in 1913, after her husband left for the United States in search of work, leaving her in the old country, their

first child, Justina, died; according to Victor Bockris, whose biography provides the fullest recounting of Warhol's early years, the infant died because "she had been unable to move her bowels." Food—candy, soup—and its evacuation are a thread in his work; movement or stillness of bowels proved vital to the Warhola family and the Warhol career (or any family, any career). Julia describes the death of her first child: "My husband leaves and then everything bad. My husband leaves and my little daughter dies. I have daughter, she dies after six weeks. She catch cold. No doctor. We need doctor, but no doctor in town. Oh, I cry. Oh, I go crazy when baby died. I open window and yell, 'My baby dies.'" (She began weeping.) "My baby dead. My little girl."

Little Andy might have been haunted by the dead infant girl left behind in her grave in Czechoslovakia, after Julia emigrated in 1921 to join her husband in Pittsburgh, where he'd found employment as construction worker; Mrs. Warhola was a histrionic storyteller, particularly about her life in Eastern Europe, and she may often have discussed dead Justina with her other babies. She had three more. The first two—Paul, born in 1922, and John, born in 1925—grew into virile and sturdy lads. Andy, third and last, born in 1928, was a different proposition. Masculinity was a subject he failed from the start.

Indeed, masculinity, a discipline, grounds the elementary curriculum, and so Andy wanted to skip school and stay home with Julia, left alone with the kids while his father, Andrej, a stocky man who seems to have been neither spectacularly kind nor unkind, traveled to scattered construction sites.

Andy's first documented trauma concerns school failure. The various studios and factories he later formed were compensatory pedagogical institutions, like reform schools or special-ed classes; through queer ateliers, he attempted to smash the template of mass instruction, and to impart knowledge differently. At the early age of four, Andy matriculated at Soho Elementary School—for one day only. Apparently, a girl hit him; he burst into tears and was so traumatized that he didn't return to school for two years. He would retain an aversion to school's harness or to any dogmatic confinements. His refusal of school, in 1932, was his first anarchic act—a revolution without a context. Tears later changed to calculated dissensions.

When he returned to school two years later, he made friends with girls, not boys. Quickly he realized that boys' life was anathema, that boys would fail him; that only girls were amusing, useful, and sympathetic. Mother was a girl, a candy purveyor, and an artist—she scissored tin cans into floral shapes and sold them door to door for twenty-five cents. She offered him treasures: flowers, cans, candy, chatter.

Andy's next trauma, after the failure to enter school, was the disease, St. Vitus' Dance, or chorea, that struck him when he was eight. (In the quixotic *Philosophy,* he calls it a nervous breakdown. One should remember, when trying to take his books at face value, that he didn't entirely write them, and that he was a liar.) Biographer Bockris reports that Andy came down with St. Vitus' Dance in the autumn of 1938, and that illness kept him away from school, an invalid at his mother's side; he occupied a bed off the kitchen for a month. Symptoms of

chorea included skin blotches and uncontrolled shaking. Both echoed in Warhol's future, and though he left no direct verbal commentary about what it felt like to shake or to endure dermatological disfigurement, in his mature artworks he refracted these experiences, letting stigma reverberate in painting, film, and performance. I will digress—or zoom chronologically ahead—to describe these later artistic re-castings of St. Vitus' Dance, for they represent childhood trauma's consummation, cancellation, and vindication.

By the time Andy became famous, in the early 1960s, the blotches had gone away, but they marked his face in adolescence and early adulthood, and he had bad skin his entire life; bad skin links him to Dorian Gray's pustular portrait, hidden by the smooth-skinned cheat. Films and paintings were dermatological cures and fountains of youth: canvas allowed Warhol to feel thick-skinned, as celluloid's transparency gave him a scarless skin of air and light. Few snapshots fully reveal Andy's blotches, but one set, taken by his friend Leila Singleton Davies, shows him cavorting in New York, in the late 1940s, with friends, and the discolored patterns on his face and neck resemble jigsaw ovoids. Facial blotches reappeared in his series of 1970s paintings that copied military camouflage patterns—the style used in Vietnam, a war that he didn't go out of his way to protest, except indirectly, through films in which his improvising actors wanly offered pacifist sentiments. He also made self-portraits in which he superimposed camouflage protozoa—boomerangs, squiggles—onto his face: these protective designs, meant to give soldiers a lizard's adaptability,

resembled the skin blotches that made Andy feel exposed and reptilian.

Blotches recurred in the colored gel projections cast on members of the Velvet Underground (the rock band he sponsored in the 1960s) in multimedia presentations that traveled under the name *Exploding Plastic Inevitable,* and also in his movie *The Chelsea Girls* (1966): Pop colors streak the face of chanteuse Nico and the dancing body of faunlike Eric Emerson, Andy's Nijinsky, and suggest that beauty consists in adulterated skin, scarified by blotches that resemble peninsulas, islands, or rocks, and that lack human referent. Finally, let me float the hypothesis that Warhol's two primary artistic methods, the "blotted line" technique (an inked image blotted onto another sheet, like lipstick on a tissue) and silkscreening, are elaborate forms of blotching, in compensatory mimicry of his skin—correcting the flaw by imitating it mechanically and making it seem expensive and attractive.

We are leaping ahead of our story. Andy hasn't yet discovered silkscreening or the blotted line. Not yet an artist, he is eight years old, dreaming of Shirley Temple and writing away for her autographed picture, and he is covered with blotches. To boot, he is shaking—not like Martha Graham, but like a spastic.

His original aspiration was to be a tap dancer, like his first idol, Shirley Temple. Coming down with chorea, he became a sort of dancer. The uncontrolled shaking, at first undiagnosed, leading others to think him clumsy and febrile, took the Shirley fantasy somewhere dark: tap is conscious, while St. Vitus'

Dance is hapless. The debate that will later rage over whether Warhol made his own art, or whether he just had assistants do it, begins with the chorea question: who controls Andy's physical movements? His entire career, he will want to pretend not to be their author. From the age of eight he understood possession: and therefore he would revise the myth of artistic inspiration, whether demonic or aetherial, and reconceive his body as a machine transmitting movements that bypass consciousness and willpower, that automatically repeat, and that embarrass. When he was a college student at Carnegie Tech, studying art and design, he joined the Modern Dance Club, consisting entirely of young women, himself excepted. Arriving in New York, he would live with dancers. His films feature dancers, such as the aforementioned 1965 portrait of Paul Swan—more Gloria Swanson than Rudolf Nureyev. Another dancer who would illustrate, for Warhol, the confusion between deliberate gesture and unwilled spasm was Freddy Herko, who appeared in several early films, and who literally danced himself to death (suggesting a vestige of *Totentanz* in St. Vitus' Dance): Freddy put Mozart's *Coronation* Mass on the hi-fi and leaped out the window.

Andy's St. Vitus' Dance (and the sickbed time spent with his mother) may not have sent him melodramatically into death's arms, but it altered his sense of touch—heightening it, turning it into a difficulty not lightly to be engaged. Thereafter he preferred not to be touched; hyperaesthetic, Andy as an adult would visibly recoil when a person attempted a handshake, a hug.

After St. Vitus' Dance, with its erratic movements, Andy next would confront stillness. His father died when Andy was thirteen. According to Julia, her husband drank poisoned water: "Andy was young boy when my husband die. In 1942. My husband three years sick. He go to West Virginia to work, he go to mine and drink water. The water was poison. He was sick for three years. He got stomach poisoning. Doctors, doctors, no help." Andy would remain fascinated by motionlessness—resting bodies, arrested by photography; his movies (which he and assistant Gerard Malanga called "stillies") preferred static objects and near-motionless individuals. The film moved, but the subjects didn't. Nor do boxes or paintings move. The only thing moving, in much of Warhol's art, is time, lapping over icons.

Andy was terrified of his father's dead body: downstairs, laid out for three days, as was customary (the family was Byzantine Catholic). Andy refused to pay his respects. He hid under his bed. Death, he now understood, was permanent still-ness; until then, it might not have occurred to him that motion, a St. Vitus' affliction he'd wanted to stop, would eventually halt forever. Andrej's dead body, with Julia sitting beside it, proved motion to be not such a bad thing.

Warhol may have been afraid to face his father's embalmed form in 1942, but in 1963 he revisited it by making his first film, *Sleep*—five or so hours of John Giorno sleeping (not directly transcribed time, but an artfully re-composed collage, shot perhaps over several nights, much footage repeated). Apparently, Mrs. Warhola liked watching her son sleep, as he liked

watching his boyfriends sleep; spying on motionlessness is a rather specialized erotic discipline. *Sleep*'s secret is that the snoozer is by no means paralyzed: Giorno moves his arm, his face shudders, his stomach rises and falls, and the camera's angle changes.

Nor is desire—Andy's or the viewer's—motionless: my eye enjoys this handsome nude body, and, as the film progresses, I hope that more flesh will be revealed. (As I recall, the camera never entirely sees his penis.) To realize the dozing body's significance takes time. Only after three hours did I recognize it as the dead Andrej recapitulated, finally given his due. At last, Andy performs his filial vigil; *Sleep* is a wake. Furthermore, he turns the horrified, deferred encounter into erotic play: the father's stillness was originally traumatic, but now it is an intimate aesthetic ritual—between Warhol, Giorno (who consents to be filmed), and the viewer (who consents to watch). Andy might have hoped for response—that the father will rise. Erotic anticipation makes the film's long duration bearable: will the sleeper thrill to our watchfulness, or will he remain indifferent? At times the body seems a crucified Christ: the viewer's faithful patience insists that the Lord *will* rise, even if it takes five hours. Erection, resurrection: maybe Andy has a hard-on while he watches John sleep.

Before Andrej Warhola died, he made a decision: there was enough money (in the form of savings bonds) put aside to send one of his sons to college, and the chosen son would be Andy, because of artistic talent already demonstrated—coloring,

cutting, sketching. His mother called him a cutting wizard: "Andy always wanted pictures. Comic books I buy him. Cut, cut, cut nice. Cut out pictures." Andy cuts nice. "Cut!" shouts the director, with a touch of cruelty: censorship, closure. For Andy, "cutting" meant excerpting, stealing—admiring his scissors' conscious, articulate violation of another's image. Andy could cut *out*—he could remove or excerpt an image, crop it, create a composition by omission. Adept at cutting, he was also superstitiously averse to it; refusing to cut junk out of his life, he erased the line between treasure and trash.

A year before Andy enrolled in Carnegie Institute of Technology, he suffered his next trauma: this time it involved his mother's body, not his father's. Julia developed colon cancer, and her bowel system was removed; she wore a colostomy bag for the rest of her life. (Bockris mentions that Andy encouraged her to replace the bag with surgically implanted internal tubes, but she refused.) It seems extraordinary that no critic, to my knowledge, has bothered to connect this maternal trauma with Warhol's art. Consider the colostomy bag and the surgical cuts made in his mother's waste system; consider, as Bockris points out, that Julia regularly gave Andy enemas during his bouts of St. Vitus' Dance, and that her infant daughter died of being unable to move her bowels; consider that Warhol's major artistic contribution was reinterpreting the worth of cultural waste products. Andy—awkward, hyperaesthetic—knew that the interior of his mother's body had been removed, replaced by an external bag, the waste system's secret workings rendered embarrassingly conspicuous. Her inside and outside had been

traumatically reversed. He would make his name and fortune through a similarly graphic, unsettling externalization of interior matter. In art, he, too, would bring detritus uncomfortably to the surface. No wonder he identified with bags, and wanted to call himself Andy Paperbag, in echo of her waste bag.

Andy never wrote or said anything, on the public record, about his mother's operation or about her bag. Dropped from sight, it shows up, however. He alludes to it—unintentionally?—in *The Philosophy of Andy Warhol:* "I think about people eating and going to the bathroom all the time, and I wonder why they don't have a tube up their behind that takes all the stuff they eat and recycles it back into their mouth, regenerating it, and then they'd never have to think about buying food or eating it. And they wouldn't even have to see it—it wouldn't even be dirty. If they wanted to, they could artificially color it on the way back in. Pink." (Thus "Pink Sam," a page from Andy's homemade book from the 1950s, *25 Cats Name Sam and One Blue Pussy.* Thus his credo of artistic production: expel an image—cut it out—and color it.) He alludes to Mrs. Warhola's surgery in his Before and After paintings, which show a woman's face before and after a nose job, a piece of the body cut out. "Cut, cut, cut nice," as Julia put it, praising the surgeon's and the son's art. The seam or slash between before and after—temporal division, severing the woman's two images—is itself a cut, as, in a film, one image yields to the next.

Julia's operation made waste real to Andy. Her surgery gave him the idea for Pop. (Andy's version of Pop has more to do with Mom's productions than with Pop's.) As Warhol

and Pat Hackett put it, in *POPism:* "Pop Art took the inside and put it outside, took the outside and put it inside." In the Pop body of Andy and Julia Paperbag, inside made a scarifying emigration to the outside, and then camouflaged itself in another color.

Andy Paperbag went to Carnegie Tech and majored in pictorial design. During his first year he flunked out, not because a girl hit him, as on his first day of kindergarten, but because of his traumatic relation to the written word.

The adult Andy Warhol became a prolific author and a memorable aphorist ("In the future, everyone will be world-famous for fifteen minutes"); these successes have obscured the fact that he could not write. The inability went further than the mere dependence on ghostwriters (unexceptional in the annals of celebrity authorship) would suggest: he avoided ever writing anything down. I found virtually no correspondence in his hand. There are exceptions— postcards he sent to his mother when he was traveling around the world in 1956:

Hi im alright
im in Rome now
its real nice here
 Bye
 me

im OK
im in Japan

Dear mum
I got you letter
im OK. everything
is real nice
here. i write
again
　　　bye

These are letters to a woman whose command of English was minimal, and so he could have been deliberately using a home language for her sake. But almost every sentence in his hand is full of bizarre spelling errors (as well as an affected, arty predilection for the lowercase *i*). Clearly, he was dyslexic, though undiagnosed (I assume dyslexia diagnoses were rare at the time). Some of his errors: "vedio" for "video," "polorrod" and "poliaroid" for "Polaroid," "tai-land" for "Thailand," "scrpit" for "script," "pastic" for "plastic," "herion" for "heroin," and "Leory" for "Leroy." He had a hard time with simple English. (He was, as well, left-handed, which may have compounded his sense that writing manually—rather than by dictation—was a humiliating obstacle course.) Biographers have suggested that sympathetic female classmates in college helped him compose his papers. But these friendly collaborative efforts weren't enough to see him through the required course in "Thought and Expression" at Carnegie Tech, and he failed his first year.

He managed to be let back in, however, and to win art prizes; he was recognized as an eccentric talent. The school's curriculum was not devoted to helping little Jackson Pollocks

discover their ids. Warhol's most prescient work at that time was the painting *The Broad Gave Me My Face, But I Can Pick My Own Nose*. A large head on a spindle-thin body receives a pinkie up the left nostril: pleasurable exploratory surgery. The artist George Grosz, one of the jurors for the Carnegie Tech exhibition, voted to include it; others refused, and the nose picker was finally not picked for the official show. (Andy, who had a problem nose, bulbous, swollen, and red, like W. C. Fields's, opted to get it fixed in 1956 or 1957.) His early painting of a nose picker was his first flamboyant self-depiction—here, as an ungainly, single-minded boy giving himself a little pleasure and relief, as if no one were watching, or as if a boy picking his nose were the most natural, riveting, and erotic sight in the world. So began Warhol's career: he strove to frame solitary bodies picking themselves, redirecting their anatomies with a broad's showy flair.

He graduated from Carnegie Tech in June 1949 and then moved to New York, leaving behind Pittsburgh, despised zone of his past—city of steel, whose color is silver. A year before leaving Pittsburgh, a city he did not pick, he bought himself a cream-colored corduroy suit. Almost no one ever called Andy handsome. Some observed that when he was young, before his nose grew, he looked angelic—in photobooth shots at fourteen or so. But did anyone desire Andy in his cream corduroy suit? To reverse interpretations of Warhol's work as the effluvia of a gawky outsider, assume that he was not an exile from beauty but its first citizen. Picture him, pale skin against cream suit, and conceive that someone wanted to touch him. Julia Warhola

created him, but perhaps she, too, thought him physically unappealing. Joseph Giordano, an advertising art director who was a friend of Warhol's in the late 1950s and early 1960s, told the art historian Patrick S. Smith, "She made him feel that he was the ugliest creature that God put on this earth."

2. PUSSY HEAVEN

ANDY, WHO USED THE NAME "WARHOL" for the first time in 1949, moved that year to New York City with the painter Philip Pearlstein—a fellow realist and aficionado of nudes. Over the next decade Mr. Paperbag would transform himself into one of New York's most successful commercial artists. He won three Art Directors Club Awards for ad images and earned enough money to buy, at the end of the decade, a townhouse, on Lexington Avenue between Eighty-ninth and Ninetieth Streets, for which he paid sixty-seven thousand dollars. Despite his eccentric appearance, he begat himself as a member of New York's topflight gay milieu: he attended the Metropolitan Opera and aspired to a queer identity defined by upper-crust men with Europhilic tastes, even if some looked down on him as uncultivated, as shamefully working class. (In revenge, a few years later he'd return populism, or at least its appearance, to the dominant gay-male image repertoire.) After trying to live with roommates, first Pearlstein, then some dancers, he settled in

1950 at 216 East Seventy-fifth Street, and his mother shortly thereafter moved in with him, preparing him bologna sandwiches with "mayon-eggs" (her word for mayonnaise), tomato soup, and mushroom and barley soup, and sleeping on the floor on a single mattress beside her son's, in an apartment without beds or furniture but with more than twenty cats. Mother and son lived frugally: they ate their first Thanksgiving dinner in New York together at a Woolworth counter. Julia spent a lot of her time assembling packages of stuff to send back to the old country. As for Andy, he sprinkled birdseed on the pavement and told friends he wanted to make birds grow. He met Greta Garbo and gave her a butterfly drawing, which she crumpled up. He retrieved it and retitled it *Crumpled Butterfly by Greta Garbo:* Julia Warhola inscribed the words herself.

In the 1950s, Andy tackled some body problems. Having lost much of his hair by the end of college, he bought his first wig in 1953, when he was twenty-five. He had his nose sanded, though the results disappointed him—he'd hoped to become a veritable beauty. To strengthen his eyes, he affected, for a time, pinhole cardboard glasses. In 1954 he went with a friend to a gym. The results were unclear.

Andy divided his labors between commercial assignments, for which he enlisted the help of a series of assistants, including his mother; and fine-art projects, comprising freehand sketches, hand-colored prints, collages (many using gold foil), and homemade books. Critics segregate the work of the two periods, the 1950s and the 1960s: the record and book jackets and ads were for money, while the Pop paintings and the

movies were for eternity. However, the division is not simple, because Andy continued to do commercial work (while keeping it secret) in the 1960s, well into his Pop period; and because after 1968 he resumed commissioned projects explicitly for profit, calling them "business art," though he continued to market them as fine art. Ironically, the enormous number of drawings and books that he produced in the 1950s—for galleries, gifts, private consumption, and social and career advancement—fall more conventionally in the tradition of fine art than do his Pop paintings, which pretend to trash as many aesthetic rules as possible. In fact, Andy was more of a fine artist in the 1950s (if we demand the presence of the "hand" in fine art) than after he actually became one in approximately 1960. That many viewers will be inclined to dismiss or devalue his 1950s work, especially his sketches of nude "boys" (actually they were grown men) or his gold-leaf drawings of celebrity shoes, because these early pieces seem sentimental, soft, kittenish— by the hard standards of Franz Kline, Jackson Pollock, Willem de Kooning, Frank Stella—suggests that the first step in understanding Andy Paperbag is getting to the bottom of what he means by "pussy."

In his *Diaries,* published posthumously, the phrase "pussy heaven" occurs in the entry for September 16, 1980: he remembers the death of a beloved female cat and suggests that this bereavement catapulted him from the 1950s to the 1960s, as if the pussy died so Pop could be born. He mentions that he should have begun *POPism,* his memoir of the 1960s, with this cat's death, a trauma that fashioned him into a cold and

legitimate artist. Before she died, he had emotions. Afterward, he gave them up. The entry begins with a description of a party attended by a bunch of "old bags." At the time, Andy Paperbag was only fifty-two, but he, too, felt like an old bag (his father had died at fifty-five). At the party, Andy recognized a man with a woman's name, Bettie:

> I saw Bettie Barnes who let my cat die. It's a man. B-E-T-T-I-E. I once gave him a kitten and the kitten was crying and I thought it wanted its mother so I gave him the mother. We had two cats left, my mother and I had given away twenty-five already. This was the early sixties. And after I gave him the mother he took her to be spayed and she died under the knife. My darling Hester. She went to pussy heaven. And I've felt guilty ever since. That's how we should have started *Popism*. That's when I gave up caring. I don't want to think about it. If I had had her spayed myself I just know she would have lived, but *he* let her die.

To hear him tell it, the death-by-surgery of a female cat spayed him of tender feelings; perhaps pussy Hester was named after Hester Prynne, who wears the scarlet *A*, Andy's own, in *The Scarlet Letter*. A man without feelings, Bettie Barnes, freezes Andy's heart by annihilating his mother pussy. "Pussy heaven"—an insensitive, jocular phrase—sounds like misogynist slang for a brothel or harem, where homo Andy would hardly have felt at ease. Thus when he says "pussy heaven"—with a mocking,

faux-naive pretense that the word "pussy" refers only to cats and not to vaginas or effeminate men—he projects an afterlife in which Julia Warhola and their beloved kitties survive, a locale of keen emotion, where there is no need for Pop, the anesthetic for death-by-spaying.

Andy's flights to pussy heaven always involved his mother's aid, for they lived together, in the 1950s and thereafter, surrounded by smelly cats. (One friend, however, claims that the cats did *not* stink, and that Mrs. Warhola was a "fastidious housekeeper.") Pussycats had sexual and aesthetic significance: they offered him a *gemütlich* paradigm for mechanical reproduction. In little love poems he typed as postcards (and probably never sent) to Tommy Jackson, a printer at Black Mountain College, in early 1951, Andy mentioned a kitty, perhaps Hester: "my kittys going to have a baby," and "my kitty lies between my legs." *Andy had a pussy:* this fantasy impelled his gargantuan productivity.

The pussycats star in two books collaboratively engineered by Julia and Andy. The book, as medium, spans Warhol's entire career, and mattered to him nearly as much as painting did; he produced many folios in the 1950s— strange, remarkable, self-published works of art. A standard press run was approximately two hundred, though he gave each copy a low number, often a suggestive 69, to flatter recipients; he bestowed them on friends, and on art directors and editors who might thus remember his excellence and offer him assignments. The first pussy book, printed in 1954, was *25 Cats Name Sam and One Blue Pussy;* his intimate friend Charles Lisanby wrote the text,

which consists of the word *Sam* repeated seventeen times and, as climax, the phrase "One Blue Pussy." The Sams are colored various shades (red, pink, orange) of Doctor Martin's concentrated dyes; Andy's comely male friends gathered for "coloring parties" to hand-tint the pages. The pussy is blue because it is sad—alone with its unique coloration, nameless and final in a world of same Sams. "Sam" seems a misprint for "Same," the word that defines not only Andy's sexual preference (same-sex love) but the technique of his mature artwork (repetitions of the same image). In fact, Julia named all their cats Sam. She wrote out the book's words herself—thus she can take credit for misspelling "Named" *(25 Cats Name Sam),* an error that points out the eccentricity of Julia-and-Andy Paperbag's naming process, which extended to the Silver Factory, where superstars rebaptised themselves with screen names, and where studio proprietor Billy Linich was called Billy Name. Warhol savored the magical arbitrariness of nomenclature—whether brands (Campbell's, Heinz, Brillo), animals (Hester, Sam), or people (Andy Paperbag, International Velvet).

The second pussy book, *Holy Cats by Andy Warhols' mother* (the apostrophe errantly placed, instating a plurality of Andy Warhols), materialized in 1957, a year or so before Julia received an Art Directors Club medal, under the name "Andy Warhol's Mother," for her design of a Prestige Records cover for *The Story of Moondog.* On the *Holy Cats* dedication page, her quaint, estranging calligraphy announces, "This little book is for my little Hester who left for pussy heaven." Although Andy later claimed that Hester died in the early 1960s, clearly

she had expired by 1957; the trauma of her departure, like any Paperbag disaster, jumps around temporally. Hester, in Christ's fashion, dies repeatedly—martyred anew each time Andy remembers the failure to have her spayed himself. There was only one Hester, but many Sams: perhaps Julia tolerated or appreciated Andy's sexual tastes because a household of same-sex and same-name Sams was, to her, second nature.

Did Julia know about Andy's homosexuality? If she knew, did she care? She wrote out the words of *Holy Cats*, even if she didn't originate them, so we can take them as her endorsement of Andy's perversities, her happy blessing bestowed on every erotic errand. The book advertises the charms of pussy heaven: "Some pussys up there love her/Some don't/ . . . Some like it day/Some like it night/ . . . Some talk to angels/Some talk to themselves/Some know they are pussycats so they dont talk at all/Some play with angels/Some play with boys/Some play with themselves/Some don't play with nobody" Andy played with boys and with himself; sometimes he didn't play with nobody. Julia and Andy cherished *playing with themselves* as a high-voltage, legal, paradisaical category of pussy behavior—an ethical act of self-companionship, chummy when compared with the truly isolated rite of *playing with nobody.*

Andy surrounded himself with boys in the 1950s. His list of conquests leads me to wonder how he gained the friendship of beautiful boys, and why he found them indispensable. Beauties congregate with beauties. How did Andy break in? A gifted listener, he knew how to flatter; he was already a well-known commercial artist; his urchin appearance brought out

protective instincts in others. And he understood the physics of beauty: he knew that his plainness was mysteriously fundamental to the good looks of others, as land depends on ocean to know it is land, or France depends on Germany to know it is France. Bordered by beautiful men (and, later, by beautiful women), he began to resemble them, to sign or own their radiance; it's hard to imagine Andy without the presence of nearby stunners, whose countenances cross over into his, as if they existed solely to frame and escort him. Warhol sought contiguity, the state of standing next to: being next to a beauty, he could body swap.

The list of beauties that Andy stood next to and hoped to resemble begins with Truman Capote; Warhol devoted his first New York art show to images of the young author and attempted to meet him, but only made it as far as the novelist's drunken mother. Warhol was captivated by Capote's portrait—odalisque ephebe—on the back cover of *Other Voices, Other Rooms;* this pose, among the most homoerotically provocative author photos in the history of publishing, intended to attract fans like Andy, who took its solicitation literally.

Andy could not conquer Truman, but he found a host of boyfriends, some of the relationships perhaps not consummated—whatever "consummation," that dreary yardstick, entails. (I can't figure out the job description for "Andy's boyfriend." If it involves sex, what kind, and how much?) Prime among beaux was the melancholy photographer Edward Wallowitch, whom Andy later called "my first boyfriend." Together they attended parties and photographed the other guests—foreshadowing

Andy's Studio 54 snapshot practice. Wallowitch took photos of children at play, which Andy recycled in his own sketches—some in his 1957 gold-foil presentation volume, *A Gold Book*, a James Dean clone on its cover. Before Wallowitch there was Charles Lisanby: the curtly handsome set designer, an associate of Cecil Beaton's and friend of Julie Andrews's, traveled with Andy around the world in 1956 (in Cambodia, Andy captioned a sketch "Ankor Wat" and "A. W.," turning the temple of Angkor Wat, via its initials, into his own double), a trip on which, apparently, Lisanby broke Warhol's heart by spurning his sexual advances. Another boyfriend, Carl Alfred Willers (also an A. W.), who worked in the Picture Collection of the New York Public Library, was probably the first genuine amour, and supplied source materials for Andy's art. Other beauties included the male playmates Warhol found to attend his coloring parties and to hang out with him at Serendipity, the fashionable restaurant-cum-boutique on the Upper East Side, where he exhibited drawings among Tiffany lamps. One afternoon, while sitting at Serendipity, Andy did a series of quick infatuated sketches of the coproprietor, Stephen Bruce (his perfectly smooth skin the opposite of Andy's), preparing for the night's business, and called the sketchbook *Playbook of You S. Bruce from 2:30 to 4:00,* as if Bruce, posing for Warhol, had staged a one-man "play"—the word Julia used in *Holy Cats* to describe events in pussy heaven, a fictitious locale retrofitted for habitation by Andy's stable of men. (Bruce describes Warhol's manner as "dancing.") Other beauties he pursued included the subjects of his drawings: dancer John Butler, sketches of whom

Warhol showed in 1954 or 1955 at the Loft Gallery, and the subjects of "Studies for a Boy Book," which he showed in 1956 at David Mann's Bodley Gallery. The works, casually called "cock drawings" (for a proposed "cock book"), were not exhibited in his lifetime. With a minimizing, refined line, they prove that his aesthetic aim was documentary; he wanted to document the body's presence, to capture on paper a consoling sign that the beheld face, limbs, and members actually existed. Art critics call such a sign an "index"—proof of the subject's reality, usually in the form of a photographic imprint. Andy's "cock drawings" do not have an "indexical" relation to genitalia—they are not snapshots. And yet they supply an index for his desire—they prove that he wanted to draw the groin, and that he was in the room to witness its unveiling.

The "cock drawings," like cats and angels playing eternally with themselves in pussy heaven, never call a halt to desire, and so the frolicsome instances multiply: the amorous viewer, who respects the pornographic impulse to build an archive of hunger's objects, will understand that each body needs to be documented, for every man possesses an individuating detail—a pattern of hairs on the arm, a slope of the nose, a sufficiency of the lips. Andy drew "cocks" so he could pick up tricks without bedding them. In the 1950s he frequently asked handsome men whether they'd let him draw their privates. Many consented. Sometimes he'd draw one man's penis with a second man present, and the session would lead to a "three-way," Andy's role merely to watch and draw. Robert Fleischer, a stationery buyer for Bergdorf Goodman in the 1950s, modeled

for Warhol, and he described the encounters in an interview with Patrick S. Smith:

> Andy *loved* to sketch models and very intimate sexual acts. Really! And Andy sketched us screwing a couple of times. Andy would get very, very excited. He wouldn't quite join in, but he *loved* watching. He would very often like to draw me nude and see me with an erection, but he never actually touched me. And I think that I never really put myself in a position of letting him [touch me] or leading him on, or [letting him think] that I was interested physically, because I wasn't. And at one time he said that he got so hot when he saw men with erections that he couldn't have an orgasm himself. But he started to strip that day. "And wasn't it all right if he sketched in his Jockey shorts?" And he did. And I was really upset. And it kind of *confirmed* what I had thought about Andy's personal habits in those days.

(Fleischer mentions that Andy "didn't bathe terribly regularly," perhaps because the bathtub was "filled with dyes and water" used for making paper.) Biographer Fred Lawrence Guiles claims that Andy and his friend Ted Carey—with whom Andy commissioned a double self-portrait by Fairfield Porter in 1960—arranged for three-ways in which Andy sketched Ted and a partner having sex. The first few times Andy made "cock drawings," he'd run away, flustered, when the action got too hot (one participant reports that Andy screamed, "I can't take

any more!"), just as, in the 1970s, he would disappear from a session of shooting nude Polaroids, associates recall, by retreating into the bathroom to have a private "organza."

The erotic drawings did not stop at penises. Warhol's line captured feet or other body parts, sometimes juxtaposed with mundane or outré objects, such as the score of Samuel Barber's opera *Vanessa:* in one undated drawing he paired two feet with a can of Campbell's Vegetable Beef Soup. The image originated in Julia's larder: she served him Campbell soups for years. The Campbell soup cans that Andy painted and silk-screened in the 1960s, which helped make him famous, are usually interpreted as commentaries on mechanical reproduction. However, displacement and other metaphoric processes contributed to his choice of Campbell soup as subject, and connected the image to his erotic hungers. Indeed, cans, in Warhol's work, continue the task of the "cock drawings," for cans allude to the sexual body, and to limbs iconically isolated from the whole: as a foot (in his drawings) is divorced from the body, or a penis (in his "cock drawings") is featured in relative isolation from the face and torso, so the can is alienated from the act of eating that it nonetheless announces as a purchasable possibility. The can's most arresting word— the eye ignores it for the first hundred times—is *condensed:* "Campbell's Condensed." Condensation is a property of dreams and the unconscious; the soup-can fetish condenses Andy's unspeakable interior procedures, and gives them a shopwindow's attractiveness. "Can" means "ass" ("He's got a nice can!"); Andy's career in advertising, in the 1950s, gave

him a working knowledge of the subliminal substitutions that Vance Packard claimed, in his book *The Hidden Persuaders* (1957), sparked the marketing of commodities. Andy Paperbag liked receptacles—cans, bags, boxes—and aimed to disguise whether they were full or empty. His Heinz Ketchup never pours. No hand ever reaches the bottom of his bag.

In the 1950s, Warhol had a professional stake in feet. His most successful advertising images were for the I. Miller shoe stores, an award-winning campaign that appeared weekly in the *New York Times*. The feet and shoes he drew were sleek as spinal cords. He also painted and decorated freestanding lasts—wooden shoe forms—and made a series of golden shoe drawings ("the golden slipper show or Shoes shoe in america" reads Julia's handwritten script on the invitation) exhibited at the Bodley Gallery in December 1956 and featured in *Life* magazine in early 1957 under the title *Crazy Golden Slippers*. He haphazardly assigned the shoes to celebrities—Elvis Presley, Kate Smith, Zsa Zsa Gabor, Truman Capote, Mae West, Judy Garland, Diana Vreeland, Helena Rubinstein, Christine Jorgensen, Julie Andrews: a lavender pantheon. Warhol also made a presentation book, entitled *A la Recherche du Shoe Perdu;* shoe drawings accompanied "shoe poems" composed by friend Ralph Pomeroy, such as "The autobiography of alice B. shoe." Whether or not he had read Marcel Proust and Gertrude Stein, Andy announced himself their fellow traveler.

In 1956 he crafted a book entitled *In the Bottom of My Garden,* a second rendering of pussy heaven—angels, cherubs, sailors, pussies, dowagers, and other disporting animals. "Do

you see my little Pussy," reads one caption, below a drawing of a girl with a kitty tucked crotch-level into her dress pocket; we only see the cat's pink head. The words *the End* decorate the bottom of a cherub, back turned to the viewer; across a blank chasm, this final cherub observes a girl and boy angel embracing. (The spied-on boy's tiny penis and testicles are a mere squiggle.) We cannot judge whether the outcast—whose line-drawn buttock curves form the Warholian *W*—interrupts the boy and girl's love play or whether they fornicate specially for him.

Andy may have done the "cock drawings" by himself—with the aid of live models—but he employed assistants to help with commercial illustrations. His first was Vito Giallo, who looks, in pictures, like friendly "rough trade." That Vito's father was a well-known gangster interested Andy, whose fascination with glamorous criminality would bear fruit in many later projects, including the film *More Milk Yvette* (1965), which touches on Lana Turner's scandalous affair with mobster Johnny Stompanato, who was killed by her daughter, Cheryl. (Andy saw a lot of himself in Lana, a fake blonde who gave up caring.) In John O'Connor and Benjamin Liu's book *Unseen Warhol*, Giallo recalls the limits of Warhol's cordiality:

> Once, [Andy] was taking sex lessons. There was a woman named Valerie and she had a sailor boyfriend. Every Wednesday night, Andy said he would go over for "sex lessons." They would give him lessons in how to have sex. I guess they would just show him what they

did and how they did it. He loved to watch. He wanted
me to go with him one time. I refused, and he got very
upset. So I didn't hear from him for a long time.

Giallo told me that Andy never saw him socially again after
he'd refused to attend the sex lessons, though they continued
to work together. (Vito felt sorry for Julia; she seemed to have
no friends. He remembers: the TV was on while Andy worked—
and Andy wasn't unattractive, merely pale.)

Warhol's productivity escalated after he discovered that
he could make more money by having assistants do his work
while he drummed up new business; beneath this convenience
lay the insight that transformed him into a mixture of Picasso
and Henry Ford—the realization that the artist's atelier could
be turned into a factory by mechanizing reproduction and
minimizing manual touch. Warhol's work, though full of desire,
is not full of feeling; the work is not touching because, with
the exception of the line drawings, he rarely touched it. For
his advertising work and his presentation books, he used a
blotting technique, a forerunner of silkscreening: he drew on
one piece of paper, and his assistant traced this drawing onto
another page and then inked the drawing and pressed it onto
yet another sheet. Andy would discard the originals and keep
the third-generation imprint. (So, too, would Andy wish to
speed as quickly—and artificially—as possible past the stigma
of being a first-generation immigrant: blotting, a process that
hides the image's "touching" or sentimental roots, was Andy's
model for successful Americanization.)

Vito was Andy's first assistant; the next, Nathan Gluck, would prove the most important to Warhol's early career. Andy hired him in fall 1955, and they continued to work together until 1965. Soft-spoken, erudite, Gluck was perhaps the gentlest of Warhol's many collaborators. Interviewing him, I experienced his old-fashioned niceness, a sweetness at odds with the Warhol manner; perhaps Andy needed to put "feelings" behind him if he wanted to turn, like Lana Turner or Henri Matisse, into a myth. If he'd taken his assistant's advice, Warhol would never have become famous, for Gluck disapproved of the misregistration in Pop paintings—the silkscreened photo-based image not lining up with the separately applied colors. His tastes ran toward Jean Cocteau, Paul Klee, André Gide. Before Andy went to the opera, Nathan explained the plots, though Andy archly botched the titles—"Ariadne Obnoxious" for *Ariadne auf Naxos*.

Gluck did the work that enabled Warhol to circulate among design-world professionals and land more assignments; content to be merely an employee, he never socialized with the boss—except for Christmas parties at the apartment Gluck shared with his companion, Clinton Hawkins, who worked as window dresser at Bonwit Teller. (Today, looking at a photo of the three of them, Nathan points to the expressive looseness of Andy's wrist—an angle that men in the 1950s would call limp, nelly, pussy— and says, "The wrist is very Andy.") Nathan buttressed Andy's faltering sense of family, and was the last assistant to work in the Warhol residence rather than the studio: Nathan, ten years older than Andy, sat at home with Julia during the day, re-inking drawings, making art-gum stamps,

composing ads, painting shoe lasts, listening to her sing Czech folk songs into the tape recorder—Andy's gift—and then play back the tape and sing along with herself in duet. Nathan heard Andy shout, "Where's my tie? Where's my shoes?" to his mother in the morning, and saw Andy scissor off the bottoms of his long cravats (rather than simply retie them for a proper fit) and store the cut-off ends in a box. (Andy had mixed feelings about size; he glorified it, but he was also troubled by it.) Every morning Julia put Andy together: she found his clothes and brought him orange juice. Nathan helped inspire Andy to collect, for Nathan's apartment was (and still is) an archive of multiples—masks, canned foods, European drawings, Asian and African artifacts, toilet bowl fresheners—a compendium that I would call "Warholian" if the Warholian did not already depend on the Gluckian.

Andy learned something from everyone he worked with, and he may have learned the most from Nathan; he learned how gay taste tended, in 1950s New York, toward multiplication and archiving. In the bleak McCarthy era, gay culture paradoxically flourished in the home—safer than police-threatened bars and tearooms. The private apartment—or townhouse—became a Joseph Cornell shadow box, a vitrine, an inside-out Brillo carton; in domiciles, queers amassed artworks, cleansers, masks, records, and receipts, with a curatorial intensity that Warhol would translate into an art of serial and repeated imagery, and into the collections (cookie jars, jewelry, superstars, drawings, cardboard-boxed time capsules) that were his signature, his incarceration, and his

bid for immortality. Warhol's mature practice takes its cue from the urban gay fetish of "interiors"—such as Nathan Gluck's apartment of serial objects, or Stephen Bruce's restaurant decor (Andy paid the "Serendipity boys" to recreate that look—proto-Pop Americana, a Mobil Gas sign's winged horse—in the Warhol apartment). Many of these men never became famous artists, but they reconsecrated their apartments as galleries, temples, artisanal havens, and warehouses. Andy's 1960s studios continued this 1950s domestic vanguardism; the Factory—an ambient artwork, a living museum that replaced the Museum of Modern Art and those other institutions that would remain unsympathetic to Warhol's experiments during his lifetime—extended the apartment philosophy he first learned from decor-conscious gays. (Indeed, Warhol's concern for physiological interiors corresponds to his passion for architectural interiors.) In the company of men I would call "design queens" if they were not also, and more important, rigorous conceptual artists, pioneers in understanding how perverse sexuality interrupts the distinction between public and private space, Warhol learned how to collect, how to decorate, where to put the couch, how silver foil—a Heloise hint, nearly—can double as wallpaper. (Martha Stewart owes a lot to Andy Warhol. Coincidentally, she recently purchased Vito Giallo's entire antique collection.)

Andy's beloved mother cat, Hester, went to pussy heaven after she died under the knife. Afterward, he stopped caring—but he didn't stop caring about pussy heaven. He wanted to copy it. He wanted it to be a real locale, with a telephone

number, an address, and a guest list. Though he proposed it as a comic, Utopian vision of kitties playing together eternally in a land of flowers and bottoms and clouds, he hoped to prove the fiction genuine, as a transsexual yearns for surgery. Pussy heaven, at first a fantasy, became, in the 1960s, a factory.

THE SIXTIES

3. SCREENS

HOW DID ANDY WARHOL BECOME A PAINTER? One answer he concocted: "When I was nine years old I had St. Vitus Dance. I painted a picture of Hedy Lamarr from a Maybelline ad. It was no good, and I threw it away. I realized I couldn't paint." That flip response diverts attention from his secret seriousness; his verbal deflections are always deep. Paradox: Warhol was not a painter, although he painted.

The story of how he became—sort of—a painter is mechanical and oft repeated (it is well told in David Bourdon's monograph) and so can be dispensed as automatically as a tuna sandwich from an Automat. More heartfelt is the tale of the human relations behind the Pop paintings—intimacies that spring to life in his films. Each painting, too, reveals a friendship, betrays an interaction, transmits a newsflash of interpersonal desire. Whether his subject is soup, a HANDLE WITH CARE—GLASS—THANK YOU label, S&H Green Stamps, dollar bills, or do-it-yourself paint-by-number art kits, each canvas

asks: *Do you desire me? Will you destroy me? Will you partici-pate in my ritual?* Each image, while hoping to repel death, engi-neers its erotic arrival.

At the beginning of the 1960s Andy Warhol decided again to be a painter. For subjects, he chose comic strips, adver-tisements: Popeye, Nancy, Coca-Cola, Dick Tracy, Batman, Superman—images of childhood heroism, thirsts quenched, fantastically draped he-men standing up to insult. He told superstar Ultra Violet one origin of this iconography: "I had sex idols—Dick Tracy and Popeye. . . . My mother caught me one day playing with myself and looking at a Popeye car-toon. . . . I fantasized I was in bed with Dick and Popeye." His dilemma—a pretend conflict?—was whether to render these figures expressionistically with drips and overt signs of the hand, or flatly, without personality. He showed his paintings to curators and dealers, and solicited opinions about the direc-tion his work should move—toward "feeling" (wild marks), or toward "coldness" (mechanical reproduction).

One consultant was filmmaker Emile De Antonio, nick-named "De." Sometime in 1960 (the date is uncertain), accord-ing to Warhol and Pat Hackett's memoir of the period, *POPism,* he showed De two renderings of a Coca-Cola bottle, and asked which he preferred. One was "a Coke bottle with Abstract Expressionist hash marks halfway up the side." The other was "just a stark, outlined Coke bottle in black and white." De pro-nounced the expressionist version crap and the mechanical version a masterpiece, and so Warhol, for years, avoided paint-erly stigmata and strove for machinelike execution.

The term *Pop* does not adequately explain Warhol; although he used popular and commercial images for his silkscreened paintings of the early 1960s, each has a clear link to his own body and history. He profited from the term *Pop,* but he didn't believe in it: he casually defined it as a way of "liking things." As a commercial artist in the 1950s, his task was to make the public like the objects he drew, enough to buy the products. Andy liked a promiscuous gamut of objects: men, stars, supermarket products. He liked zing, oomph, vim, pizzazz—any hook, whether ad or accident, that could rivet the eye by exciting or traumatizing it. Such images included disasters, and so he painted car wrecks, electric chairs, race riots: scenes you couldn't bear to ignore because they aroused unholy fascination, what Freud described as *unheimlich.* Warhol appreciated any immediately recognizable image, regardless of its value. In 1963, when he began wearing a silver wig, his own appearance (documented in self-portraits) acquired the instantaneous legibility that he demanded of Pop objects.

Ashamed of his appearance, or wishing to spin it as performance, he covered his face with a theatrical mask when Ivan Karp, scouting for the Leo Castelli Gallery, came to call in 1961. Karp remembers that the artist in his studio was loudly playing the Dickie Lee song "I Saw Linda Yesterday" over and over: Andy claimed not to understand music until repetition drummed its meanings in. Henry Geldzahler, an associate curator at the Met, accompanied Ivan one day; Henry would become a staunch ally, although later he would alienate Andy by not including him in the 1966 Venice

Biennale. Irving Blum and Walter Hopps from Los Angeles's Ferus Gallery also visited, and eventually gave Andy his first solo painting show.

At first, however, no one accepted or exhibited his paintings. Leo Castelli already represented Roy Lichtenstein, committed to comics, and Castelli deemed that one Pop artist was enough. Andy showed paintings for the first time not in a gallery but in a Bonwit Teller window, in April 1961: with this gesture, he paid dual allegiance to commerce and art—a split he hardly took seriously, though pundits did—and proved that his work could roost in clothing stores, those feminine bazaars of fetish and decor.

More mysterious than how Andy became a painter, or why he chose to paint comic-book and commodity images (perhaps he calculated that these American objects and icons were a safely majority taste, while the naked men and shoes he'd rendered in the 1950s were a minority taste), is why he became a painter at all. He'd always wished to express his body, to push it through a silken mesh of given images; he'd always wanted to be a "fine" (classy) artist, and had merely been biding his time. His sketches and presentation books had a limited audience; he knew that painters were more famous than commercial or coterie artists. He took inspiration from the careers preceding and surrounding him—Jackson Pollock made a splash in *Life* magazine in the late 1940s, and Andy's peers Jasper Johns and Robert Rauschenberg had recently arrived. Andy bought a Johns drawing of a lightbulb and was desperate to be noticed by Johns and Rauschenberg, lovers who kept

their sexual identities under wraps. Andy was too fey in manner, as he admits in his memoirs, to hide his homosexuality, and De Antonio told him that the reason Johns and Rauschenberg avoided him at parties (and mocked him behind his back) was that Andy was too effeminate, and that his swish conduct threatened to rock the boat they were trying manfully to row toward success. In praise of what he could not embody, in 1962 and 1963 Andy did two silkscreen paintings of Rauschenberg, one titled *Let Us Now Praise Famous Men,* in which he pictured his peer as heroic artist, epitome of rugged pioneer self-made masculinity—a cowboy, or at least a dreaming farmhand. Eventually Rauschenberg and Warhol became grudging acquaintances (photos of the two embracing in the 1970s reveal the limits of their mutual affection), and Warhol's fame (though not his reputation among influential critics) trumped Pollock's. Warhol's decision to become a painter in the first place was an attempt to queer the Pollock myth—to prove that art stardom was a swish affair: all this business of men dripping paint on floors and posing in T-shirts and khakis in barns! The desire to be *like* a man—to be a painter *like* Pollock—was a project in resemblance, in imitation: not to be a master, but to be *like* a master, and thereby to master mastery.

Pollock's champion in the early 1960s was Frank O'Hara, the insouciant, nervy poet and curator at MoMA, which as early as 1958 had proclaimed its indifference to Warhol by refusing the donation of one of his shoe drawings. Warhol admired and envied members of the aesthetic gay intelligentsia—Rauschenberg, Johns, and O'Hara key among them—and he

attempted to court O'Hara, although O'Hara disliked Warhol's work and only came around to an appreciation of it a year or so before his own untimely accidental death in 1966. According to O'Hara's biographer Brad Gooch, Warhol sought the good graces of the smart gay set: "Warhol gave O'Hara an imaginary drawing of the poet's penis, which he crumpled up and threw away in annoyance." (Recall that Garbo, too, had crumpled one of Andy's drawings.) Warhol wanted to draw O'Hara's feet: the poet declined the offer.

Andy's breakthrough as an artist came in 1962, and it had nothing to do with O'Hara, who I wish had shown more tolerance for the pasty-faced, unlettered Mr. Paperbag, whose art had affinity with such O'Hara gems as "Lana Turner has collapsed!" and "To the Film Industry in Crisis." In August 1962 Andy began photosilkscreening, commencing with a baseball player and then actors Troy Donahue and Warren Beatty. (Although his portraits of Liz and Marilyn earned him the most fame, he preceded female deities with male; his goddesses, not intrinsically women, may indeed be *men at one remove*.) On August 5, Marilyn Monroe fatally overdosed, and the very next day he silkscreened her needy face. Dead, she begged for respectful (handle-with-care) replication. Andy held that Marilyn desires or deserves no image but her own, a death row of doubles, or a single face enshrined in a godless, lonely field of gold. Andy also began silkscreening fatalities: he had already painted a disaster, apparently at Geldzahler's suggestion—depicting the front page of the *New York Mirror,* June 4, 1962, the headline reading "129 Die in Jet."

Silkscreening allowed him to appropriate an image—publicity still, press clipping. A shop printed a negative of the Warhol-chosen photo on a screen, through which Andy and an assistant pushed paint to form a positive image on canvas. Sometimes he first hand-painted color zones or primed the entire canvas, and then screened the image on top. Silkscreening, faster and easier than painting, removed the obligation of using the hand; silkscreening undercut (and poached on) photography's claims to depict the real. And silkscreening required a historically new variety of visual intelligence—a designer's or director's, perhaps, rather than a conventional painter's. Andy had a clairvoyant sense of what subjects were worth copying; he had an iconoclastic notion of what surprising colors should garnish or offend the bare black-and-white image, and what blues or reds or silvers had the power to verify and ratify the self who gazed at them; and he knew precisely what cockeyed rhythms of repeated images could defamiliarize received truths. He had a crush on hazard and flaw—places where the screen slipped or got clogged with paint, moments where the image was smudged or not fully applied, or where one image accidentally overlapped and screwed up the clarity of another. He had hand-painted his earliest Pop works from projections or with stencils, but in silkscreening he was jubilant to discover an efficient way of making paintings that were virtually photographs, illicitly transposed—smuggled across the hygienic border separating the media.

Silkscreens—baffles—introduced distance between himself and the viewer. Literally, silkscreens were nets, webs,

mazes—crisscrossing meshes, composed of silk (the stuff of fine clothing, especially women's wear); and thus his beloved silkscreens were structures of enchainment and enchantment, poised between spider's web and widow's veil. In the 1950s, Andy had painted folding screens, one in collaboration with his mother: it was festooned with the numerals 1 through 9, as if intended to teach schoolchildren how to count. An undressing body could hide behind a folding screen's ersatz wall; one imagines modest Andy changing outfits behind its zigzag barrier. Screens, like fences between fractious homesteaders, made good neighbors. Andy, who chose not to screen out information (words and pictures rushed pell-mell into his consciousness), doted on screens because they were antidotes to his unscreened, hyperaesthetic constitution. As objects, they were heavy to draw across a canvas; he needed an assistant. Silkscreening resembled weight lifting: a dapper physical act. Art's ulterior motive, for Warhol, became the pleasure of watching the strong-muscled assistant work. He was Andy's screen: the two of them together, forcing paint through the silk mesh, came closer than artist and helper otherwise might. Art screened their intimacy.

Andy had his first solo painting show in 1962, in Los Angeles, at the Ferus Gallery (he didn't attend): it consisted of thirty-two individual Campbell soup cans, each a different flavor. Each painting was the same; only the label's words varied. Difference, not a visual affair, lay in semantics, gustation: Cream of Asparagus was not Cream of Celery, and Green Pea was not Bean with Bacon. The sequence's deadpan effrontery

made Andy famous, and news magazines anointed Pop art a trend. He had his first New York show, at Eleanor Ward's Stable Gallery, that same year: he showed Marilyns, Elvises, and disasters. He was pursuing two parallel iconographic missions, stars and disasters. The two overlapped: stars interested him when they died (Marilyn), when they hung on the verge of death (Liz), when they inflicted death (Elvis with pistol), or when they threatened Andy-the-viewer with orgasmic death. Deaths of anonymous people intrigued him because he believed people should pay attention to the nonstellar and thereby give them a soupçon of fame. To be famous, for Warhol, was merely to be noticed, turned on, illuminated; to bestow fame was charity, like feeding a neglected child. His goal was to make everyone famous—the creed of "Commonism," Andy's revision of communism. He believed himself "com-monist," not Pop—he wanted to place glamour communion on the tongues of the world's fame-starved communicants.

In 1963, Warhol had forged himself into a painter, but his story would be less melodramatic if he had remained merely a painter, a vocation that never captured his undivided attention; it has been a lasting public misperception that he primarily painted. In 1963 he ventured into two alternative spheres. The first realm was spatial, interactive: he created his first Factory—studio, party room, laboratory for cultural experiment. The second realm was cinematic: he bought a 16mm Bolex camera and made his first film. And though he essentially stopped moviemaking at the end of the 1960s but continued

painting for the rest of his life, his movies are as important as his canvases to American art history, and deserve equal consideration. He removed the films from circulation in 1972; for a generation they have been absent from public view. Now they are being systematically restored. In coming years, as more people watch them, his complex achievement as filmmaker will challenge the limited notion of Warhol as painter of soup cans and celebrities.

The films, Factory mementos, were excuses to populate the loft with personalities; thus he could lure incandescent weirdos (as potential actors) to his lair. By staging a spatial artwork—the Factory, a workshop for miscommunication, tableaux vivants, exhibitionism, hysteria—and ensuring that it was well documented by photographers, Warhol proved that his core love was not the two-dimensional art of paper and canvas but the three-or-more-dimensional medium of performance.

In a notebook (undated, probably from the late 1960s, it is lodged in a time capsule at the Warhol Museum), Andy speculated, in broken phrases and images, on how to push art beyond tangible artifacts. One of his notations was "iliminate ART"—his scrawl seems a cross between "eliminate" and "illuminate." He wanted an art that would dispose of distracting surfaces and thus illuminate the invisible, unfetishized core, and he also wanted to "eliminate ART" as one excretes matter from the body. The Factory eliminated art—crossed art out, but also mechanically evacuated it. In the notebook, he entertained the idea of "GALLERY LIVE PEOPLE"—an exhibition in which people were the art. He realized this dream recurrently,

not only at the Factory, but, in 1965, at his first retrospective, in Philadelphia; the museum grew so crowded with spectators that the staff had to take the art off the walls to protect it, leaving the gawkers to stand in for the art.

In June 1963, he moved into a studio on East Eighty-seventh Street, the former Hook and Ladder Company 13 (a firehouse). Here, to help him silkscreen, and to help him realize his ambition of "GALLERY LIVE PEOPLE," he hired Gerard Malanga, who became his major assistant of the 1960s. Andy paid Gerard $1.25 an hour. He had paid Nathan Gluck $2.50.

The first painting that the new assistant silkscreened was a *Silver Liz*. However, to the biographer, Andy's relation with Gerard is nearly as important as the artworks that came from it. Andy called him Gerry-Pie, and Gerard called him Andy-Pie. Gerard was a twenty-year-old Italian boy from the Bronx, an aspiring poet enrolled at Wagner College; he'd studied with poet Daisy Aldan and had won prizes, and was the protégé of husband-and-wife experimental filmmakers Willard Maas and Marie Mencken (a dour-faced woman who has the title role in the 1965 Warhol film *The Life of Juanita Castro*). It mattered to Andy that Gerard could silkscreen: he'd worked a summer job for a textile screenprinter known for rooster ties. It mattered that Gerard was a poet, for just as Andy had wanted to be a tap dancer, he aspired to be (and soon became) a writer. Most of all, it mattered that Gerard looked like a seraphic piece of trade—a slim, versifying Brando. Gerard rekindled Andy's desire to be Truman Capote. By hanging out with Gerard, Andy could imagine himself achieving Trumanhood. Andy made at

least one pass at Gerard, which the younger man rebuffed. Avowed heterosexual, he nonetheless did a good job of performing and impersonating homosexuality. He had sex with men in the Warhol films *Couch* and *Apple;* his dandy flair—a beat Beau Brummel—riveted many artistic gays in New York. (As if to prove this point, Gerard kissed poet and dance critic Edwin Denby in a Polaroid that Andy took for the cover of the underground poetry magazine *C.*) When Gerard and Andy did the town together, attending parties, openings, and readings, Gerard was perceived to be his kept boy. And yet he also screened Andy's gayness with a straight veneer, however palpitating and insincere. Gerard's most striking features were his upper lip, curved in a somnambulistic sneer; his Roman nose; and his large, liquid, Liz-like eyes. At first he wore Wagner College sweatshirts, and gave one to Andy; Gerry-Pie and Andy-Pie soon graduated to leather. As if presenting the fiancée, Andy brought Gerard home to meet Julia on the second day of his employment.

For a few charmed months Gerard and Andy were alone in the studio working together; enervating crowds had not yet arrived. Gerard, when I interviewed him at a Cuban restaurant in SoHo, seemed to recall those first undistracted days in the Firehouse as a prelapsarian idyll. Once Andy moved, in November 1963, to the loft at 231 East Forty-seventh Street, which would become the Silver Factory, Gerard functioned as bait, procuring cultured or physically prepossessing visitors: he had a wide acquaintance in the artistic and literary worlds, and, as talent scout, he was responsible for bringing to

the Factory many of its crucial players. In the studio together, Gerard silkscreening while Andy lent a hand, they mimicked Batman and Robin. Gerard was Andy's ward, the Factory their Bat Cave. One of Andy's first Pop paintings was of Batman, and in 1964 he made a film starring the unclassifiable Jack Smith as a combined Batman and Dracula. Andy would eventually acquire the nickname "Drella": a mix of Cinderella and Dracula, the moniker signaled his early poverty and his current pathos, as well as his vampiric relation with his entourage.

The works that Andy fabricated with Gerard's assistance stage his desire for the edible ephebe: hypothetically, the Liz paintings are cross-dressed Gerards, and the Most Wanted Men and the 1964 Flowers embody the physical charm of a gangster Narcissus. (In a fetching photograph of Gerard giving a poetry reading at the Leo Castelli Gallery in front of the silkscreened, brashly colored flowers, he seems another of Andy's blooms: the old-as-Ophelia language of flowers silently translates Warhol's heart.) He favored Gerard's physical type—in the fifties he'd hired the handsome Vito Giallo, and in the 1970s he'd hire another sturdily built Italian American, Ronnie Cutrone, as assistant. The star of Andy's first film, *Sleep*, John Giorno, was yet another handsome Italian American poet with a pleasingly square face. Andy dropped him after *Sleep;* Gerard had replaced him.

Warhol's other crucial collaborator in the 1960s was Billy Linich, who rebaptised himself Billy Name. They first met when Billy was a waiter at Serendipity; Ray Johnson (whose preferred art form was correspondence sent through the U.S.

Mail) took Andy to see Billy's apartment, entirely decorated in silver foil. Billy, who worked as lighting designer for Judson Dance Theater productions, moved into Andy's loft and became the studio manager and caretaker, and, for the first year of his residency, the kept boy. Billy told me, as I sat with him in his Poughkeepsie house, within sight of the Hudson River, that these relations were standard in the art world, and that it was widely noticed that he was Andy's boy. Warhol asked him to silver the loft with foil, in imitation of his apartment. Name took hundreds of pictures of the 1960s Silver Factory, with high-contrast, expressionistic lighting; these images have given the otherwise ephemeral Factory a tangible historical existence. He mastered Andy's mise-en-scène: he lit the photos and many of the films, and he designed the metaphor—the silver back-drop—that draped Warhol's melodramas.

Billy Name was the subject of three of Andy's early important movies, each called *Haircut,* the first of which, known as *Haircut (No. 1),* is the most dramatically and compositionally arresting. As noted by curator Callie Angell in her catalog of the films, *Haircut (No. 1)* consists of "six 100-foot rolls . . . shot from six different camera angles." Characteristically, the rolls were unedited and then spliced together, back to back, including the so-called "leader"—the blank white unexposed film at the beginnings and ends of reels, useful, says the *OED,* "for purposes of threading or identification." In these early works, Warhol always retained the leader; its whiteness, at the end of each unedited reel, begins to overtake the image and eventually whites it out altogether. I wonder whether Andy ever used the

term *leader* to describe those strips. Superficially absent from his films, he almost never appears within the frame, though occasionally his voice can be heard, giving faint directions. Strips of leader, however, reinstate his ghost-pale presence; they appear, revenants, at that last moment when soporific whiteness triumphs over actors trying to create impressions of their own.

In *Haircut,* the leader functions magically: at the end of the final reel, the performers—haircutter Billy Name, the young man (John Daley) whose hair is being cut, and the shirtless dancer Freddy Herko, who moves, pipe-smokes, and strips in the haircut's vicinity—yawn and rub their eyes, as if they were *A Midsummer Night's Dream* players awakening from imposed enchantment. As the *Haircut* participants, disbelieving their visions, try to disperse the fog of deluded sense, the leader gradually falls, a white pall, over their faces. In any Warhol reel ended by the leader, it lands, always, twice—first as a foreshadowing, a slight whitening that doesn't entirely efface the image, which resolidifies, but only for a moment; and second, for good, when the leader resumes, erasing the image forever, or until the next reel. Thus at the end of each segment, the viewers experience a miniature, spunk-white death, a blotto orgasm, a swooning obliteration of consciousness: first we foretaste death, which encourages us to pay strict attention to the faces when they return, because we know that in another moment the grave whiteness is going to rob our sight; and then we experience the last onset of blankness, and we are relieved, fatigued by the reel's *longueurs.*

Watching Warhol films is a pleasure that too few people have experienced, and I want to proselytize. As Jonas Mekas, Stephen Koch, and other appreciators have noted, these films question every assumption that cinematic art has accreted in its century-long history. And though Warhol influenced experimental and mainstream film, most of his innovations have not been pursued by his successors. Into the viewer's viscera, Andy pumps full-strength his experience of time as traumatic and as erotic. Time has the power to move and the power to stand still; time's ambidextrousness thrills and kills him.

In *Haircut (No. 1)*, typical for Warhol, there are no title credits; always, only a piece of tape on the reel's canister gives a simple identifying word—*Eat, Shoulder, Horse,* or *Afternoon.* In most of the pre-1965 films, there is no sound, and the film is projected at silent speed, (ideally) sixteen frames per second, though sometimes eighteen. (Sound speed is twenty-four frames per second.) The films, therefore, take longer to show than they took to make. Literally, they stretch duration. Within each reel, the camera does not move; the stationary camera is his trademark. (In his other films, when the camera budges, it erratically disregards the action; it digresses, ignores the star. Ronald Tavel, who wrote scenarios for many of Warhol's finest sound films, said in an interview, "As the script starts to build toward a climax, the camera leaves and goes up to the ceiling and begins to examine furniture" Warhol's camera, like an inattentive schoolchild, wanders away from the lesson.) In *Haircut (No. 1)*, each reel has a painting's hieratic stillness. And because the actors' movements are minor, plotless, the

eye registers every change as a cataclysm, worthy of scru-
tiny. Warhol magnifies the importance of each facial vibration
and thus teaches arts of empathy and diagnosis. Although his
technique relies entirely on the camera's personality, and thus
seems mechanical, without soul (Billy Name has intimated
that Andy's cinematographic aim was to learn how the camera
saw), the lesson of the films—pay attention to a face's subtle
psychological evidence—induces a paranoid relation to the
other's emotional oscillation, rather than blissed-out apathy.

Watching dozens of hours of these early Warhol films in
which little or nothing happens, I couldn't take my eyes off the
screen, lest I miss something important. I didn't dare look down
at my pad, peer around, close my eyes, or leave the room. I
could barely take notes, so entirely was I hypnotized by min-
ute gradations of light and shadow, anger and lust. My life—or
the film's—depended on keeping a keen eye on his screen, as
if I were a nurse on intensive-care bedside vigil in a hospital,
and the screen were Andy's beating heart. The eye, not hav-
ing a narrative to lead it, and not having camera movements
and quick editing to manipulate what it sees, may tour the film
frame as if it were unmoving, and may enjoy or puzzle over
stray pieces of what the frame contains, without fear that the
camera will shift angle and deprive the eye of its present feast,
whose oral dimensions were not lost on Andy. He understood
the relation between seeing and eating, and described, in an
interview, how reel-long close-ups gratify the viewer's hunger:
"People usually just go to the movies to see only the star, to
eat him up, so here at last is a chance to look only at the star

for as long as you like, no matter what he does, and to eat him up all you want to. It was also easier to make." Two pleasures converge: mine and Andy's. I, the viewer, get to look for a long time; Andy gets to take it easy. (He loved the word *easy*. He would exclaim to prosperous-seeming friends that they were living on Easy Street.)

Like Warhol's camera, I will try your patience by lingering longer on *Haircut (No. 1)*, a film that critic Reva Wolf has discussed in detail in her illuminating book *Andy Warhol, Poetry, and Gossip in the 1960s. Haircut (No. 1)* is perhaps the strongest of several film portraits that Andy made during the early 1960s—cameos of renegade masculinity. The profession of hairdresser, stereotypically gay, was stigmatized as effeminate. Paradoxically, Billy brings butch power to it: he approaches it as a Zen meditation, and the film's slowed-down time makes it a sacred ritual, fervent as a *bris. Haircut* is a covert portrait of Billy taking care of Andy. Although Mrs. Warhola said that Andy "cuts nice," he was averse to cuts: he didn't have much hair to cut (he covered it with a wig), and he certainly didn't like to edit. Billy's focused, entranced haircutting is an act of erotic ministration to a passive, suppliant man (John Daley), whose vaguely Slavic features resemble Warhol's; but this is not an attention that Andy himself will admit to receiving or wanting. He claims, in his invisible seat as *auteur*, to transcend the need for haircuts, or any kind of cut.

Critics will condescend to Warhol for being passive; indeed, his art is masochistically open to the thrust of external images and assistances. And yet his portrait of haircutting—a

metaphor for other kinds of craft and care-taking—actively looks at a naked man, Freddy Herko, whose hairy chest seems immune to the film's scissoring *donnée*. On one side of the frame, Billy cuts hair; on the other, Freddy undresses. The hair-cutting may seem to snip away masculinity—Delilah shearing Samson—but Freddy reveals more and more male flesh as the haircut unwinds. No one is passive—neither Andy's camera, nor Billy's scissors, nor the undressing dancer. The only passive creature is the sylph receiving the haircut. (*Haircut* poses as documentary of an intimate rite, but it may be a simulation. Few hairs seem to fall.) As usual, Warhol gives us two bodies or practices to observe, and we must decide which matters the most: on the left a dancer, and on the right a haircutter. Do the two influence each other? Are they separate atmospheres? Doppelgängers? Will one action infect the other? Do we (Andy and the viewer) occupy a third, isolated atmosphere, or can we enter the camera's bipartite room of haircut/striptease?

In late September 1963—a few months before filming *Haircut (No. 1)*—Warhol drove across the country to Los Angeles to see his Elvis paintings exhibited at the Ferus Gallery; with him in the car were the underground film actor Taylor Mead, the painter Wynn Chamberlin, and Gerard Malanga. (Warhol himself didn't drive; he sat in the backseat.) While in Los Angeles he met Marcel Duchamp, attended the Duchamp retrospective at the Pasadena Art Museum, as well as a movie-star party thrown in his honor by Dennis Hopper; among the guests were Suzanne Pleshette, Russ Tamblyn, Sal Mineo, and Troy

Donahue, subject already of a Warhol silkscreen. Andy had crashed through the wall separating star from fan; at last he was mingling with screen glamour. He loved California. In an interview he said, "I think the people in California are good because, well, they're more naked." In *POPism,* he expressed the pleasures of Hollywood, his visionary ideal: "Vacant, vacuous Hollywood was everything I ever wanted to mold my life into. Plastic. White-on-white. I wanted to live my life at the level of the script of *The Carpetbaggers*—it looked like it would be so easy to just walk into a room the way those actors did and say those wonderful plastic lines." California was easy. On this trip, in a hotel room, Andy took out his penis and asked Taylor to suck it; Taylor was offended.

The thwarted pass, no insult, formed part of Andy's concerted homage to offbeat, dissident manhood, a tribute that climaxed in the films he made with Taylor as star. Taylor was already known to followers of hidden cinema for his roles as a deaf-mute drug pusher in a 1959 film, *Too Young, Too Immoral,* and in the experimental filmmaker Ron Rice's *The Flower Thief* (1960). As Mead said to me, "Andy Warhol didn't create me as a Superstar. I *was* a Superstar." He was also, like Malanga and Giorno, a poet. One eye sags downward; Taylor's features, a dolorous Stan Laurel's, droop from mirth at the impossibility of expressing grief.

Warhol loved Adonises, but he also appreciated men who were, like him, odd-looking. His films didn't merely reiterate the physical ideals promulgated by classical art and later by the nudie output of Robert Mizer's Athletic Model Guild, the

Los Angeles house of flesh, which gave work to Joe Dallesandro before he entered the Warhol Factory; rather, Warhol pitted muscular studs against avowedly (and proudly) "nelly" comedians like Mead.

The *Mattachine Society's Newsletter,* house organ of the homophilic organization, precursor to gay lib, was not pleased with Warhol's cinematic oeuvre ("How dare they present their horseplay to an audience looking for Art?"), but its reviewer aptly summarized the action of *Tarzan and Jane Regained . . . Sort Of,* the first film that Warhol made with Mead, shot in Los Angeles in late September or early October 1963: the film, "a loosely connected series of self-consciously cute episodes, stars Taylor Mead, whose major problem as an underfed yet amazingly athletic Tarzan, involves keeping his scanty leopard-skin briefs from falling below the knees." (Mead edited the film.) In one scene, he takes a dump, roadside, and wipes himself: the movie, loving the infantile and the unfettered, dwells on Taylor's rear end. In the second reel, Andy himself appears on screen; directing, he smacks Taylor's ass. The briefs (or loincloth) continue to drop and drop, an entropy toward nudity that expresses Warhol's own ideological preference for nakedness in others. As he said in an interview, "I don't really believe in clothes."

The next Warhol/Mead film more explicitly celebrated—even as it mocked—Taylor's body. Entitled *Taylor Mead's Ass,* it was a response to a filmmaker who wrote to the *Village Voice* to complain about a Warhol movie featuring two hours of Taylor Mead's ass. As Mead said, they immediately noticed the

absence of such a work, and promptly rectified the situation by, the next day, September 5, 1964, shooting not two hours but seventy-six minutes of nothing but Taylor's ass, mooning the censors and the spoilsports, and thus enacting what Roland Barthes, in *The Pleasure of the Text,* described as the radical, pleasure-taking text's prerogative: "The text is (or should be) that uninhibited person who shows his behind to the *Political Father.*"

Taylor Mead's Ass doesn't show his penis. The buttocks, full of personality, upstage it. Taylor told me that he sabotaged the film and proved that he could "defy even Andy Warhol" by refusing to stand still, as the director had requested: by moving, sashaying, dancing, and declining to remain as stationary as the Empire State Building (of which Warhol made a notorious eight-hour movie), Taylor "ruined [Warhol's] film and adulterated his concept." Taylor not only moves; he pretends to stuff a variety of objects up his ass. He begins with dollar bills, as ironic commentary on Andy's cheapness (he would rarely pay for thespian services), or as a faux hustler taking tips straight up the rear. Taylor then stuffs books, magazines, and photos up his ass. He pretends to stuff up himself a copy of *Time* magazine with Lady Bird Johnson's face on the cover. (Taylor quipped to me: "Lady Bird probably pecked my innards out.") He stuffs up himself a photo of the other Taylor, *Elizabeth* Taylor, as well as a blank circular canvas—a tondo, the shape that Andy used for his round Marilyns. Taylor may be criticizing Warhol's art by mimicking his method (incorporating found images), but he also does his friend's work the favor of illuminating its sexual

undertone: Andy receptively absorbed media images because the act of taking the media into his body (as if "up the ass") gave him unspeakable pleasure. After Liz, Taylor stuffs literature up his bottom, including a copy of Ernest Hemingway's *A Moveable Feast.* Then he moves on to household products: a box of Tide detergent sends up Pop art, for Andy had shown his Brillo boxes just a few months before. Taylor's ass, a pint-size Factory, engulfs talent and imagery, but not passively: he actively calls the shots.

Many of the objects that enter also leave. With a pair of pliers he pretends to remove a copy of his own book of poetry, *Excerpts from the Anonymous Diary of a New York Youth.* He also retrieves the blank tondo he'd inserted earlier. Unfortunately, it's still blank; the transformational powers of Taylor's ass have limits.

Staring at his cleft moon for seventy-six minutes, I begin to understand its abstraction: high-contrast lighting conscripts the ass into being a figure for whiteness itself, particularly when the ass merges with the blank leader at each reel's end. The buttocks, seen in isolation, seem explicitly double: two cheeks, divided in the center by a dark line. The bottom's double structure recalls Andy's two-paneled paintings (for example, *Mustard Race Riot* of 1963), and suggests another, anatomical, abject way to read the double in Warhol's work: as a representation or displacement of the butt's two cheeks, or of any bodily bifurcation (testicles, vagina, breasts). Taylor himself was Andy's double—a man with the knack of overturning stigma through outrageous pantomime.

By the time he filmed *Taylor Mead's Ass* (which may never have been screened—Taylor confesses he never saw more than rushes of it), Andy had perfected his asinine persona, the mute and inexpressive face that, Billy Name told me, Andy developed in response to media stupidity. Reporters wanted to make a joke of Warhol, who was wary of words, and who may also have been terrified—paralyzed—by interviewers. So he responded with evasions, stammerings. As he told photographer Gretchen Berg, "The interviewer should just tell me the words he wants me to say and I'll repeat them after him. I think that would be so great because I'm so empty I just can't think of anything to say." Gerard Malanga, in an interview with John Wilcock, for his odd, devilish book *The Autobiography and Sex Life of Andy Warhol,* said, "Basically he's a liar when he's being interviewed." When Gerard published an interview with Andy, he bore out this hypothesis. To Gerard's question, "Are you human?" Andy answered "No." And yet, to Gerard's question, "Why do you answer what you answer?" Andy replied, truthfully, "I'm sensitive." In another interview, published in *Arts Magazine* in 1967, Andy, interrogated again by Gerard, says that if he were to remake *Chelsea Girls* in the South, "As the fat pill pusher and dope addict I would probably use my father." He also falsely refers to his father's "refrigerator factory." In a TV interview, when a reporter earnestly asks Andy about art, addressing him as Mr. Warhol, he asserts, "That's Miss Warhol," and resumes painting or buffing his fingernails. (He understood that painting nails, though it lacked the cultural capital of painting canvases, was an estimable human endeavor; engaging in

manicure, he demonstrated that art was a beauty ritual, a ceremony of self-construction.) He considered interviews to be collaborative art pieces; his job was not to convey truth but to perform. Avoiding direct response and concocting an affectless persona were credible ways of "coming out" to the media, which would hardly have tolerated him explicitly stating his intention to elevate homoerotic desire above every representational or expressive task.

He put desire forward more explicitly at the beginning of his film and fine-art career than he would virtually ever again have the guts to do. Nowhere is sex more richly portrayed than in his great trilogy of 1963 and 1964—*Kiss, Blow Job,* and *Couch.* These films, which sit at the center of his artistic achievement, are not widely known (as opposed to his Marilyn or Campbell soup images, which have proliferated, in media representations of Warhol, to the point of inanity). As this trilogy of films makes clear, eros does not exist apart from time; time is arousal's medium. Excitement imposes a "before" and "after," and extends the "during," making the duration of sex—waiting for it and having it and remembering it and replaying it—seem, some days, spacious and airy, and, other days, cloistered as a tomb. By "sex" I do not merely mean agreeable genital acts but the entire disagreeable gamut of how the body, and the eye, behave in relation to their parochial circumstances. Sex may mean reading, or promenading, or shopping. Sex certainly means sight.

The first of the erotic trilogy, *Kiss,* filmed in September through December of 1963, was actually a series of short films,

each a one-hundred-foot-long cartridge. In each, a couple kiss, in tight close-up. The mouths look odd, wet, the tongues unpleasantly athletic; I find myself wondering, "Did people kiss differently in 1963?" Certainly the men seem aggressive, more so than might be tolerable today, and the women are often giggling. These kisses played as "Andy Warhol Serial" at screenings organized by the experimental filmmaker Jonas Mekas: the installments of *Kiss* were like cartoons or newsreels, foreplay to the evening's central attraction. Baby Jane Holzer—one of Andy's first Superstars, whom Tom Wolfe called "Girl of the Year" in a cynical essay—kisses John Palmer; when recently she saw *Kiss* again for the first time in thirty years, she exclaimed, "Who am I kissing?" and then, after a few puzzled moments, shrieked, "It's John Palmer!" Naomi Levine, costar of *Tarzan and Jane Regained . . . Sort Of,* kisses several men, one at a time. Most remarkably, two androgynous figures smooch, and we assume they are a young man and woman, until the camera pans backward (a rare instance) to reveal that the couple are two shirtless young men necking on a couch, with a Warhol painting of Jackie Kennedy propped behind them. Warhol didn't exhibit the Jackie silkscreens until 1965; here, the painting, not yet a masterpiece, not yet valuable, functions as wallpaper, though also as an icon of a minatory goddess, as if Jackie were observing the boys kiss and giving their embrace an explanation, an historical context. (If any viewers of Warhol's classic images of Jackie and other iconic women were to doubt their homoerotic specificity, this moment from the rarely seen *Kiss* clarifies for all time that Warhol's choice of

female figures for memorialization in silkscreens depended on an atmosphere of homoerotic license, a Factory where boys could kiss on the couch, and where, moreover, they could be filmed kissing, not because Warhol wanted to shock viewers, but because he believed that nothing could be more worth documenting—nothing could be more abstract and hence aesthetic—than queer fondling.) We don't know the identity of the boys smooching under Jackie's eye; they become algebraic ciphers for homo-erotic desire. Despite my conviction that Warhol is celebrating their kiss, he remains distant from it; the viewer never knows whether the artist appreciates or is horrified by the activities he records.

One of the kissers in *Kiss* wears a wristwatch. The watch reminds us that time is passing within the film, a specific duration in 1963, now lost. Because the film runs at silent speed, our time, as we observe, is longer than the wristwatch's. Arousal's slowness ripens in the next of the erotic trilogy, and perhaps the greatest film Warhol ever made, *Blow Job* (1964), a film of almost unbearable intimacy—unbearable, because one realizes, watching it, that one has never before spent forty minutes without pause unselfishly looking at a man's face during the course of his slow movement toward orgasm. In life, as opposed to Warhol's cinema, there are always other things to look at; Warhol gives us, in *Blow Job,* six one-hundred-foot-long reels, black-and-white, dramatically lighted, of an unnamed man's face in close-up as he is being given a blow job, the film's title leads us to presume. We can't verify that fellatio is happening. We take it on faith. His expressions—from boredom to

ecstasy—appear authentic. We can tell when he reaches climax because, after the grimaces subside, he lights a cigarette.

Much in *Blow Job* is unverifiable. We don't know whether a man or a woman is fellating the actor. Perhaps several different men or women, perhaps one per reel. We may even wonder whether Warhol himself is servicing his star, while someone else mans the Bolex. Thus we don't know the recipient's sexual preference: he looks like trade (a straight man who, especially if paid, lets another man blow him). We don't know whether he truly reaches climax, or merely fakes it. There is no money shot: evidentiary ejaculation, a porn staple. Every Warhol fan has a version of the story behind *Blow Job*. The most convincing: the guy getting head is a New York actor who appeared in smut as well as Shakespeare. The Warhol Museum has copies of a porno in which this actor performs. (No one knows what became of him. No one knows whether he ever saw *Blow Job*.) He resembles Marlon Brando or Gerard Malanga; the likeness must have excited Warhol. The surprise is that his face recalls that of the actress Falconetti in Carl Theodor Dreyer's *The Passion of Joan of Arc*. Without the title (*Blow Job*), one would have guessed that here was a man in pain, on the stake or the rack, suffering death or religious ecstasy. He winces; sometimes he appears to weep.

Any description of *Blow Job* will fail to express its sublimity—its seriousness, its tortured play of interrogating light and oneiric shadow. Watching, sitting silently for forty-one minutes, observing a portrait of a face that seems more a painting than a film, I have time to muse on the entire history of

sexuality, as well as my own personal sexual history; I have the privacy, and the leisure, to study a human face in its most intimate and lonely transport. Here, a face is offered for our contemplation but not for our consumption. Here, religious and profane meanings collide more keenly than in any other Warhol image: we see a physiognomic record of the "blows" that Job received. The hero's ecstasy shows that the payoff for stoicism, in Warhol's view, is the ability to transvalue pain into pleasure. The title of Warhol's first commercial art assignment comes to mind: he illustrated an article in *Glamour* magazine entitled "Success Is a *Job* in New York." Both Warhol and his nameless actor have certainly achieved metropolitan success.

The action in *Blow Job* may suggest sacred sensations, unlike the goings-on in *Couch,* the most explicit of his early films—a frankness that will only be equaled, later in his career, by *Blue Movie.* Psychoanalysis, via the title, and the sole prop or set (a couch), enters the picture, however; Warhol never spent analytic time on the couch, perhaps because he spent so much valuable time on his own Factory couch. (Freud might have recognized in Warhol a colleague, a systematic explorer of wish and drive. Indeed, Andy was invited to speak, in 1966, at the annual banquet of the New York Society for Clinical Psychiatry. He brought his rock group, the Velvet Underground, along.) Warhol's *Couch,* filmed in 1964, seems to have been, like *Kiss,* a serial—various reels of people cavorting on the Factory couch. I wonder, even thirty-five years after its making, how on earth Warhol got these people to do such things in front of a camera. In the land of *Couch,* there is only pleasure, no

shame. Most astonishing are the scenes of Gerard Malanga getting a hand job and then a blow job from Robert Olivo, nicknamed "Ondine," a nonstop raconteur and speed freak whose eloquence and temper titillated Warhol. Ondine, in all his future film appearances, as well as in his tape-recorded (and transcribed) monologues, is flamboyantly queer; Gerard is not. And yet Gerard has already, by 1964, made the transition from painting assistant to polyperverse superstar. As Malanga put it to me, "I had fewer inhibitions then." Baby Jane Holzer, who appears, clothed, in an early segment of *Couch,* was unaware of the sexual events in the later reels, and was not present for their filming.

The Factory was not, despite appearances, a twenty-four-hour orgy; Andy was still living with his mother, although we can safely presume that he did not invite her to see *Couch* filmed or screened. And yet Andy's camera, a spy, could incite sex, earn the right to see it. His Bolex authorized and legitimized excess. It functioned as a moral solvent, a mechanized confessional, dragging out bugaboos and detoxifying them, the absolving repetitions of reels like a host of Hail Marys. Not that the participants in *Couch* were flooded with guilt. Why should they have been? Warhol and his cast knew what they were up to: abstracting sexuality from its particulars. *Abstract* was Andy's favorite word to describe sex. Sex was abstract because it was not just a feeling or an action but a complicated impersonal system, a set of signs and practices, remote from Mr. Paperbag's—or anybody's—internal storied turmoil. Listen to him describe, in an interview, the pornographic impulse,

the *vérité* urge to capture the drives. This interview took place in 1969, when Warhol's filmmaking had nearly ceased but his wish to see had not. Here, he ignores his detractors' moralistic charges and defines the one-to-one correspondence of sexual revelation and cinematic time (one exposed reel of film equals one sexual exposure):

Interviewer: It's been suggested that your stars are all compulsive exhibitionists and that your films are therapy. What do you think?

Warhol: Have you seen any *beavers?* They're where girls take off their clothes completely. And they're always alone on a bed. Every girl is always on a bed. And then they sort of fuck the camera.

Interviewer: They wriggle around and exhibit themselves?

Warhol: Yeah. You can see them in theaters in New York. The girls are completely nude and you can see everything. They're really great. . . .

Interviewer: Have you actually made a beaver yet?

Warhol: Not really. We go in for artier films for popular consumption, but we're getting there. Like, sometimes people say we've influenced so many other filmmakers. But the only people we've really influenced is that beaver crowd. The beavers are so great. They don't even have to make prints. They have so many girls showing up to act in them. It's cheaper just to make originals than to have prints made. It's always on a bed. It's really terrific.

Therein lies the philosophy of *Couch;* it's easier, cheaper, and more aesthetically efficient to make originals of sex acts on the bed or couch than to piece together a conventional work. He saw in pornography's methods a paradigm for artistic economy in general, for his primary desire was to perpetrate maximum exposure, maximum veracity, and maximum profit. *Couch* never made a cent; it was hardly even exhibited. But Warhol's future efforts could rest on its conceptual bedrock.

He praised "beaver" films, but the 1950s "cock drawings" reveal his priorities. *Beaver* and *pussy,* words Warhol loved to use whenever possible, particularly in dictated texts he knew would be published, betray his uncertain—derisive?—relation to women. He relished the female-centered worlds of fashion, face, beauty, commodity, and decor. Women were among his greatest subjects, in silk-screens and films. And yet, despite his identification with women, and his fear and dislike of homophobic men, he also felt vulnerable to female assault. Case in point: in fall 1964, a woman of occult disposition named Dorothy Podber entered the Factory, aimed a gun at a stack of Warhol's Marilyn Monroe paintings, and shot a hole through them. Warhol, always receptive to mistakes and accidents, saw them christened the Shot Marilyns, including a *Shot Red Marilyn,* a *Shot Orange Marilyn,* and a *Shot Light Blue Marilyn.*

4. TORTURE

ANDY MET EDITH MINTURN SEDWICK, known as Edie, at a party in early 1965. Chuck Wein, her Svengali, a handsome, clean-cut, manipulative Harvard boy who managed her unmanageable career, tells the compilers of the oral history *Edie*: "She was doing her dance—a sort of balletlike rock 'n' roll. We'd had an idea of opening up an underwater discotheque where Edie'd dance her ballet to Bach played at rock 'n' roll tempo." (Tempo alteration was also Andy's forte.) Sam Green, who organized Andy's first retrospective in 1965, told me that Edie was more eyecatching than Elizabeth Taylor: "Every bit of Edie was fine." She became Andy's new superstar. His desire for female doppelgängers was not the usual story of a male artist seeking his anima: he used these women not to consolidate his masculinity but as his accomplices in taking it apart. Edie was the most sensational of these foils. She wouldn't last long at the Factory, but she left more of an impression on Andy and on the public than did any other of his mirroring sidekicks.

Before Edie there had been Baby Jane Holzer of the parabolic coiffure, star of his film *Soap Opera,* in which images of a guy rubbing his crotch or of Gerard shirtless on a couch are juxtaposed with real television commercials of 1964—ads for wave-controlling hair cream, for Jerry Lewis's muscular dystrophy drive. Jane, like Edie, was high society, but Edie, unlike Jane, came with a patina of things intellectual; Edie implied metaphysical depth and the charm of book learning, even if she hadn't endured much of it herself.

She changed her appearance to match his, and he adopted her look—or else his carriage unconsciously grew svelte and assured, imitating hers. She gave him the confidence to pare down his movements and to reformat his erratic mannerisms as a high style. She was the first ravishingly beautiful woman to pay him entire attention, to seem, for a moment, almost in love with him. He may have wanted her quickly out of his life, but for most of 1965 she was his rationale. Billy Name cut her hair; she dyed it silver. Her eyebrows were thick and dark as Liz's, an undisguised car-crash scar between them. She had a troubled history—breakdowns, hospitalizations—and came from a wealthy and prominent New England family, littered with wrecked hopes. Her dangling, spidery, ambitious earrings, in Warhol film appearances, cast mythic shadows on the walls. She modeled for *Vogue* and *Life,* wearing black tights and oversize shirts, mod updates of the outfit Judy Garland wore to sing "Somewhere There's a Someone" in *A Star Is Born.* Edie had sensational legs; everybody said so. She may have wanted to break into

Hollywood, but starring in a series of Andy Warhol films was not a logical step in that direction.

Hollywood, then or now, wouldn't know what to do with Edie, who was undisciplined, and whose genius lay in unpremeditated, unhindered gestures. Moving onscreen, she choreographed her own baroque ballet—a troupe of one, without narrative engine. She seemed always to be dancing to an inaudible, imaginary song. Andy, ambivalent about movement, nonetheless specialized in movement artists: his stars excelled at perverse *pliés,* undinal paroxysms. He made films of men—Jack Smith, Paul Swan, Taylor Mead—whose movements, not conventionally graceful or beautiful, broke masculine rules and argued for expressivity as life's purpose: he liked to see limbs sent reeling, the unnatural spasms of St. Vitus' Dance, a tropism toward death. Edie's sinuous movements obeyed inscrutable inner promptings and didn't aim to communicate. Instead, she seemed hypnotized by her own gestural carnival. She was a dandy's dream: woman as a work of art. She became Andy's Shirley Temple, his tap-dancing "upper"; he could get high just by watching her move. She was high most of the time ("Andy liked high people," said superstar Ultra Violet), and Andy himself was taking a quarter Obetrol, a diet pill, once a day.

Edie starred in a series of Andy's movies: *Poor Little Rich Girl* (titled after the Shirley Temple vehicle of 1936), *Beauty #2, Camp, Afternoon, Inner and Outer Space, Space, Lupe.* Here were his first experiments in a cinema vérité of the female everyday. In them he created a "cinema of attractions," which film

historian Tom Gunning claims was the origin of motion pictures. At its start, the art of cinema was equivalent to burlesque—a peep or freak show. Narrative came later in its evolution (as it would arrive later in Warhol's film career), and the storytelling impulses of cinema have always sparred with its aim simply to present a female attraction. *Poor Little Rich Girl* offers us nothing but the breakthrough—you've got to see her!—of Edie rising in the morning, putting on makeup, dressing. The process takes a long while. Andy was attracted to Edie's wealth: she could afford to take her time doing nothing. The entire first reel of *Poor Little Rich Girl* is unfocused; the blur hides Edie's features, and invisibility gives her a privacy that the next reel will destroy. In the second reel, she is back in focus, but her appeal is thereby reduced. She no longer looks like a Degas painting.

In Edie's first film appearance, as an extra in *Vinyl* (1965), she nearly steals the show. Mascot, addendum to the action, she watches a male sadomasochistic tableau and seems untraumatized and unmoved by it. Andy recognizes—feels kinship with—Edie's elite indifference, her nonparticipatory adjacency to the homoerotic scene she half observes and half ignores. He prefers to see desire centrifugally scattered into two separate bodies, two spectacles, neither influencing the other; he prefers a relation that is not a dialogue but a cold juxtaposition, the two pieces echoing in heartless analogy.

Vinyl is one of the few Warhol films to be based on a prior text—Anthony Burgess's *A Clockwork Orange* (Warhol bought the rights for $3,000). Ronald Tavel, who worked with Andy on many films at this time, wrote the scenario: Andy understood,

once he began making sound movies, that he'd need a collabo-
rator to devise dialogue and action, and so he enlisted Tavel,
a playwright. (In a documentary on Warhol's cinema, *Mirror
for the 1960s,* Tavel describes Warhol's directorial method as
torturing performances out of his cast.) The manifest subject
of *Vinyl* was torture. Gerard Malanga, who plays the juvenile
delinquent Victor, is one victim. Subjected to aversion ther-
apy, he is tied to a chair, a mask over his face; electrical tape
binds his chest, hot wax drips onto his flesh, and he is force-
fed "poppers" (amyl nitrate). The inhalation is not simulated.
Progressively more stoned during the movie, by its end he is
incapacitated, and we feel we're watching a snuff film, a docu-
ment of genuine torture. Warhol kept Gerard out late the night
before the filming, to prevent him from learning his lines, and
invited members of the press to watch the shooting, to put the
actors on the spot. He introduced Edie into the film at the elev-
enth hour, over Gerard's objections: Gerard didn't want any
women in it, but Andy told him that Edie looked like a boy, so
she would fit in. According to Tavel (quoted by Victor Bock-
ris in his biography): "he was laying into Gerard and sabotag-
ing him. His motivations were to prevent the film from looking
like a normal movie, and to get at Gerard." In *Vinyl,* Gerard's
torture occupies the frame's foreground; the background is a
more authentic-looking sadomasochistic scene involving hot
wax and poppers—a newsboy tortured by a doctor and his
assistant. At moments, Edie seems on the verge of intervening.
Always, a split governs Andy's work: in *Vinyl,* the image is riven
between Gerard's torture on the left side of the screen, and

Edie's regardless dance on the right. Edie watches the torture of Gerard, but she doesn't comment on it; at one moment in the film, she dances with him, but otherwise she remains in a separate, observing sphere. Perhaps she dances to distract herself from the nearby torture. Perhaps she dances to narrate it. Perhaps, for Edie, dancing is torture—her tormenter the off-screen director who licenses her *perpetuum mobile.*

The film that most dramatically expresses Warhol's relation to torture, to Edie, and to the dividing line—cleft, cut, schism— between doppelgängers is *Outer and Inner Space* (1965), his first film to use the device of the double screen. Warhol filmed two reels of Edie, and then screened them simultaneously, one on the left, one on the right. Each reel consists, itself, of two Edies: Norelco lent video equipment to Warhol, and he experimented by making videos of Edie, which he then replayed on a monitor, and for *Outer and Inner Space* he filmed Edie reacting to—discomfited by—her own video image. As in *Vinyl,* she endures torture: in this case, it is her own image that needles her, its replay a haunting she'd rather forgo. The experience, for the viewer, of seeing four Edies is remarkable: this quadruple portrait of Edie proclaims his steady interest in seeing a star four times (at least!), a preoccupation that will bear fruit in the title of a film he begins the next year, **** *(Four Stars).* Amid the pleasures of stellar multiplication, some pathos clings: in *Outer and Inner Space,* the sense of touch has no place. Edie can't touch or alter her own videotaped image. Nor does anyone touch her.

Edie's voice, gravelly, light, is a marvel; her laugh knows the limits of the uses to which she will be put. I came closest

to comprehending her voice, and her relation to Andy, by listening to his audiotape of a conversation between Edie and Ondine. (It later appears, transcribed, in Warhol's novel, *a.*) Urgent, reckless, her voice alternating between whisper and wail, she blurts out confidential and sometimes incoherent bulletins of existential extremity: "Ondine, what is to be done?" "We must die," Ondine replies, and she says, "I already did die." She says, "You know what he said to Andy—'Don't forget I discovered her.'" She says, "When Mummy tried to commit me to the hospital . . . " Here is a trembling flower that Andy will never be able to save.

Edie undergoes torture at least once more in a Warhol film: *Beauty #2,* made in 1965. She lies on a bed with sexy Gino Piserchio, each stripped down to underwear. They neck while Chuck Wein's offscreen voice taunts and insults her: we wonder whether his invisible hectoring is actual torture or its imitation. He excoriates her for "using people," and says, "Do better than that, Edie!" Fed up, she throws an ashtray at him. Last words matter in Warhol films: the last word in *Beauty #2* is *abortion.* The film's abrupt ending, after the word *abortion,* itself aborts the drama, and the word begins to seem the symbolic designation of the entire preceding drama. What has been aborted? Intimacy, among other virtues. The title *Beauty #2* may mean that there was an earlier film, *Beauty #1* (as there is a *Haircut #1* and a *Haircut #2),* but the title also alerts us to a reigning uncertainty: are there two beauties onscreen? Which is preeminent? Gino Piserchio is a beauty, but so is Edie. Warhol presents male and female beauty side by side and lets us choose. Placement

beside a rival beauty exacerbates Edie's vertigo, her visible slipping away from stability and psychological certainty; even in *Outer and Inner Space,* with four Edies on screen, she does not have undisturbed reign, for at one point, gorgeous Gerard Malanga appears in the frame and slowly combs his hair. His beauty wrecks Edie's space, alters it, and poses the question, momentarily, whether male beauty is *outer* and female is *inner* (corresponding to "outie" versus "innie" genitalia). Warhol rarely envisioned noncompeting beauties; one beauty inevitably tortures another. Beauty is itself an instrument of torture.

Edie had several silkscreen precursors: Marilyn, Jackie, Liz. With each of these women, Andy would be identified to the point of twinship. Andy tortures Marilyn by portraying her, so soon after her suicide; also, Monroe's beauty tortures him, her death mask a grimacing high-gloss multicolor gibe at his pallor. Another of Andy's girls from this period was Ethel Scull, her name akin to "skull," apposite to Andy's many memento mori; for a commissioned portrait of this Pop-art collector, he took her to an automated photobooth, and the machine—better than Richard Avedon—took her picture countless times. He silkscreened the choicest images and assembled them (or had someone else link them) in strips, as if fresh from the booth. He loved the photobooth's cheapness, its automation, its connection to the identity-verifying basis of the photographic art, its power to evoke spontaneous performances from its victims, and its resemblance to the Catholic confessional and to the voting booth. Within the photobooth, one could vote for

oneself, the kind of politics that Andy preferred. He recycled or apotheosized photobooth shots of himself into silkscreened self-portraits. And in 1966 he made a photobooth-based silkscreen portrait of actress and art dealer Holly Solomon, who described to me her dismay upon initially seeing it—she thought it made her look like a "cocksucker." Indeed, it made her look like one of Warhol's women: repeated yet motionless, brightly colored yet remote, and drained of vulnerability. In these images of Ethel Scull and Holly Solomon he first realized that non-celebrity beauties could, through silkscreen manipulation, be rigged to resemble trademarks like Marilyn or Liz. On first seeing either the Solomon or the Scull portrait, one assumes that the women are screen luminaries, not art-world figures. With these portraits, Andy invented the artmaven-star and built a bridge between mortality and divinity.

The most ambitious portraiture project of this time, however, was not painterly, but cinematic: his series of *Screen Tests,* begun in 1964 with the collaboration of Gerard Malanga (with whom Andy in 1967 produced a book entitled *Screen Tests,* containing stills from the tests, as well as poems by Malanga). The screen tests were explicitly acts of coercion, of psychological torture: each victim, instructed not to move, sometimes not to blink, would sit before a tripod-mounted 16mm camera for three minutes. A subject could defy the punitive eye of Warhol's camera by moving, or by manifesting affect. Ultimately Andy did more than five hundred of these tests—each an unedited hundred-foot cartridge of silent film. The experience of watching these tests in bulk has permanently changed my attitude

toward the human face: I realize that I have never looked with enough love or forgiveness at the features of strangers. Not that Warhol's gaze is loving; to judge by their expressions, the sitters experience the screen test as an ordeal, a punitive sounding-of-depths, which they resist by not emoting. (Paradox: Warhol tells his subjects not to emote, but if they obey his instructions, they contradict his unspoken desire, which is to provoke the victim into a visible breakdown.) And yet each subject also seems to be judging Warhol's enterprise—to be staring critically at Warhol's eye, not accepting its criteria, deflecting or deflowering it by impassively mirroring back at it a mechanistic frontality. Andy is testing his camera, measuring how closely a camera can peer at human secrets. He is also testing the subject's screen—his or her ability to defend, repress, and postpone.

Some particularly resilient screen tests are of writers: they can effectively sidestep the silent camera's probe, for their treasures are verbal, invisible. Warhol did perhaps five screen tests of Susan Sontag, who represents a learned world that would on occasion express approval of his work but would more often dismiss him as lacking high seriousness. The screen tests form a cumulative portrait of her ascent to glamour, for in the first she is young, haunted, and awkward, while in the later episodes she has the self-assurance and beauty of a French film star. Another reason that Warhol might have been keen to screen-test Sontag was that she championed the work of the underground filmmaker Jack Smith; her essay on camp might have been one origin of Warhol's 1965 film *Camp,* in which

Smith appears, asking the director, "Should I open the closet now, Andy?"—as if Andy's closet had ever been closed! Sontag herself participated in a documentary film about Warhol, made for the BBC; in this film, she visits the Factory, BBC crew in tow, and sits for a screen test while Andy watches. To the BBC, Gerard says, "He's camera shy," and Andy has an attack of camera envy: as if comparing bodily endowments, he asks Sontag, "How come your camera doesn't make any noise?" He tells her that his next movie will be strip poker, four boys and three girls, and asks, "Can you play strip poker, Susan?"

Happy to scrutinize intellectuals like Sontag, he also used the screen tests to put art-world potentates under pressure. In *Henry Geldzahler* (1964), a portrait film that is essentially a ninety-nine-minute screen test, he puts the curator on the spot. Although only Henry is in the frame, the film seems a portrait of two nerdy guys—Warhol, Geldzahler—sitting in a room together trying without success to seduce each other; neither finds the other sufficiently desirable, so neither makes a move. Henry tries to strike a comfortable or glamorous pose, to no avail; he touches his stomach, sneezes, blows his nose, wipes his forehead with a handkerchief. He rubs the couch fabric, then his own face; desperate for palpation, he reminds us that a camera can stare but cannot touch. Time passes, and we realize that Henry is still Henry, even after all these effortful minutes; we—Henry, Andy, you, I—are forced to remain ourselves for our entire lives. Off and on, Henry vouched for Andy's art: but Andy must periodically have felt the lash of Henry's educated and sarcastic tongue, and so this portrait

becomes a roundabout way of paying Henry back, and of retaliating against every merciless eminence who thought Warhol a poseur, a hick, or a freak—even as this film is also his generous attempt to make Henry a beauty.

Warhol's camera could torture men and women, but not drag queens: their appearance was already an arduous performance, in which they played director and star. His great drag queen of the 1960s was Mario Montez; previously a player in Jack Smith films, she was the namesake of Smith's beloved Maria Montez. Mario appeared in several short Warhol films known as *Mario Banana,* in which this Puerto Rican post-office worker, in imposing drag, slowly eats, or fellates, a banana. In one of Mario's greatest roles for Andy, *Screen Test #2* (1965), scripted by Ronald Tavel, she auditions for the part of Esmeralda, love object of the Hunchback of Nôtre Dame, while the offscreen Tavel shouts promptings that might seem sadistic were it not for Mario's imperturbable surface, more concerned with maquillage than thespian success; her hair keeps straying into her mouth, and she repeatedly removes the strands.

In another great vehicle, *More Milk Yvette* (aka *Lana Turner),* made in 1965, she plays Lana. This film is especially interesting because it presents an entire family—false, parodic, but nuclear—together in one drama, and because Warhol's camerawork is idiosyncratic, enraging, and expressive: it conveys his wandering indifference to the meat of the matter. The inquisitive camera dithers to the floor for a close-up on shoes; swerves to study the ceiling; zooms in and out to the rhythm of sultry Mario singing "Night and Day"; examines the

crotch (in jeans) of a young man who resembles Bob Dylan and plays the harmonica, like a theocratically impartial Greek chorus, during the film's action, not as a commentary on the action but as an avoidance of it; peruses the joint where a midscreen floating wall abuts the floor; examines the fabric of Mario's sweater; returns to the ceiling, as if wanting to fly above the prison of filmmaking, above perceptual limits. The camera behaves toward the performers much as Edie, in *Vinyl,* behaved toward tortured Gerard—as a contiguous but impartial witness. Lana's daughter, Cheryl, is played by a young male tough who resembles Brando, Dean, Malanga, or the star of *Blow Job*; naturally, mother and "daughter" smooch. "I have a son named Cheryl," says Mario, and mother and son eat a single hamburger together and drink one glass of milk brought by the servant, Yvette, responding to Mario's peremptory command, "More milk, Yvette." The film, a screen test of the category *motherhood,* inspects and demotes Lana's mothering of Cheryl, Yvette's mothering of Lana, Julia's mothering of Andy, Andy's mothering of his Factory troops, and it displays the indifference of both Andy the cameraman and the harmonica-playing Puck to the star family's sexual antics and mutations.

Mario, metamorphically moving from outfit to outfit, slowly undressing and dressing, occupies her own time, which critic Parker Tyler has called "dragtime," opposing it to "drugtime," the two essential clocks of the Warhol cinema. Mario's dragtime is in sync with Edie's time in *Poor Little Rich Girl* or *Vinyl*—a tempo that a stern skeptic might call narcissistic self-absorption but that I, more charitably, if portentously, would

call an investigation of the schisms that make up presence. Through these protracted tempi, Warhol investigates how a woman or a man, or a man pretending to be a woman, splits into an observing and an experiencing self; and he investigates how consciousness is a dialogue, like a telephone chat, and thus staggered, slow, and desultory. The skeptic might also fault *More Milk Yvette* for being dull. I would argue, however, that it is suspenseful: the situation in which Warhol places his actors is aesthetically motivated torture, and we nervously or excitedly wonder whether Mario will be seduced, raped, exposed, worshiped, or humiliated. (All are possible.) Suspense: will she succumb to torture, or remain a resilient queen? Will she fail the screen test? Will she fall apart? Or will she maintain her facade, singing "If I Loved You" to no one listening, her reiteration of Hollywood originals (Lana, *Carousel*) vacillating between comic foreplay and grave abstraction? In *More Milk Yvette,* Warhol meditates on someone else's body, not his own, but Mario pretending to be Lana gives Andy an excuse to subpoena his own identity, and to unmask "Warhol"—or any "I"—as a sum of deflections and substitutions. "My name is Lana Turner," says Mario, with the ludicrous seriousness of a self-evident utterance that demands reels and reels of proof. No one's identity is indubitable: not Lana's, not Mario's, not Andy's. Each needs to pass a screen test, to see if the face can fly.

Another Factory player in the mid-1960s who evaded the camera's torture—if only because the camera ignored her—was Dorothy Dean, a brilliant, Harvard-educated art historian and editor, and the only black woman to be an important part

of Warhol's circle at this time. Not that she would have enjoyed being called black. Critic Hilton Als, in *The Women,* describes Dean's aversion to unironic racial identification: she was fired from a position at *Essence* magazine—which Dean claimed "proves black is *pathetic*"— allegedly for suggesting they put Andy in blackface on the cover. She appears in several Warhol films of 1965, most extensively, if abjectly, in *Afternoon,* essentially an Edie vehicle, which places Dean in an uncomfortably tangential position. Edie had functioned as the scene-stealing mascot in *Vinyl,* adjacent but unrelated to the main proceedings; Dean, in *Afternoon,* is a mascot, but she fails to steal the scene because Warhol's camera ignores her. We can hear Andy's voice offscreen, directing the participants. This may be, in fact, the film most explicitly to show Andy's presence, for Dorothy addresses the man behind the camera directly at one point, calling him "Drella," the nickname that she (or someone else?) coined for Andy. At Dorothy's insidious instigation, others ask questions of Drella, and he becomes a point of discussion—the torture turned on the torturer. Indeed, the film could be subtitled *Portrait of Drella.* Drella tries to provoke fights between the cast members. He encourages Dorothy to "do something mean" to Arthur Loeb, her close friend, a rich white Harvard man; in response, she pinches Arthur. Andy instructs someone else to "pick on Ondine," and asks Dorothy to pick on Edie. As the quarrels escalate, Edie says, "I can't stand when people fight," and we feel that she genuinely hates conflict, and that the aggressive shenanigans of *Afternoon* are staged to unsettle her. Members of the gang take amphetamine; Dorothy

removes her schoolmarmish glasses, and Edie puts them on. In exchange, Dorothy tries on Edie's jewels. That's as far as the trade goes. Dorothy will never be Edie; marginal to *Afternoon,* Dean is one of the more conspicuously tortured figures in the Warhol canon, although her verbal virtuosity, and her ability to look Drella directly in the eye, behind the camera, and, by calling him "Drella," to cast the spotlight on *his* identity, clarify her resistance to torture, a resistance grounded in unphotogenic, competent imperviousness. She spends a lot of the film looking down at her lap. She sulks; she never gets a solo; Ondine puts a plastic bag over her head, and, in the last moments of the film, gives her drugs—a sad send-off. She fails the screen test, and she knows it, and the afternoon is long. Warhol would not call Dean a failure, however; he had the highest respect for performance. Although Dorothy Dean never became famous, she is as crucial as Edie Sedgwick to Warhol's enterprise in the mid-1960s. His work and life had become not (as later critics would stereotypically assume) a theory of fame but a theory of relationships, a query into the texture of human bondage—the web of interpersonal affiliation that includes, and surpasses, the ties that bind the not-famous to the famous. Much as he wished to identify with Edie, and to become her twin, he was less an Edie and more a Dorothy, an outsider, a nonbeauty for whom touch was not the primary spiritual vernacular.

I've been speaking about Andy's films, in 1965, and not his paintings, because in May 1965, at a Paris show of his flower paintings, he announced his retirement from painting to

devote himself entirely to moviemaking—a defection, however theatrical and hyperbolic, that his public still has a hard time swallowing. Warhol's audacious announcement had been foreshadowed by his art's movement—in 1964, before the arrival of Edie, and the expensive burgeoning of his filmmaking activities—into adventurously three-dimensional or interactive forms.

In 1964, Warhol was invited by Philip Johnson to decorate the exterior of the New York State Pavilion of the World's Fair. Warhol chose to silkscreen the mug shots of male fugitives wanted by the FBI, and to install a masonite grid of these across the skin of the building. After the painting was hung, resistance arose, and the work was taken down. Warhol suggested that he replace the offensive "wanted men" with twenty-five silkscreened images of Robert Moses, the city planner in charge of the fair. This proposal, too, was refused. Finally, Warhol overlaid the mural with silver paint. Warhol's first venture into public art superficially failed, but as a conceptual performance it succeeded. The obliterated "Most Wanted Men" has become, in retrospect, one of his most powerful statements—powerful, in part, because of the work's evanescence. In the *crise* of the vanishing mural, he demonstrated his sly style of civil disobedience: vanish, float away, do not resist. When confronted by authority, go limp. Vaporize. Turn silver. Warhol let his men evaporate into faceless silver mist, much as he must have experienced so many of his own desired objects vanish into abstraction, the solid blank wall of a spurned advance. The strength of this work, too, rests, as is typical for Warhol, on

a double entendre: the word *wanted*. As critic Richard Meyer has pointed out, the men are wanted by the FBI, but more to the point they are wanted—desired—by Warhol. For Warhol, if not as intensely as for Jean Genet before him, criminals were stars; Warhol would spend his career demonstrating that there was something criminal—antisocial—about desire, period (as there was, in 1964, something literally illegal about his desire for men). Finally, with this public work, erased, like Robert Rauschenberg's famous *Erased de Kooning Drawing*, Warhol advertised the pleasures of erasure and vanishing, and he revealed that any of his blank surfaces—the Factory painted entirely silver, a canvas entirely one color—always hides a loss. Repressions populate Warhol's empty stretches; excisions lie beneath his inexpressive mien, or behind the solid monochrome canvas he sometimes appended as pendant to a silkscreened painting, to increase the price and to eviscerate the stability of its companion image.

That same spring of 1964, Warhol exhibited his most audacious set of sculptures—wooden boxes silkscreened to resemble grocery cartons of Brillo pads, Heinz Ketchup, Campbell's tomato juice, Kellogg's corn flakes, and other products. Wordless Warhol shocks us with these boxes, for they are vehicles for suggestive words—words separated from grocery-product contexts and now functioning as troubling innuendos and provocations. The boxes make an offer that they can't follow through on: invitations to a waltz that never plays. In words, the boxes proclaim their largeness, or the hugeness of the products they supposedly contain: the Heinz box advertises

"The World's Largest Selling Ketchup," and the Brillo boxes promise "24 Giant Size Pkgs." Like Warhol's comic strip heroes, the boxes caricature masculinity: giant size, largest! But in fact they are merely boxes, facsimiles at that. He may be suggesting that manhood is a loud fib; masculinity, if reduced to an abstract form, is empty and null as a *box,* slang for female genitals (a fact that Miss Warhol, devoted to the words *pussy* and *beaver,* would not have overlooked). Masculinity, as a system, fails, just as ketchup rarely pours: even if the largest-selling ketchup in the world were here, in a bottle, before him, Warhol couldn't manage to make the blood flow out the recalcitrant tip. Warhol often depicted braggart masculinity as emptiness: one of his paintings of 1960–61 proclaimed "3-D Vacuum / Full Size / Easy Terms." A vacuum—vacuousness, vacuity—doubles as hustler: Warhol felt the void's existential seduction most palpably in the form of hustlers, men and artworks available on easy terms, on Easy Street, through easy art techniques, permitting easy evacuation of his uneasy interior matter, transposed to the skin's outside.

The boxes brag of largeness, but they also beg to be opened. The Del Monte box top gives tips for undressing: "TO OPEN – Press Down / Pull Up." The viewer is invited to engage in an impossible act—opening a box that isn't a box. The Heinz Ketchup box also announces the site of opening: "Open Opposite Side / This Side Up / To Prevent Breakage." The boxes, like stereotypical Victorian women, pretend fragility and terror in the face of sexual advance, and are difficult or impossible to open, and yet power lies in their brilliant coloristic assault on

the eye, their clamorous advertisements for cleanliness ("Soap Pads"), for makeovers and eternal youth ("Rust Resister"), and for purchase. Take me home! the box cries: a vehemence of self-advertisement that stupefies the viewer and prevents interaction. These boxes without openings seem simulacra of Andy's body—a queer body that may want to be entered or to enter, but that offers too many feints, too many surfaces, too much braggadocio, and no real opening. And yet it would be a mistake to see the boxes as emblems of Andy's pathos. Rather, the boxes—loudly shouting *"New!"*—represent proud impenetrability; he'd graduated from Andy Paperbag to Andy Boxer, and a box is certainly a sturdier—and more immortal— container than a bag. His embrace of the grocery-store box was a clever way to position himself as both a conceptual artist, in the tradition of Marcel Duchamp, and a man profoundly devoted to women's worlds and motherly arts.

He pushed the unopenable boxes to their logical conclusion when, in April 1966, he showed, as an embodiment of his farewell to painting, a series of silver clouds: helium-inflated, floating, Mylar pillows. (They look like Campbell soup cans *sans* labels.) He filled one room of the Leo Castelli Gallery with the silver clouds, and the adjoining room he covered with wallpaper: silkscreens of pink cows—the same pink cow, repeated—on a yellow background. (In a 1967 interview for *Mademoiselle,* Warhol said, confirming that he considered painting passé: "I hate to see things on walls. Doing the whole room is O.K., though.") Here at the Castelli Gallery, in the form of the clouds, were boxes or cans filled with a nothingness that allowed them

to wander away from the ground, to bump into each other like grazing cows, or slowly to leave the room, emigrating from the exhibition. Indeed, the pillows don't behave; they are like stubborn or developmentally handicapped children. They are mute. And their surfaces are mirrored. They represent the Warhol personality, or one public aspect of it, to perfection: their movements are steady, unpredictable, antisocial; they flash back your own image; ballooning with spirit, they yearn for infinity. In an audiotape that Warhol made of the unveiling of an early version of the silver clouds, on the roof of the Factory, his delight is evident, as is his conviction that ethereal objects are espoused to the sky: he squeals with joy as the silver structure (an "Infinite Sculpture") rises and disappears, blending into clouds and vacant blue. Words on a page can't capture the perfect pitch of Warhol's ebullience, as he watches his silver sculpture float away (occasionally he interrupts to give orders to Billy Kluver, the engineer who produced the clouds): "Oh, this is fantastic! Oh! Oh! Oh, this is fantastic, Billy! . . . It's going to fly away! It's like a movie! Fantastic! This is one of the most exciting things that's ever happened to me! It is *so* beautiful. Oh, Billy, it's infinite, because it goes in with the sky. Oh, it is fantastic! Oh! . . . Billy, do you know what our movies are called? Up movies, and up art." Up yours: the pillows gave him the pleasure of denouncing art, and renouncing it, eliminating its stranglehold on the senses—for a painting that floats away is one less painting to clutter up a wall. As he recalls in *POPism,* "I felt my art career floating away out the window, as if the paintings were just leaving the wall and floating away."

The silver clouds are up—drugged, perhaps, but happy to be getting off, getting away. The cows are taking another drug altogether: downers. They represent the bovine aspect of Warhol's temperament. Like the clouds, the cows congregate, vaguely, together, never forming an organized society. Andy favored beasts: we recall his pussies from the 1950s, and his 1965 film *Horse* starred a live horse, which the men in the cast try to molest. (The horse responds by kicking one of the offenders.) The beset horse's irrelevance to human sex seems a figure for Warhol's pretended remoteness from erotic reciprocity. Indeed, he allows the horse to be his vocal stand-in, for a microphone is positioned, in the film, by its mouth, as if the beast were going to break into song or give an interview. The horse, like the cow wallpaper, allows Andy to parody his own public persona as a mute who can't explain himself. The onscreen silver-painted pay phone rings several times during the course of filming *Horse,* and Andy, not stopping the camera, appears within the frame to talk on the phone. The horse's microphone picks up Andy's words. That's as close as he will get, in his films, to vocal self-portraiture. And yet he had fallen in love with the microphone. He first began using a tape recorder in the mid-1960s, perhaps as early as 1964, and it became his constant companion, allowing this wordless man to leave a legacy of verbal traces. His ambivalence toward sound, however, remained: like Hollywood silent stars traumatized by the birth of talkies, and facing their own obsolescence, Andy responded to the rental of his first sound camera by using it to film an essentially silent movie—the eight-hour, nontalking,

non-singing, nondancing *Empire*. This 1964 film, his most infamous, stars the Empire State Building, which does not budge; steadfast, its alien torso, like a dead Marilyn, endures night's arrival and the indifferent floodlight beams.

In 1964 and 1965, as for the rest of his life, Andy was interested in openings. Art openings, for example, like his own smash Philadelphia Institute of Contemporary Art gala launch, which he attended with Edie and company. Another extolled party took place in the Factory itself, given in the spring of 1965 by film producer Lester Persky: called "The Fifty Most Beautiful People" party, its guest list included Tennessee Williams, Rudolf Nureyev, Montgomery Clift, and Judy Garland. Such parties were not simply fun. They were profane monstrances, statements proposing publicity as his new art. He ensured that life at the Factory received full documentation: the house photographer was Billy Name, but others also donated services. An earnest high-school lad named Stephen Shore began hanging out at the Factory and taking pictures in 1965; Edie didn't give him the time of day, but Andy made a pass at him, which was rebuffed (Stephen revealed the disappointing fact that he was straight), and he got close enough to Andy to take a photo of the artist having sex with an unidentified man. Shore's photos, like Name's, later gathered in a volume issued on the occasion of Warhol's 1968 retrospective at Stockholm's Moderna Museet, definitively propagated the image of the Factory as a glamorous den of silver and shadow. Without these photos, we would not, today, have the same romantic vision of Warhol's 1960s milieu, nor would we have the inspiring, if sometimes delusional, sense

of his studio as a *Gesamtkunstwerk,* an environment-as-total-artwork, comprised of parties, scenes, poses, theatrics, friendships, illicit intensities. Name's and Shore's black-and-white photos are Warhol's self-advertisements, and part of his claim to immortality. While Nat Finkelstein took memorable color photographs of the 1960s Factory, color changes our perceptions of Warhol. He was better suited to black-and-white, which allowed his pastiness to read as argent refinement. Black-and-white made him handsome.

Photos were advertisements; and of advertisement, Warhol was never shy. He put an ad in the *Village Voice,* February 10, 1966: "I'll endorse with my name any of the following: clothing AC-DC, cigarettes small, tapes, sound equipment, ROCK N' ROLL RECORDS, anything, film, and film equipment, Food, Helium, Whips. MONEY!! love and kisses ANDY WARHOL EL 5-9941." Promiscuous endorsement became Andy's signature.

One endorsement that transported him far from art galleries was his adoption, as producer, of the rock band the Velvet Underground, composed of Lou Reed, Maureen Tucker, John Cale, and Sterling Morrison. Their music has many admirers, but it may be the aspect of Warhol's world with which I have least sympathy, and so I will beg off any attempt at analysis. The Warhol Factory was home to several kinds of music, as I wish my ear could be. Ronnie Cutrone told me that there you had "Callas up the ass until you were dead," due to Ondine's conviction that Maria was the necessary angel of the age. The Velvet Underground, however, not Callas, defines the Warhol

Factory's sound. After the group, under the name the Exploding Plastic Inevitable (originally the Erupting Plastic Inevitable), made its initial, incongruous appearance, under Andy's aegis, at a banquet for the New York Society for Clinical Psychiatry, it started playing at the Polski Dom Naradowy (Polish National Home) on St. Marks Place. At these explosions, Warhol screened his movies, Stephen Shore and others projected light shows with colored gels, and Gerard Malanga in leather pants (joined by Mary Woronov and sometimes by Ronnie Cutrone) performed a "whip dance"—orgiastic undulations, with bullwhip as prop. The Exploding Plastic Inevitable's swirl of sound and sensation epitomized a nascent genre, the multimedia happening.

Warhol loved Gerard's whip dance, but I imagine he felt more intimately confirmed by the appearance of the German model Christa Päffgen, nicknamed Nico, who sang along with the band, if singing is the proper word for her nerveless, dreamy drone, slowed down nearly to the point of death. She entered the Factory more or less at the time that Edie left it; Nico, with her Nordic pallor, white-blond hair, wide cheekbones, and dominating eyes, gave off some of the chill that Andy himself, with his Slavic features and silver hair, did; the two were kindred ghouls, anesthetic twins. Like Andy, she hated it when people touched her.

The theatrics enveloping Nico and the Velvets were jubilantly sadomasochistic. The decibel level of the Velvets tortured the audience's eardrums. Gerard's whip was a token of punishment. Nico's lack of relation to the band—her extraneousness,

girl among the wolves—was another kind of torture: she was a bane to the band, the band a bane to her, because neither entirely belonged together. In a fascinating film that Warhol made of the group, *The Velvet Underground* (circa 1966), the drummer Maureen Tucker, a cheerful and rather mannish young woman, is tied to her chair for the duration. Nico, however, is never tied up, though she is often unhappy, and she had a coldness of temperament that may have disturbed many around her, including her darling young son, Ari; the father was alleged to be actor Alain Delon, who declined to acknowledge paternity. We witness Nico most beautifully embodying coldness and cruelty (masochism's lodestars, according to philosopher Gilles Deleuze), in another film that Warhol made of the group, *The Velvet Underground and Nico* (1966), which features two traumas, each didactic. The first trauma is visual: the oscillating movement of Warhol's zoom, and the erratic focus, shifting in and out, consign the viewer to nausea. The virtue of blurred objects, however, is that they can resemble other things. Blurriness licenses mutation and metaphor: if she is out of focus, Nico can begin to look like other people, including Andy, or Andy's mother, or Edie, or empire, or a host of substitutes. The second trauma in the film is the situation of her child, Ari, who plays at her feet while the band rehearses. Listless, inactive, Nico perches on a stool and hits her tambourine, while gazing affectlessly over the blond pageboy hair of her son, who is doubtless befuddled by the Velvet's volume. Ari seems as extraneous to Nico as she seems to the band she supposedly accompanies. And the wildly unstable camera—blurry,

zooming—mimics this extraneousness: it ensures that no one belongs anywhere or has a function. Ari and Nico are disjoined; Nico and the Velvets lack a hinge. Andy's eye for doubles, whose visual appeal conceals un-happiness, shows a mother and child to be as separate as a girl singer and the band she weds—a merely nominal union. Andy's violent camerawork gives us a sensational, empathic entry into Ari's sorrow. He is one of the few children to appear in the Warhol films, and his presence turns a simple documentary of a Velvet Underground rehearsal into a portrait of a mother-child relationship, and, inevitably, if only through the maze of metaphor, into a portrait of Andy's own philosophy of maternity. Ari did not sign the implicit Warholian contract, whereby players conscripted themselves for compromising, protean exhibition; Ari may be the only player in a Warhol film whom we may justly pity for his unwitting participation in a purgative ritual of cosmetic, educational psychosis.

Nico's most memorable film appearance is in Warhol's masterpiece, *The Chelsea Girls,* a three-and-a-half-hour double-screen extravaganza. It was released in the fall of 1966, and at the beginning of 1967 it became the first Warhol film to play in a commercial movie house. It was also the first to make money: so far he'd financed his filmmaking ventures through sales of his paintings. Many of his entourage appear in *The Chelsea Girls;* yearbook for the Warhol Class of 1966, the film gives febrile glimpses into his girls' school—home ec, gym, lavatory, and cafeteria, all cubicles concentrated at the Chelsea Hotel

on West Twenty-third Street, where, sometimes, Brigid Berlin (aka "The Duchess") and other Warholians resided. The Chelsea Hotel, like General Hospital, or Peyton Place, or other geographical frames, is a convenient box—perhaps the most ideal that Warhol ever found—for amassing his modular images in a comprehensible grid. (The reels were made as individual works and then assembled into the composite *Chelsea Girls*.) He gives us, in this film, a psychology of hotels, as well as perfect portraits of hotel women—lazy spirits reprieved from the rigor of a fixed address.

The Chelsea Girls is composed of doublings: two screens, with two different reels of film simultaneously projected, in staggered rhythm. As if picking which twin to love, and having a hard time choosing, the viewer must watch one screen or the other: it is difficult, though exhilarating, to focus on both. *Chelsea Girls* drives home a dilemma: every human being has a limited power to love or absorb others. Daily we endure this Darwinian paucity of the affections; so did Andy. Surrounded by needy exhibitionists, he could not be savior to them all. Instead, sometimes silently, he gave them his nonresistance, and his camera's love. His camera pampered each of them, but not equally: inequality bred rivalries. And if Andy paid attention to them, the world paid more attention to Andy. That was his recompense. One person receives love at another's cost: thus the screens compete for our favor. The viewer, watching *Chelsea Girls*, will be more riveted by one screen than by another, because one image is color, another black-and-white; or because one has sound, while the other is inaudible; or

because one is sexier. Stardom, Andy knew, was based on human attention's whimsical infidelity: the eye (or the soul) wants Person A more than it wants Person B. Person A is a star. Person B is not. A is stellar because A can hypnotize— through beauty, seductiveness, recognizability, colorfulness, and, sometimes, as a last resort, through verbal pirouettes, the untoward disclosures of echolalia.

Chelsea Girls ends with an interminable close-up of Nico crying, the colored lights playing over her face as kind camouflage and cruel scarification. The film also begins with Nico. On the right screen, in a kitchen, she trims her bangs in the presence of her son, Ari, and a gold-tressed, out-of-it young man named Eric Emerson—a flower child, a terpsichorean self-intoxicated druggie whose intentions we presume are pure. What an unlikely nuclear family: Ari, Nico, Eric! Against this queer trio of Virgin Mary (Nico), God (Eric), and the Son (Ari), we see, on the opposite screen, Ondine, known as "the Pope of Greenwich Village," receiving the confession of Ingrid Superstar, a plain girl from New Jersey who was discovered on Forty-second Street and brought into the Factory to taunt Edie.

(A brief note on Ingrid Superstar: Andy made Ingrid his new Edie, humiliating Edie in the process, and misleading bovine Ingrid with the attention. Ingrid took to the limelight, however, and delivered lucid comic performances. Eventually her mother advertised in a newspaper for the return of her daughter: "Please come back. You do not have to see your father again. Everything's cool now. We all miss you. Your Standel Imperial XV is here. Come back so we can play Morning Dew

without feeling sad." Andy enjoyed torturing her, though he also seemed to love her. In an audiotaped phone conversation from the late 1960s or early 1970s, Andy insinuates that others believe she qualifies not as a superstar but as a "retard," and though he rescinds the insinuation—"You know I don't call you retarded! Ingrid, no one says you're retarded! You're up there! Ingrid, I was just kidding!"—it's clear that Ingrid was considered the "retarded" superstar, the joke. No one in *Chelsea Girls,* or in any Warhol movie, wants to be a joke; each is shooting for salvation. Ingrid, like the rest of us, may never have attained it. She disappeared in 1986.)

In *Chelsea Girls,* Pope Ondine hears Ingrid's confession, and their screen (the left screen, Nico cutting her bangs on the right) is itself bifurcated: Ondine sits on the right, in his own couch or chair, and Ingrid occupies a separate chair on the left. A line divides them—not only the space between the two chairs, but a vertical line on the Factory wall. Warhol's cinematic images, often static, are always compositionally acute, entitling us to interpret them closely. And the clear line between Ondine and Ingrid communicates the sad fact that he cannot fathom her thoughts, no matter how much she confesses. More tragically, Ondine and Ingrid will never be able to migrate into the adjacent screen and enter the kitchen where Nico, Ari, and Eric perform their masque of happy family. The two rooms do not communicate. Only we, as viewers, hold both in consciousness at once: and our responsibility (Warhol wrote in his *Philosophy,* "I think I'm missing some . . . responsibility chemicals") is to pay sufficient attention, and, by absorbing *Chelsea Girls* in

all its battering fullness, to build redemptive links between the rooms.

Taking confessions is a mode of torture; Ondine's desire to extract them is as insistent as a craving for drugs ("I want a confession, and now!" he impatiently cries). His practice reaches its climax when a young woman named Rona Page, not a superstar, dares to call him a "phony," and he lashes out, slapping her: she flees, Ondine has a tantrum, and any illusion that we're watching a mere scripted performance breaks down. Ondine suggests that the filming stop ("I don't want to go on"), but the camera continues to expose Ondine, to exact from him its tincture of truth. Ondine predicts that his explosion—his rupture of the frail fictive frame—will make the film a "historic document." His abuse of Rona Page is not the only instance of torture in the reel. At the beginning of the reel, he'd tortured— or given pleasure to—himself by injecting speed in his wrist.

Injections drive the Chelsea Girls. The most speed-compelled of the gang is Brigid Berlin, nicknamed Brigid Polk because of her practice of giving "pokes" of amphetamine to herself and to others, often straight through the jeans, and often unrequested. In her reel, which plays on the right screen, while, on the left, a boy lies semi-nude on a hotel bed (whip-wielding Mary Woronov ties up one of them), Brigid generously services herself with pokes and gives a poke to Ingrid Superstar, who has little choice in the matter: says Brigid, "I give pokes where I give them, Mary!" Joking about her own injection, Brigid quips, "And they wondered why I got hepatitis!" Brigid (or the Bridge), a difficult and unconventional woman, of

glamorously uncertain erotic tendency, whose father was head of the Hearst Corporation, and who sporadically worked or played, until the end of Warhol's life, as his typist, receptionist, telephone confidante, and fellow Polaroid hound, always acts the aggressor, even if her aggressions, delivered with a manic, high-society wit, fascistically sharp, compulsively honed, were often aimed at herself—her conspicuously large body, which she enjoyed flashing in Factory photos, her breasts (she called them "tits") employed to make her famous "Tit Prints." She also made "Cock Books" and "Scar Books," documenting the physical features of her associates. (Warhol later bought her print of Jasper Johns's penis.)

The crudest of the Chelsea Girls—at least on film—was Mary Woronov, who played the part of Hanoi Hannah. Wearing a butch costume of shirt and tie, brandishing a whip, she has the rare privilege of dominating two screens of *Chelsea Girls* at once—Mary on the right, and Mary on the left, in harmonious twinship. Mary was, for a time, Gerard Malanga's girlfriend, and she assumes that role in another episode of *Chelsea Girls,* known as "The Gerard Malanga Story," in which Gerard and his mentor, the formidable Marie Mencken, sit together on a bed, while his girlfriend, Mary, sits alone on another single bed in the same hotel room and says not a word to Gerard throughout the reel. Their incommunication, stranded on two separate beds, seconds the division between the two screens. Marie is hard on Gerard, who wears unmanly rebel apparel (striped pants, mesh shirt, beads): she whips the bed, berates him for his "filthy towel," whips the towel, and scornfully calls it "last

night's towel." How dare he leave last night's towel on the bed! "I wish I had a daughter!" she cries. Marie and Mary are doubles, though they don't address each other, and though Marie's voluble cruelty, ultimately maternal and solicitous, can't rival Mary's silent spite. Mary, more talkative in another reel, imprisons Ingrid Superstar under a desk in a hotel room and verbally tortures a hapless pale nonphotogenic girl named Angelina "Pepper" Davis, who lies in tears beside Mary on the bed and seems just to want a hug. Another young superstar, International Velvet, whose real name was Susan Bottomly, and whom many of the Factory regulars remember as the most beautiful of all the superstars, becomes a victim of playful erotic torture when Hanoi Hannah rips her crochet-mesh top. Pepper is the film's biggest loser; she can't even narrate. As Ondine slaps Rona Page for failing her screen test, so Hanoi Hannah humiliates Pepper for not narrating in sufficient detail the story of her home. Pepper skips some information, and Hanoi interrupts her, shouting, "Skip nothing!"—the Warhol credo. Mary tries to brainwash Pepper into loving home: "Home is beautiful. Your mother is beautiful." *Chelsea Girls,* Warhol's home story, proves these adages mere placebos.

Only one person in this film escapes torture: Eric Emerson. He earns a reel of his own, and it is an island of nonviolent bliss. His charm—like Nico's, Ingrid's, or Andy's—comes from his connection to the mute, the animal, the "retarded." Much did Andy travel in this realm of inarticulation, which was, in his work, often the locus of ecstasy. In *POPism,* Andy said of Eric: "I never know what to think of Eric: was he retarded or

intelligent?" (The same question has often been asked of War-hol.) "Retarded," though a word now considered offensive, was widely used in his time, and it is an essential term in his lexicon, impossible to avoid. In Warhol's cinema, time is retarded. Time moves at a regular pace in *Chelsea Girls,* which, unlike Warhol's early silent films, is projected at twenty-four frames per second rather than sixteen or eighteen, but because the players are mostly on drugs (amphetamine—speed—might make them the opposite of retarded), their reactions and interactions respect an altered temporality, and the schism between the screens defamiliarizes the passing of time for the viewer. Doubled time is prolonged time. And Eric's reel is the most retarded of them all, though also the most ecstatic. He undulates, by himself, while colored lights play over a body—his own—that he finds supremely desirable, sufficient unto the day: "Do you ever groove on your own body?" he asks, rhetorically. He speaks for himself and to himself, but he is also speaking to Andy the filmmaker, and may be speaking *for* Andy, especially when he says, "Sometimes I hate to be touched." Eric is saturated with sensation but also seems afloat in a sensory deprivation tank: "I can't see a thing, except me— that's all there is to see, as far as I'm concerned." Such solipsism might be irritating were it not for Eric's beauty and unpretentiousness, for the bewitching play of blue and red lights on his body as he dances (while, on the adjacent screen, similar colors play over the entire cast), and for the unforced intensity of his self-fascination. It's as if he were discovering a body for the first time; the body happens to be his own.

I don't know what drug Eric was on during his dance, but certainly some substance unleashed his performance. The sense of estranged time in Warhol's work takes root in the drugs his cohorts were taking, and the sensibility that the drugs fostered. In *POPism,* Warhol and Hackett analyze amphetamine consciousness: "intense concentration *but!* only on minutiae. That's what happens to you on speed—your teeth might be falling out of your head, the landlord might be evicting you, your brother might be dropping dead right next to you, *but!* you would have to, say, get your address book recopied and you couldn't let any of that other stuff 'distract' you."

We may no longer be able to remember or recreate the culture in which such surrender to drugs—and the belief in what kinds of consciousness and art they might promote—was a potent strain in the honorable fields of activism and aesthetics. More than any of the other Chelsea Girls, Eric seems quintessentially a creature of the 1960s, a product of that generation's rediscovery of anarchism and surrealism, the poetry of the surrender to chance and to accident. Warhol's 1964 silkscreens of car crashes show the fatal conclusion to many accidents. The sorts of accident that drugs and Warhol's open-ended approach to filmmaking gave his cast a license to explore, however, need not have been lethal, though Eric Emerson, for one, died young in the 1970s. "They found Eric Emerson," the voice of *POPism* remembers, "one early morning in the middle of Hudson Street. Officially, he was labeled a hit-and-run victim, but we heard rumors that he'd overdosed and just been dumped there—in any case, the bicycle he'd been riding was intact." While we

watch Eric dance in *Chelsea Girls,* his imminent death is not yet scripted; his monologue, heedless of mortality, preaches the value of listening. Warhol was always listening, and audition requires disembodiment. Warhol evacuated his self in order to take on the stories of others. Eric says, "Of course people only listen for so long. I'll listen for the rest of my life." Warhol would also listen for the rest of his life; the heroine (or Pope) of *Chelsea Girls* is finally Andy, who takes in this flock, to quote Ondine, of "homosexuals, perverts, thieves . . . the rejected of society," and nearly loses his body in the process. Our historical distance, now, from Eric's dance, should make us envy him, not condescend to him. It will be many moons before another actor has the audacity to appear on screen as himself, dancing a striptease, grooving on his own sweat, saying, "Sweat's exciting," saying, "I usually talk to myself, but I don't have anything to say, so I won't say anything, I'll just sit here and groove on myself." Warhol identified with Eric, but also envied him: Warhol might have liked to be the striptease artist, the body happy to groove on itself. His position behind the camera, administering the torture of screen tests to his willing cast, should not encourage the moralistic reading of his career that books like Jean Stein's and George Plimpton's *Edie* have disseminated—a picture of Warhol as a man who drove his entourage to drugs and self-destruction. Many sources confirm that it was not Warhol who led Edie to her drug addiction. That Warhol viewed human relationships as torture, and that he experienced his own embodiment as torture, do not mean that he consistently inflicted damage, as an aggressor, on others; rather, his films

articulate and analyze the bondage that is our daily bread—for any human attachment, Warhol's work darkly illustrates, is a prod, a poke, a whip, a pistol, a paroxysm, a collision, an explosion, an electrocution. Warhol was no saint. But he oddly maintained an even keel amid the havoc, not himself taking too much speed, but turning on the camera and the tape recorder while others did. When I spoke to Holly Solomon, whose portrait Warhol created during the fertile year of *Chelsea Girls,* she emphasized his ethical sense. As if rebutting his posthumous detractors, she said to me, "Andy was a moral man. He never did anything *not nice.*"

5. RUPTURE

THE PREVIOUS CHAPTER IGNORED ANDY'S BODY. His own films stinted it, though they expressed its mechanical desire. During the heyday of Factory torture, his body went underground; it continues to hide from the critic's scalpel. From the start of the 1960s, when Andy moved his atelier from apartment to studio, and cordoned off the superhero scene of artmaking from the milquetoast realm of breakfasts with Julia (orange juice always brought by Mom to Andy's bedside, as Madalen Warhola Hoover, his niece, told me), a rupture grew between home existence and his widely publicized Factory shenanigans; the split between public and private operated as surgically in Andy's case as in the career of a proper Victorian gentleman named Oscar Wilde, whose wife stayed at home while the aphorist invented decadence at dim hotels. Bedtime found Andy returned to Julia's, the townhouse on the Upper East Side, Mother devoting herself to churchgoing and also increasingly to hitting the bottle and presumably growing more histrionic

in her narrations, more random in her neighborhood wanderings. None of the Factory family penetrated the townhouse, and Andy rarely mentioned his mother to coworkers. On Sundays he went to church. Other days he hid behind the camera or behind Gerard silkscreening, and nights he dissolved into his klatch at Max's Kansas City near Union Square—Mickey Ruskin's louche *boîte,* which had, Taylor Mead told me, four great years, when it aroused Manhattan's demimonde, and became the temporary host site for the rogue cell of downtown existence. Max's opened in 1965; Andy's crowd reigned in the back room, other artists in the front. The entourage charged their meals to Andy's tab, as recompense for screen work. Randy Bourscheidt, who appeared opposite Nico in a Warhol film called *The Closet* (originally part of *Chelsea Girls*), described to me Andy's habit of treating: if not to Max's, he would take the group either to a "dreadful Italian restaurant" in the Village or to a Chinese restaurant "where Andy would preside, paterfamilias, and invariably pay for dinner—a sweet mockery of a royal court. I felt honored to be invited . . . He was so unemphatic and uncontrolling— it felt like the opposite of a big ego trip. His was the quietest voice at the table, the most unassertive."

Warhol's body was perpetually in hiding—most deeply sequestered when he sent an impersonator on a lecture tour in 1967. Andy called it an anti-star identity game; it was one of his most elegant and illegal conceptual performances. He reasoned: why should audiences suffer through my pasty, bald, halting, monosyllabic banality, when instead they could

see and hear a handsome articulate actor like Allen Midgette, star of Bertolucci's *After the Revolution,* in which he wears a wig—tresses like canary feathers—that prefigures mine? The Midgette/Warhol ruse was eventually discovered, and Andy returned to fulfill some of the faked engagements himself. When I spoke to Midgette, a statuesque man with the magnetic eyes of an alien abductee, he said that to impersonate Andy he hunched his shoulders, slowed down his movements and speech, and tamped his natural explosiveness; in retrospect he faults Andy for not understanding the difference between a real actor and a boy you paid to strip. Today we might think Warhol lazy or dishonest for inserting someone else's body in place of his own, and yet this self-erasure harmonizes with Andy's career-long conduct; forging a more attractive body was among his art's highest purposes. An author photo of Allen in Andy drag appears on the back cover of *Andy Warhol's Index (Book),* published in 1967. Warhol savored the sexual dimensions of substitutions: casting Allen Midgette's body in the Andy role, and watching the replacement occur, was, for Mr. Paperbag, an erotic act.

Andy Warhol's Index (Book) marks the beginning of his career as writer. The following year, 1968, he published a more ambitious and exhausting affair, *a: a novel,* composed with a tape recorder on four separate occasions in 1965, 1966, and 1967. (Warhol originally wanted to call it *Cock.*) Typists transcribed the tapes, and the results were published, typos included; Billy Name, who supervised the process, and ensured that the errors were left intact, composed subtitles for each page,

floating headlines that serve as placeholders, *aides-mémoires,* and puncture points, rupturing the egregiously verbose text: "my turds is a person"; "Prella, the shampoo woman" ("Prella" a play on "Drella," Warhol's nickname); "the tin foil tomb that Billy Name built"; "Maria Callas overwhelms any attempt at conversation"; "Ethel Roosevelt Hotel." (Although few consider Andy a word artist, his productions offer a grab bag of poetic treats.) The novel's subject is twenty-four hours in the life of Ondine, the most verbally pyrotechnic of the superstars. (They first met at an orgy, where Andy abstained from participation, and so Ondine demanded that the pale, peering man be ejected from the premises.) Just as Allen Midgette substituted for Andy on the lecture circuit, so Ondine subs for Andy on the page: he lends Andy a thrown, florid voice. It is often difficult to know who is talking, for the speakers are identified irregularly, and only by initials or pseudonyms; Ondine's commandeering rant easily bleeds into Andy's plaintive mumbling. Ondine, who declares, "People are not equipped for my filth," is Andy's logorrheic alter ego, and Andy's mission is to push his microphone further and further into Ondine's consciousness and body. This mike tyrannizes Ondine—following him even into the bathroom, though the besieged talker says he has no wish to "piss" on it. Warhol panics when his recording prosthesis momentarily vanishes: Ondine says, "Drella got the most worried look on his face as if the microphone would nevah come back." Taping Ondine is like making it with Ondine: Andy speaks of "finishing" a tape of Ondine as if he were bringing him to climax.

Recognizing that Ondine epitomized a generation of unrecognized queer narrative virtuosi, Warhol knew that without the vehicles that the Factory provided, Ondine would never find an appropriate forum. Like the art of many performers who worked with Andy, Ondine's—dispensing the papal bull—is ephemeral and haphazard; its nature is to scatter itself, far from the preserving receptacles of canvas, theater, or film. Andy's *a* is a time capsule of Ondine: an amber cage for the embellishing, self-destructing canary. And yet Ondine's cadenzas assemble not a portrait of himself, but an indirect portrait of Andy, for at the book's heart lie several conversations in which Drella reveals dreads and insecurities: he asks, "Oh when am I going to find someone who will like A.W." An actor named Joe Campbell, nicknamed the Sugar Plum Fairy, asks Andy pointed questions, and pushes him to admit, "Well I've been hurt so often so I don't even care any more," and, "Well I want to get to the point where somebody will tell me what to do." (Andy consistently expressed the desire for a master, a person to give him ideas; he would soon find such a boss.) Though often maddening to read, *a* is not a trivial artifact. Indeed, like Warhol's movies *Empire* and *Sleep,* it is an experiment in time. The novel took twenty-four hours to write or to tape. It took countless hours to transcribe. And though it may not take twenty-four hours to read (a careful student could stretch the experience out to that length) *a* suffocates the reader with time's slowness and turgidity; conversations that might in real life have passed quickly and communicated lightly their burdens, translate into resistant, illegible, and lethargic corpuscles on the page. Warhol's

game, throughout his career, was to transpose sensation from one medium to another—to turn a photograph into a painting by silkscreening it; to transform a movie into a sculpture by filming motionless objects and individuals; to transcribe tape-recorded speech into a novel. He prefers to tamper as little as possible with the experience, and thereby to highlight how the act of conversion, from one galaxy to another, disembodies and alienates the material—embalms it, expunging the soul. The personality that Andy reveals, in *a,* is his own: his credo is to suck spirit out of others by tape-recording them, as if the microphone were leeching animation from its victims and then preserving them. Ondine's idiom shines through the form-aldehyde: "How can you possibly speak in retrospect; I have never been there." And yet, although his words are redacted as exactly as the flummoxed typists could manage, the novel communicates the tragic gap—jet lag from which the passenger never recovers—between a living act and its transcription on the dead page.

Brigid Berlin (disguised as the "Duchess") has madcap moments in *a:* the microphone picks up a conversation from her hospital sickbed to the Factory pay phone—inebriate fioratura, reiterating her role as Mistress Poke: "My pokes in the fannies are beautiful," she says, and, "three things I dig; my vodka, my poke, and my pillys." In *a,* Andy uses the microphone as Brigid uses the hypodermic: to administer pokes. His mike flattered *a*'s participants, much as Brigid's pokes, injecting communion, exalted its victims. But the tape recorder takes more than it gives: Count Drella's microphone intravenously and

promiscuously needles the nervous systems of his entourage and feasts on their blood.

Was Drella giving or receiving pokes himself? He took his Obetrol orally. I'm not sure what kind of sex he was having in the sixties, and who knows whether it took the form of penile pokes, given or received, but certainly, for an asexual guy, he had plenty of boyfriends during this period, though virtually none have written memoirs or recounted details. (An exception is John Giorno, star of *Sleep*. He wrote about their affair: "Andy had a fragile and delicate approach to sex. I jerked off while Andy kissed my legs and sniffed my crotch. Then Andy licked the big gobs of white cum from my hand and stomach. Andy had a hard-on in his black jeans. I wanted to finish him off, but he said, 'I'll take care of it.'" Giorno describes Warhol as a voyeur: "He wanted to see it, he didn't want to touch it. He wanted to look. Occasionally, I let him suck my cock, out of compassion for his suffering." Catch the tone: Andy the poor ugly creep.) In the last two chapters I haven't mentioned boyfriends because Warhol's experiences with them are under-documented, and because the boyfriends seem only loosely integrated into Factory life. Randy Bourscheidt told me: "If the subject of Andy's sexuality—his sexual practice—was ever mentioned, it would be to repeat the common view that he had no boyfriend. That's what amphetamine does—you're only interested in scoring [drugs], not in sex." (Nonetheless, he remembers Andy's camera focusing on his crotch during the filming of *The Closet*.) Although sex may have been superficially absent from Andy's life at the Factory, five crushes stick

out from the pack: Philip Fagan, a punkish package captured in photobooth portraits and countless screen tests, who lived in Andy's townhouse in 1964 or 1965; Kip Stagg, a wild child seen wrestling with Andy (Kip on the bottom) in a photograph by Stephen Shore; Danny Williams, a bespectacled refinement who ran the strobe lights for Exploding Plastic Inevitable and Andy Warhol Uptight performances and who lived with the artist in 1965; the mysterious Richard Rheem, who appears in screen tests and in an unrestored film, known as *Mrs. Warhol*, playing Julia's husband or lover; and Rodney La Rod, whom Warhol describes in *POPism* as "a young kid," "over six feet tall," who "greased his hair and wore bell-bottoms that were too short." Ronnie Cutrone told me that Rod La Rod—a comically phallic name—often engaged Warhol in playful physical fights, wrestling and tussling in front of others at the Factory; Rod would sit on Andy's chest, and the two would trade comments like "Hee hee, I saw your pee pee." Cutrone called it "kid stuff." Warhol, in *POPism,* tries to neutralize the relationship's erotic content but fails: Rod would "stomp around the Factory, grab me, and rough me up—and it was so outrageous that I loved it, I thought it was really exciting to have him around, lots of action."

Horsing around with Rod La Rod may have looked like kid stuff, but the erotic work Andy was doing with his Polaroid camera in the 1960s was hardly juvenile, and *POPism* doesn't bother sanitizing it: "During this period I took thousands of Polaroids of genitals. Whenever somebody came up to the Factory, no matter how straight-looking he was, I'd ask him to

take his pants off so I could photograph his cock and balls. . . . Personally, I loved porno and I bought lots of it all the time—the really dirty, exciting stuff. All you had to do was figure out what turned you on, and then just buy the dirty magazines and movie prints that are right for you, the way you'd go for the right pills or the right cans of food." Warhol's vision of the porn cornucopia resembles his painted Campbell soup larder: find your flavor, among the thirty-two, and stick to it. American food manufacture affords a democracy of choice as bountiful as the populism of porn, its multiflavored openhandedness toward all comers.

Andy's erotic quest came to fruition in the films he made in the years 1967 and 1968—a series of "nudie" features, geared to the sexploitation market, which included a host of gay viewers who knew they could turn to Warhol films for up-front homoeroticism. He had an arrangement with the Hudson Theater, near Times Square: the Hudson guaranteed booking, and he tailored the films to this permissive locale, where his superstars would appear live at screenings to discuss such topics as "Pornography versus Reality." These films have not received sympathetic treatment, even by Warhol's staunchest fans. Stephen Koch, whose influential study of Warhol's cinema, *Stargazer* (1974), was the first to take Warhol's movies seriously and to do them the honor of eloquent analysis, condescends to these nudie films of 1967–68, and describes them as antithetical to the artistic films of 1963–66. Indeed, the nudies differ from the films that precede *Chelsea Girls;* they are not abstract studies of a single face or action (*Eat, Henry Geldzahler, Sleep,*

Blow Job), nor are they absurdist melodramas like Warhol's collaborations with Ronald Tavel (*More Milk Yvette, Hedy, Harlot, The Life of Juanita Castro*). Instead, they are comic, talky, down-to-earth; they are in color; the composition of their shots lacks the stylized care of the early films. The nudies depended on the collaborative assistance of an attractive, antic, fast-talking young filmmaker, Paul Morrissey, who began working for Warhol in the fall of 1965, became an indispensable part of his cinematic machine, and eventually took over all directorial duties. Morrissey himself claims a large role in the making of many of Warhol's films; he told me that he was Andy's manager from 1965 through 1973–74, and that the movies of this period were never *by* Andy, who was, Paul said, "not capable of giving the slightest direction." Other Warhol associates contest Morrissey's jaundiced verdict on the collaboration; undeniably, however, Morrissey's work on the films, beginning in 1965 with *My Hustler,* made them more accessible, pushing them toward satiric incident and away from abstraction.

As Andy brings himself indirectly forward by obsessively tracking Ondine in *a,* so do Andy's desires rise to the surface of these nudie films; paradoxically, by dispensing with authority and responsibility, and relying on collaborators, he expressed his own agenda more explicitly. The nudie films together create a portrait of Andy's dilemma (or, conversely, his opportunity): they dwell on the rupture between a beautiful boy and an unbeautiful observer, and they probe this rupture's effect on their experience of time passing, and on our experience of passing time as we watch them. The set-up resembles the situation

in Thomas Mann's *Death in Venice,* except, in Warhol's case, both of the parties are young men, a symmetry that makes the dynamic of longing more complex, less patly divisible between old and young. Time moves slowly and strangely when two men are side by side and one desires the other. The more difficult it is to push that desire toward conclusion, and the more the two men resemble each other, the more protracted and profound the sensation of time in their vicinity will be.

Of all the films, *My Hustler* lays out this scenario most nakedly. And it also points out how a woman's presence alters the erotic situation between two men. *My Hustler,* filmed on Fire Island over the Labor Day weekend in 1965, with the assistance of Chuck Wein and Morrissey, features a young blond stud named Paul America (in real life apparently one of Geldzahler's tricks), hired via Dial-a-Hustler by a portly balding john, played by Ed Hood. A sly, articulate woman, Genevieve Charbon, also has her eye on Mr. America; the john and the woman cat-fight over him. Ed calls her a fag hag, and says that fag hags are "meathooks and leeches." The first reel consists of them watching the stud sunbathe on the beach. The second reel takes place in the bathroom, where Paul and another hustler (Joe Campbell, the "Sugar Plum Fairy" of *a*) primp, shower, urinate. Their ablutions take forever—an eternity that the viewer, like Warhol, requires: no nude scene overstays its welcome. Joe tries to get Paul to admit that he's a hustler; Paul is cagy. Earlier I described this scene as a paradigm of Warhol's doubled images; indeed, here, in his neatest laboratory demonstration that eros abhors a vacuum, and that beauty is dialogic,

he shows that "beauty"—desirability—is never a solo; it takes two bodies, though it seems to quash one of them. The Sugar Plum Fairy may be attractive, but Paul America is young meat of the first order. The fairy wants America's body—touches it whenever possible—but dares not make his desire too explicit. Perhaps Andy, like Sugar Plum, lusts for eidolons as ideal as Mr. America, but I am convinced that Warhol's eye is ensnared not by the viewpoint of the man who fruitlessly pines for another but by their interdependence. Paul America's beauty discovers itself in the Sugar Plum Fairy's admiration; the fairy's fawning creates a pregnant imbalance between the two men, almost as strict and salvific a rupture as sexual difference. As Genevieve intercepted Ed Hood's pursuit of Paul America in the first reel, so Dorothy Dean, at the end of the second, interrupts the flirtatious pas de deux of the two hustlers. She appears outside the bathroom, puts on makeup while looking into a compact mirror (echoing the mirror Paul America gazed into while combing his hair), and makes him an alternate offer: "I'll get you educated. After all, why be carved up by these old faggots?"

The situation that structures the films of 1966 through 1968 resembles Shakespearian (or Greek) stichomythia, defined by the *OED* as "dialogue in alternate lines of verse, used in disputation in Greek drama, and characterized by antithesis and repetition." Warhol's films don't deploy verse. But the nudies consist of scene after scene of a couple in warring dialogue—argument leading nowhere, the quarreling parties snugly interlocking. *My Hustler* enjoys its rhythms of discord: the two hustlers trade beauty tips and quibble over prostitution's fine points, and the

fag hag and the john argue over Dial-a-Hustler's latest delivery. Irresolution—the parties never settle into accord—keeps the atmosphere tense. Like Martha and George in Edward Albee's *Who's Afraid of Virginia Woolf?* the horny couples in the Warhol (and Warhol/Morrissey) nudies never shut up, never stop fighting, and never have sex.

One of these films, *The Loves of Ondine,* shot in 1967, featured a scene-stealing performance by a new superstar, Susan Hoffman, known as Viva, a frizzy-haired, skinny, sharp-nosed, articulate, whine-voiced comedienne, her features spacious as a lost Praxiteles statue of Athena. Warhol once said, of Viva, that he never knew a voice could express so much tedium; like Brigid Berlin, she could sustain forever a monologue about her life's minutiae, and wasn't afraid to strip whenever necessary. Viva liked to talk about her Catholic girlhood, as did another superstar of the period, Ultra Violet, her real name Isabelle Collin Dufresne, a French aristocrat, schooled in a convent. Viva recounts her childhood's seamy side in her roman à clef, *Superstar,* revealing a prurient sensibility perfectly in sync with Andy's. In *The Loves of Ondine* she lies abed, topless, beside Ondine, her nipples covered by Band-Aids; she will only remove them if Ondine pays her. Viva, an off-kilter Pre-Raphaelite beauty, conveys serious levity: she delivers her improvised speeches in an affectless, cadenced monotone, as if she's intoning mass or reading a list of war dead, even if her narration is invariably bawdy. The disconnection of her bland voice from the rough nature of her revelations resembles Warhol's split between tone and content: lurid subject, cool presentation.

Another superstar debuted in *The Loves of Ondine:* Joe Dallesandro, émigré from Bob Mizer's AMG, beefcake capital of California. Everyone called him "Little Joe." Small-statured, he had a perfect body and a serene disposition, and no one could ever pin him down to anything: vacillation and spaced-out contemplativeness were Warholian virtues. Curiosity and desire never flicker across Little Joe's adolescent face; he makes heterosexuality and homosexuality seem irrelevant digressions, wastes of energy, compared with the pleasure of letting the chips fall as they may. His beauty, however, is an action, whether or not Joe ever seems to act. His good looks overpower the wisecracks of Ondine, whose manic stream of talk runs out when he shares the screen with lovely Little Joe. Word (Ondine) and image (Joe) do not gel; Mr. Paperbag knows—and is traumatized by—the gulf between. Here is the essential Warhol dilemma: speech can never catch up—no matter how much of it the tape recorder collects—to the assured and masculine stillness of visual presence. Stillness, for Warhol, was always virile, even if it took the form of a female face: stillness conjured the masculine imperturbability of the dead father.

The Loves of Ondine, as well as several other films from this period, had a dual existence as a separate feature and as a segment of an ambitious and nearly unrealizable project, known as *Four Stars,* or ****, or *Twenty-Four Hour Movie,* or *Twenty-Five Hour Movie.* It was only shown once, on December 15 and 16, 1967, at New York's New Cinema Playhouse. For *The Chelsea Girls,* Andy utilized the double projection format. He modified it, in *Four Stars,* by projecting the two reels not side by side, but

superimposed, one on top of the other. I cannot begin to imagine the blinding results: two meshed films for twenty-four or more hours seems a venture at the farthest edge of the possible. Callie Angell, adjunct curator of the Andy Warhol Film Project, is at work reassembling *Four Stars;* when completed, it promises to be Warhol's *Finnegans Wake* or *120 Days of Sodom*—hubristic compendium and enclosure, an encyclopedia of every transfiguration he ever dreamed, final as a mausoleum and fanatical as a menagerie. A number of the films included in *Four Stars* have never been seen since that original screening—including *Since,* about the Kennedy assassination, starring Mary Woronov as Jack, International Velvet as Jackie, Ingrid Superstar as Lady Bird, and Ondine as LBJ; and *Mrs. Warhol,* featuring Julia Warhola in the part of an aging peroxide-dyed actress with many husbands, each of whom she's killed. (According to Bockris, Andy said of the film, "I'm trying to bring back old people"— bring them back into fashion but also restore their youth.) One eight-hour chunk of *Four Stars* is *Imitation of Christ,* of which I have seen the 105-minute version: its subversions of Holy Family values include a sequence with Brigid Berlin and Ondine as the parents of a young stoned superstar named Patrick Tilden Close (who Taylor Mead told me could have been the James Dean of the underground). Brigid says, "What more of a family could there be but Ondine and me?" Their ménage rivals Bethlehem; Ondine shoots up in bed with Brigid—the couple's "morning poke." Their impersonation of parents is scary but also Utopian: we know it's a joke, but it also seems to be Warhol's seriously proffered alternative to the heterosexual nuclear family.

Another portion of *Four Stars* with an independent existence is the rarely seen *Tub Girls,* in which he presents a series of doubles in a tub, duos who parallel Paul America and the Sugar Plum Fairy flirting in the Fire Island bathroom—a diptych of unresolvable tensions, ambiguous as a metaphysical poem whose central conceit never comes clean. The tub, like a Campbell soup can condensing a meal within its silver cylinder, condenses the drama of a human dialogue, and, more effectively than theft or intercourse, seals the couple together. Not everyone in the tub is a girl: Viva bathes with a man, and, underwater, below the camera's horizon line, appears to have sex with him. The best scene pairs Viva in the tub with Abigail Rosen, a black woman— their blackness and whiteness reiterated by the Vermeer- like checkerboard linoleum floor on which the transparent tub rests. A bird in a cage chirps behind them. Viva accuses Abigail of having dirty feet, and the water grows dark from the grapes and watermelon the girls are eating—as if the tub were condensing racial difference, the water's transparency clouding into a complex, dark hybrid. Viva is always happy to couple on film, while Brigid remains aloof from touch, except from her own pokes. She drifts in and out of lesbianism as if in and out of coma: she refers to lesbian life as something she is profoundly *over.* Warhol films often conclude with a kalei- doscopically resonant image or phrase, as if the players, real- izing that the reel is running out, deliberately shift to loaded ground. *Tub Girls* ends with Brigid talking about healing baths at Lourdes, to remind us that the tub is, after all, a site of

baptism, and that the most fleshly and irreverent of Warhol's offhand conceptions hide spiritual ramifications.

In the nudies, words vie with images. These vociferous films, like the novel *a,* celebrate the loquacity of his entourage. In *The Nude Restaurant* (1967), Viva and Taylor Mead discuss the Vietnam War while they sit unclothed at the Mad Hatter, a restaurant distinguished by the nudity of staff and customers: this colloquy was enough, in Warhol's mind, to qualify the film as an antiwar picture. In *Bike Boy* (1967), Ingrid Superstar, in a kitchen, delivers a monologue about the different ways of cooking eggs. And *I, A Man* (1967) features the hyperverbal Valerie Solanas, author of the unproduced screenplay *Up Your Ass.* Her style of delivery is winningly flat and streetwise, and a viewer can't be blamed for thinking her a sweetheart when she says, "I'm a pushover for a squooshy ass" and "I want to go home, I want to beat my meat."

Two other films, *Lonesome Cowboys* and *San Diego Surf,* made during the era of the nudies, had more ambitious narrative dimensions, and were actually edited. (The earlier nudies were edited in camera through the use of a strobe cut, a device that Warhol first employed in *Bufferin,* a 1966 film of Gerard Malanga reciting his poetry. To insert a strobe cut, the camera and sound recorder stop and then start again, creating a gap in continuity, a rupture marked by a beeping noise.) *Lonesome Cowboys* was filmed on location in Arizona in January 1968; it had a wide release in 1969, and may be his best-known film from this period. In an interview, he referred to it as his "first completely outdoor movie," and added: "It's based on Romeo and

Juliet. If they won't let us call it 'The Glory of the Fuck' I think we'll call it 'Cowboy Movie.'" So scandalized were members of the local community by the excesses of Warhol's cast and crew that the FBI, duly notified, began surveillance of his activities and compiled a file on him, which includes this naively muck-raking account of *Lonesome Cowboys:*

> The sheriff in one scene was shown dressing in woman's clothing and later being held on the lap of another cowboy. Also, the male nurse was pictured in the arms of the sheriff. In one scene where VIVA was attempting to persuade one of the cowboys to take off his clothes and join her in her nudity, the discussion was centered around the Catholic Church's liturgical songs. She finally persuaded him to remove all of his clothes and he then fondled her breasts and rolled on top of her naked body. . . . Another scene depicted a cowboy fondling the nipples of another cowboy.

The film was confiscated in an Atlanta showing in 1969 because, according to the criminal court solicitor, of its "absolute filth"— "just the type of thing that, in my opinion, would make the ordinary person sick."

The second movie that Warhol filmed on location was *San Diego Surf*—shot in revolutionary May 1968 in California, that golden state where, four years before, he'd met Duchamp and Troy Donahue, and exhibited Elvises. *San Diego Surf* features the square-jawed, meditative, limestone Tom Hompertz, who'd

debuted in *Lonesome Cowboys;* here he is a surfer, opposite Taylor Mead, who plays Viva's husband. She opens with a diatribe exposing the connection between homosexuality and surfing, and notes that she can't tell the difference between unfilmed reality and those unreal moments when Warhol's camera is observing her. Long shots of the Pacific Ocean remind the viewer how distant from the natural world the Warhol films have been. In the scene that most closely conforms to Warhol's desire, Mead lies facedown on a surfboard and begs Hompertz to piss on him: "Tom, will you piss on me? I want to be initiated. I want to be a real surfer. Don't you want to piss on a respectable middle-class husband?" Not that Warhol liked boys to piss on him: I doubt he did. And yet the split between Tom (surfer stud) and Taylor (faggy clown), who may, through abject baptism, transubstantiate into surferhood, cuts to the quick of Warhol's method and substance.

Warhol, believe it or not, was on the verge of becoming respectable; Factory fever showed signs of abating. Morrissey, as manager, was organizing the fertile chaos, professionalizing the operation; not only did he introduce more substantial narrative and humor into the films, he added cubicles in the loft, according to Bockris. The location itself changed, signaling a permanent shift in tone: in early 1968, Warhol moved the studio (once called the Factory, it would eventually be called the office) to the sixth floor of 33 Union Square West, two floors below the headquarters of the American Communist Party. Later that year, Billy Name moved into the darkroom of the new digs and rarely emerged; the only people admitted into

his lair were Lou Reed, Ondine, and others who shared his occult proclivities. Gerard Malanga had gone to Italy to make films and to pursue fashion model Benedetta Barzini, his muse. (While in Italy, he sealed his defection by silkscreening images of Che Guevera and trying to pass them off as Warhols, perhaps with the master's prior approval. He would be forgiven by Warhol, who was fond of saying that Brigid did all his paintings; Gerard eventually returned for a brief time to the fold.) Another change in personnel proved decisive: Fred Hughes, a dandy from Texas, protégé of the wealthy de Menil family, entered the Factory in 1967, and thenceforth dominated Warhol's aesthetic and business decisions, which would grow interchangeable.

And then, out of the blue, the rupture: on June 3, 1968, Valerie Solanas took the elevator up to the 33 Union Square West office and shot Warhol. "No! No, Valerie! Don't do it!" he shouted. He remembered: "As I lay there, I watched the blood come through my shirt and I heard more shooting and yelling. (Later—a long time later—they told me that two bullets from a .32-caliber gun had gone through my stomach, liver, spleen, esophagus, left lung, and right lung.)" His friend Mario Amaya had also been hit, though not severely; she almost shot Fred Hughes, too, but he stopped her by saying, "*Please!* Don't shoot me! Just *leave!*" Warhol remembered: "Right when it looked like she was about to pull the trigger, the elevator doors opened suddenly and Fred said, 'There's the elevator! Just take it!'"

Warhol was declared dead. But then he was brought back to life by the doctors, who made a renewed effort at

resuscitation when Mario Amaya told them who the dead man was.

Valerie Solanas gets a lot of attention from Warhol buffs, who try to figure out her motives. She was the leader and sole member of the Society for the Cutting Up of Men: SCUM. She felt Warhol had too much control over her life. She'd given him her manuscript, *Up Your Ass,* and he hadn't bid on it or gotten back to her about its merits. Some revisionists go so far as to see Valerie as she portrayed herself—a feminist heroine; the 1996 film *I Shot Andy Warhol* takes this wish to an extreme. One common critical tendency is to treat the shooting as an unfortunate yet sensational accident, a colorful disaster, an inevitable consequence of Andy's own desire to surround himself with crazies. Valerie's crime passes judgment on Andy's prior conduct: in this view, he is culpable for his own execution because he failed to protect himself, led too many people on, and enraged his actors by not paying them or bringing them fame. (Taylor Mead has ironically said that he would have shot Andy if Valerie hadn't done it first.) Andy, too, interpreted the shooting as retribution for his omissions, and as termination of his creativity; in later years he imagined, having ceased to rely on the errant and the mad for inspiration, that he had lost touch with his art's source. Those who see a feminist, oedipal, or revolutionary meaning in Valerie's homicidal act—the rejected protégée, returned to revenge herself on the indifferent paternal master—forget the reality of his wounds, the worth of his body, and the final damage done to it. Warhol himself ignored his body; perhaps his critics and coworkers should be forgiven

for cooperating in its liquidation. As for Valerie, she received a three-year sentence. After her release, she telephoned Andy at the Factory and continued to threaten him.

The shooting of Andy Warhol took place one day before the killing of Robert Kennedy. Andy remembered waking up in the hospital and seeing coverage of a Kennedy slaying and thinking that he was dead in heaven watching reruns of JFK's murder in Dallas. The temporal coincidence of the two attacks cemented Warhol's position as a representative 1960s figure and gave new power to his earlier images of car crashes, disasters, suicides, electric chairs, and death-circumscribed figures like Marilyn, Jackie, and Liz. It became possible, now, to see Warhol himself as one of the martyrs his art was devoted to apotheosizing; his miraculous resurrection from the dead, on June 3, 1968, ratified his sainthood, his status as an exception to mortality's rule. And yet he continued to believe, after the shooting, that he'd already died, and that the rest of his life was an afterthought. Profoundly disembodied already, he became, after the assassination attempt, more radically severed from his body, now a canvas of wounds and scars—the apparatus of his torn and flayed flesh held in place, for the rest of his life, by tightly bound abdominal belts, corsets that Brigid Berlin dyed for him in optimistic pastels, like the colors of his silkscreens. After the shooting, he posed topless for Brigid's camera, as well as for Richard Avedon and Alice Neel; Neel's painting, Avedon's photograph, and Berlin's Polaroids show the extent of the damage, and the bizarrely artistic signature that the scars inscribed on his flesh. Warhol himself described the scars as

beautiful, like haute couture gowns; the artist who had made a practice of removing all traces of his deft line from his artwork, since 1960 or so, wore for the rest of his life a fabulous set of line drawings on his chest. I've held Andy's abdominal belts in my hands, in the back stacks of the Warhol Museum Archives, and I can report that they are frighteningly tiny, like blouses worn by a four-year-old Shirley Temple, and as fancifully colored as any Walt Disney concoction. These corsets feminized him; they gave external, sartorial, vaguely shameful form to his inner distress, much as his mother's long-standing colostomy bag had brought out her interior. Like Julia, Andy now wore his inside on the outside; like Julia, Andy now had a verifiably traumatized body, tampered with and refitted by surgery. The corset added another step to the task of dressing up as Andy. Before, his wig had served to hide baldness and to advertise a dandyish artificiality. Now, the wig and the corset, combined, became more radically prosthetic; dressing up as Andy was no longer a camp or a lark, but a physiological necessity, for without the corset his body would not hold together, just as, without the wig, his identity could not be recognizably sustained.

It is a cliché to say that part of Andy died on June 3, 1968; but it is also literally the truth. Had Andy completed his dying then, he knew, he would have become an even bigger cult figure than he is today. No one would need to consider his ambiguous work of the 1970s and 1980s; he would have remained forever the Pop martyr, who died to free our bodies and sensibilities. Warhol would have been a civil-libertarian Christ, and doubtless his work would be more reverently treated now. But he

lived on, and, in the eyes of many, he soiled his artistic reputation. That is not my view. His work in the last two decades of his life is often as remarkable as the work from the two decades before; indeed, the shooting only intensified his conviction that art must be a sequence of prostheses, of collectible receptacles to embalm experience. But the later art takes place *after* the rupture, after the body in which Andy never felt at home was nearly taken away from him, and thus the works from the 1970s and 1980s bear the shadow aura of bulletins from the afterlife.

After the shooting, Andy spent nearly two months in the hospital. When he returned to the Factory in the fall, he had one unfinished piece of business—one last task, from the project that had dominated his life from the early 1950s until 1968, to complete. His search to see the secret of sex—a miracle that he'd seen time and again, but that remained elusive and magnetic—reached a pinnacle, and a termination, in the film *Blue Movie* (its working title was *Fuck*), which he shot in 1968. It is essentially his last film; it brings to a peak, and puts the tombstone on, his monumental project of filming, in the 1960s, virtually everything. After *Blue Movie*, his memorializing energies would leave cinema and go toward silkscreen-portraiture, photography, collecting, publications, tape-recording, video, and the assemblage of ephemeral social atmospheres.

Blue Movie is a simple film. The most intimate of Warhol's films, it is the one from which his presence is most rigorously and painfully excluded, although he was as present for its making as he'd ever been. Paul Morrissey didn't approve of the

project, he told me. The film consists of Viva and Louis Waldon (who'd appeared in *Lonesome Cowboys*) performing approximately two hours of intimacy, including oral sex, vaginal intercourse, and conversation. Sex actually takes place; and though this is not the first Warhol film to include "live" sex, his camera's attitude has shifted, away from the impassively fixed distance of *Couch,* and toward a greater emotional investment in the couple's intimacy. Sex took place, too, in *Tub Girls,* in *Blow Job* and its sound remake, *Eating Too Fast* (1966), starring the art critic Gregory Battcock, but in *Blow Job* the fellatio itself remains offscreen, and in *Eating Too Fast,* although the camera pans down to the crotch, the most surprising conversation is not between the two men having sex, but between Battcock and an unseen friend, who telephones to inform him of a death. "Bob's grandmother died," Battcock reports to the fellator, who interrupts his sucking to respond, "Too bad," and the film ends: this abrupt finale, juxtaposing funerals and fellatio, suggests that, in the Warholian economy of arousal and retaliation, for every homosexual blow job the gods exact a maternal death, as if sodomy were a particular affront to uterine proprieties.

In *Blue Movie,* which ends not with death but with Viva rushing to the camera saying she's going to "vomit," the players are well aware of the camera's presence. Viva often shields their genitals from the viewer's sight; she refers, with incongruous shyness, to the fact that "everybody" will see the various acts; she winks at the lens, and she says, "Maybe we should give a profile view." Viva lets pride, doubt, shame, joy, sloth, and other moods play across her face, so that *Blue Movie* pays

stricter heed to visages than to genitals, and reveals psychology more than did *Blow Job,* in which the high-contrast lighting often lent the silent, nameless fellatee's features the morbid abstraction of a German lithograph, a Parisian mime, a Biograph close-up. In *Blue Movie,* Viva and Louis, not archetypes, reveal quixotic, unbuttoned personalities. We, eavesdroppers, spies, glean a more than sexual vision of them: Viva and Louis cook together in the kitchen, discuss Vietnam, watch a sunset. Warhol's camera, like the all-knowing Kremlin in the Cold War American imagination, sees not merely the secret of sexuality but the secret of intimacy, the crucible of mutual comfort and amusement. And I suspect that Andy might have envied their rapport. At last, two people in a Warhol film are not sparring— two people are actually getting along! Though it would be a mistake to see Louis and Viva's performance as unmediated reality, when the couple lyrically discover each other, they seem to zap Andy—and artifice—out of the picture. In virtually every previous Warhol movie, the leitmotiv of torture invoked the maker's presence; the absence of torture, in *Blue Movie,* removes him. And the film redeems heterosexuality, which had never been top on his list of cinematic treats. In *Blue Movie,* a man and woman are horsing around without heavy-breathing porn overlay. Here, for the first time in Warhol's work, heterosexuality is not a joke.

The film is literally blue—blue because pornographic, but also because the screen seems doused in blue, as if everything were glimpsed through blue glass. Andy's relation to the color blue began with the book he made in 1954, *25 Cats Name Sam*

and One Blue Pussy. In the face of feline reproduction and rep-
etition—twenty-five Sams—one blue pussy stood alone, unre-
peated. In *Blue Movie,* Andy is the one blue pussy, facing the
replete spectacle of Viva and Louis. He is blue because bullet-
wounded: his skin is literally black and blue (and probably
purple, red, and yellow). Blood is blue: Viva says, "Blood is
really blue before it hits the air." And the film's blue is depres-
sion—Andy's. He is blue because Viva and Louis's lovemaking
omits him. One must remember that Andy's sexual radical-
ism clashed with his strangely conservative vision of male
and female identity: he could be anarchically free with canons
of gender behavior because he felt so unmasculine that he
needn't bother qualifying for the part. (Money, however, often
made him a man: he played the pop who brought home the
bacon to the kids at the Factory.) He may have refused con-
ventional sexual and social arrangements, but he also believed
that homosexuality was a "problem" and that straight men
were real men. Of course he knew and acted otherwise; prob-
lems fascinated him (they made good tapes), and it charmed
him that "normal" men had "problems," too. Nonetheless, I
believe that *Blue Movie*—his summa, his key to all mytholo-
gies—may have proved decisively to him that he was not a
real man; peering more closely at the secrets of other people's
bodies than ever before, he removed himself from his own
irreversibly ruptured body. *Blue Movie,* which records two
bodies intertwining, seals Andy's rupture from his body—his
premature exile from organs, those irrelevant irritants. I am
using the word *rupture* in two senses—a metaphorical schism

and an actual wound. Long before Valerie's bullets literally ruptured him, he had consistently portrayed reality as ruptured between two screens, two twinned images, and had repeatedly experienced bodies as traumatically divided and imploded. Now, in *Blue Movie,* Viva and Louis are not ruptured from each other, but they dwell in a blue light that brings Andy's absence forward: his body returns in the blue that tinges the screen with an atmosphere of aftermath.

In August 1969, *Blue Movie* was seized by the police after it had shown at the Garrick Theater in New York (renamed the Andy Warhol Theater), and the next month the film was ruled obscene. Warhol had hit his limit.

AFTER

6. SHADOWS

WARHOL SURVIVED THE 1960S, though he lived—and post-humously thrives—in the shadow of what he accomplished. The endless art he made after Valerie Solanas shot him could not assuage his morbid fear that he had run out of ideas. He told his diary in November 1978, "I said that I wasn't creative since I was shot, because after that I stopped seeing creepy people." Banishing borderlines from the Factory, he exiled mad talk, soul impingement, flayed nerves. He was tormented by the idea of growing old (he turned a mere forty-two in 1970), and though he reserved his strangest energies in the 1970s for stockpiling and hoarding, he wanted to seal off the past and not revisit it. "I can't face my old work," he told his diary in 1978; "It was old." By wearing a silver wig as a young man, he'd hoped to outfox old age, but, as the years passed, and as he continued to depend on prostheses (corsets, glasses, face creams) and to trust in screens (not only silkscreens, but the social buffers of camera, tape recorder, assistants), these accessories gave him

an alien aura, as if his vital fluids and gases had been evacuated. Describing Truman Capote, he indirectly sketches himself: "It's strange, he's like one of those people from outer space—the body snatchers—because it's the same person, but it's not the same person." Art historian Robert Rosenblum, the most engaged and sympathetic critic of Warhol's later work, told me that Andy seemed to have "no human affect": "His tempo was different—slow, deliberate, totally disconnected from anyone else's tempo. Like James Bond, or Dr. Evil." Time artist, Andy had tampered with his own animation, hoping to stretch it to a *largo* that God wouldn't have the temerity to interrupt.

Shopping became Andy's fine art. He'd always been a conceptual artist, preferring the idea to its laborious execution: his 1970s assistant Ronnie Cutrone told me that "painting was slow, for a mind that fast." Shopping, however, now that Andy had cash, was quick; and shopping, like philosophy, involved categories. Cruising stores, flea markets, auctions, he pursued Platonic forms by seeking new types and then amassing their instances. As the infamous disco Studio 54, which opened in 1977, was his favored laboratory for social admixture, so antique and jewelry stores and flea markets were his labs for commodity admixture. Andy had always been a collector, but in the 1970s his collecting overcame prudences that usually kept it in check, and he was free to collect everything: mercury glass vases, space toys, costume jewelry, cigarette cases, masks, perfume bottles, Mayan vessels, Russel Wright pottery dinnerware, Navajo blankets, silver bracelets, art deco Cartier watches, Jean E. Puiforcat French silver flatware, and a

thousand other impracticalities. He accumulated stuff in such variety, it would take hundreds of pages to list the genuses. One early form that this fever assumed was an exhibit he curated at the Rhode Island School of Design's Museum of Art, in 1970, called *Raid the Icebox*. The show consisted solely of items he chose from the museum's storage vaults, and his selections were perverse: the entire shoe collection, including duplications, still housed in cabinets; dozens of parasols and umbrellas, stashed in an opened, freestanding closet, like a peep show; bandboxes and hatboxes; paintings, not hung but left stacked on the floor. "He couldn't stand 'old art,'" David Bourdon wrote. Indeed, Warhol couldn't stand old *anything*—a paradox for a collector, who usually thrives on the departed. His collecting urge was actually a renovation or rejuvenation project in disguise, for he sought *new* categories, but of old stuff. Kidnapped by sameness, Andy chased difference wherever he could find it—usually in the embrace of a fresh category, yesterday's stale modalities kicked aside. He wrote in *The Philosophy of Andy Warhol*: "you're always repeating your same things all the time anyway, whether or not somebody asks you or it's your job. You're usually making the same mistakes. You apply your usual mistakes to every new category or field you go into."

In the 1970s his new category—some would say his new mistake—was business. He became a corporation, with art department, film studio, development office, and magazine. Andy, the captain, wanted someone to boss him, and he chose Fred Hughes, the Texan dandy adored by style-sibyl Diana

Vreeland, who, like her swain, seemed to have absorbed hair lacquer through her scalp into her soul. Fred superintended and organized Andy's career but also terrified him: judgmental of Warhol's aesthetic choices and the lacunae in his formal education, Fred sometimes humiliated him in front of Factory visitors by pointing out his gaffes and malapropisms. More sympathetic was the young Vincent Fremont, who entered the Factory in 1969, two months shy of his nineteenth birthday, and served his apprenticeship by cleaning shop and sweeping floors. He began to write checks for the firm in 1973, and became studio manager and vice president of Andy Warhol Enterprises in 1974. Vincent, a guy Andy might have approvingly called "normal," was level-headed yet ironic, like a Sartrean surfer; he stabilized Warhol, for Vincent, though one of the "kids," could play the role of laid-back father to the spindly, white-haired son.

The film department was run by Paul Morrissey, who, under Andy's imprimatur, made several commercially successful movies, vaguely in the Warhol style, beginning with 1968's *Flesh,* starring Joe Dallesandro—filmed while Andy was in the hospital, recovering from Valerie's assault. Morrissey then made *Trash* (1969), *Heat* (1972), and *Women in Revolt* (1972), as well as the more tangentially Warholian *Andy Warhol's Dracula* and *Andy Warhol's Frankenstein,* both in 1974, after which Morrissey left the poisoned nest. The most blissful aspect of these films may be the performances that he elicited from actresses: Sylvia Miles, who, playing a has-been in *Heat,* invents an unrivaled amalgam of blowsiness and voluptuousness; and that tart trio

of drag queens, Candy Darling, Jackie Curtis, and Holly Wood-lawn. Jackie and Holly epitomized deliberately failed drag: maleness, alarming as a pimple, pops through their feminine screens. Candy was more demure. Originally Jimmy Slattery of Long Island, she died young, in 1974, and her appearances in *Flesh* and *Women in Revolt* could melt a Popsicle: beautiful as her affect-free idols Lana Turner and Kim Novak, restrained in delivery, abstracted by ruminations on her own minor lus-ter, Candy is the briefly flaming Edie of Warhol's 1970s period, giving his daydreams a wardrobe and a locomotion. Candy's biggest disappointment came when Twentieth Century–Fox, despite her unsolicited letter-writing campaign, refused to cast her as Myra Breckinridge, and chose Raquel Welch instead. Candy never recovered from the blow.

Andy had replaced the movie camera with his new "wife," the tape recorder, and with the aid of tape, he launched a mag-azine, first known as *inter/VIEW*, later as *Andy Warhol's Inter-view*. It started as a project to keep Gerard Malanga busy, but internecine wranglings left it the property of Bob Colacello, who became executive editor in 1970. Bob was a gregarious, articulate Italian American with conservative political ten-dencies and a taste for high society; Ondine, like the rest of the 1960s superstars, had left the Factory (the new adminis-tration had no use for them), and so Bob Colacello, like Bob Olivo (Ondine's real name), had the job of feeding stories and gossip to Andy, who needed perpetual stimulation. Pat Hearn, an art dealer whose portrait Andy later painted, told me that a conversation, for Andy, was not about "getting somewhere

together," but about "information." Andy liked information. On a tape he made of a conversation with Bob, Andy's needling, invasive hunt for facts is clear, as he tries to convince the reluctant Bob to describe a sexual experience. Here is Andy's part of the dialogue: "Who was it, Bob? Oh, come on, Bob. Who was it, Bob? Who was it, Bob? Oh, come on, Bob, who was it? Might as well spill the beans. What? What? Oh, come on, Bob. Who was it, Bob? Please? Oh, come on, Bob, who was it? Please tell me." This is the nosy Andy who followed Ondine into the bathroom with the microphone.

Interview magazine was Andy's most sustained attempt, after *a*, to cross the border between tape-recorded speech and the written word: his experiments in bridging this divide involve a serious philosophical quest to figure out where and how verbal meaning breaks down, and to track the imprecise, shiftless way that words occupy the time it takes to utter and understand them. Andy's intensest experiences were visual, not verbal, yet he remained fascinated by his own difficult, hampered process of verbalization. *Interview,* an ideal vehicle, allowed him to indulge his interest in dialogue, as well as his desire to bodysnatch reality and to seal it in falsely labeled canisters. Via the technological mediation of tape recorder, Andy hoodwinked time and talk, and canned it as a product bearing his own name. *Interview* innovated the practices of running features on the not-yet-stellar or never-to-be-stellar, of having stars interview other stars (Lee Radziwill queries Mick Jagger, for example), and of publishing the apparently raw transcript of the encounter, without editing or doctoring. Stars grilling

stars permitted Andy a new form of vicarious twinship: here was dialogue from an A to another A, two eminences, a doubled glow, each downgrading the other by proving the other not unique. (He aimed not only to create new stars but to dim the existing ones.) *Interview* became Andy's house organ; in the 1960s he brought people under his influence by offering them movie stardom, and now he lured them with an appearance in the magazine. He was notorious for promising several people each month the same coveted position on the cover.

Although he had abandoned ambitious filmmaking, Andy had begun to explore the cognate technologies of TV and video. With Vincent Fremont, he produced several ventures in the 1970s: two tests for possible TV series in 1973, one a soap opera involving a hotel (a take-off of *Chelsea Girls*) known as *Vivian's Girls,* the other called *Phoney,* involving phone conversations—a project that tapped Warhol's own obsessive telephonic practice. He also experimented with a project (later known as *Factory Diaries*), which was simply ongoing video documentation of studio doings. As Vincent Fremont told me: "Andy would have liked to have the camera and tape recorder running twenty-four hours a day." (He would have been pleased by today's videocam computer technology, whereby ordinary people can star in their own live-transmission twenty-four-hour pornographic serials.) Andy wanted imperially to occupy time and space, fill them to capacity, as if with heavy stones. Perpetual filming was a technique for wasting space, laying waste to it, junking it, and clutching it. And yet he also liked empty space. He said in *The Philosophy*: "When I look at things,

I always see the space they occupy. I always want the space to reappear, to make a comeback, because it's lost space when there's something in it." His collections refused space its comeback, for they eventually took over his townhouse, the rooms rendered useless, blocked by unopened bags and boxes, plunder from shopping junkets.

Did he want to empty space, or fill it? With a time capsule—a cardboard box stuffed with ephemera—he could accomplish both tasks. The time capsule flirted with nothingness because its outside was silent and unidentified as a Brillo box *sans* lettering or logo; the time capsule, a generic, non-brand-name solution to his time/space conundrum, was also a pill (like a time-release Tylenol *capsule*) that he could swallow to avoid the past, sealing it off from sight. The project may have originated when Andy moved his studio in 1974 from 33 Union Square West to 860 Broadway (a few blocks north); the cardboard cartons, in which stuff was stashed for transporting to the new premises, were rechristened "time capsulses," and left unopened—abstract sculptures awaiting posthumous *réclame*. Eventually he amassed more than six hundred, which he hoped to sell. He found it painful to open them: in one, he found his bloodstained clothes from the June 1968 shooting. Now, after his death, many have been opened, their contents cataloged. The time capsule known as #47, for example, contains porn, fashion magazines, Natalie Wood publicity photos, a newspaper with a picture of John F. Kennedy Jr., a copy of Kenneth Anger's *Hollywood Babylon,* invitations from Warhol's 1957 *Golden Pictures* show at the Bodley Gallery, bills, issues of *Life* and *The New Yorker,* a piece

of blank canvas, a letter from Gerard Malanga, a mimeographed book of poems by Joseph Ceravolo, a handwritten cinematic treatment of a project known as "Vibrations," and more and more. The contents of the time capsules range from junk mail to Warhol drawings to other people's artwork to airline in-flight menus and filched flatware. As conceptual pieces, the time capsules fall somewhere between Marcel Duchamp's *Box in a Valise* (containing miniature replicas of his artworks), which Warhol bought in 1962, and his oft-proposed idea for a TV show he cleverly wanted to call *Nothing Special,* a televisual box for whatever happens to occur. The unopened time capsule—its stories inaccessible until the seal is violated—offered him a perfect compromise between tomb and body; he could occupy space but also empty it, and he could be a body but also vanish. It's difficult to understand how Andy could have amassed six hundred time capsules but also have wanted to disappear. As he said in *The Philosophy*: "At the end of my time, when I die, I don't want to leave any leftovers. And I don't want to be a leftover. I was watching TV this week and I saw a lady go into a ray machine and disappear. That was wonderful, because matter is energy and she just disappeared. That could be a really American invention, the best American invention—to be able to disappear."

The painterly equivalent of this disappearance trick that the time capsules finessed—emptying space while filling it— was his monumental series of commissioned portraits, begun in 1970, a project that occupied him for the rest of his life. Their greatness has yet to be recognized: when the portraits were

exhibited at the end of the 1970s at the Whitney Museum of American Art, critics lambasted him for having sold out. Not only did Warhol receive pots of money for doing them, he committed the political sin of portraying figures like the sister of the shah of Iran. The screen purpose of these portraits, in the Freudian sense of a "screen memory," was to make money; Andy charged perhaps fifty thousand dollars for each. But, on an ulterior level, the portraits, like Andy's other ceaseless projects, attempted to capture everything in the world, to stylize the act of capture, and to make his rapacity seem acceptable and legal because it led to decorative, pretty surfaces. Warhol did fifty to one hundred of the commissioned portraits a year; many are privately owned, and unfortunately they may never be exhibited as a series. Imagined in their totality, however, they eviscerate the identity of each sitter, even as they pretend to perpetuate it. The lure of the portraits—what the artist presented as bait to the client—was the chance to appear Warholian: to be rendered in a garishly colored silkscreen, in the manner of his trademark images of Liz, Marilyn, or Jackie. But the joke was on the client: by being portrayed *as if* a Liz, the subject admitted an identity as stand-in, nonstar, aura seeker, just another flavor of person, without a monopoly on presence. Although many of the 1970s and 1980s portraits are of famous individuals, many more depict *not* famous people (a rich nobody, or a nobody's daughter, son, wife, husband). Each sitter for Warhol, whether famous or not, longs for a stardom beyond attainment; the portrait mocks—and fulfills—that desire. The sitters are stars and nonstars at the same

moment—as boxes, bodies, and rooms were, in Andy's eyes, both empty and filled.

The method Warhol used for making the portraits was labor-intensive, and hardly instant. He took fifty or so Polaroids of the subject, chose an ideal image, silkscreened it (sometimes onto a prepainted background), and, on occasion, added flourishes of hand-painting as parodic homage to the expressionistic artiness he'd long ago renounced. The Polaroid camera he favored was called a Big Shot: for proper focus, it required a three-foot distance from his subjects. This cordon sanitaire, rarely violated, separated him from his prey—and protected him from the subject's usurping touch. The portraits celebrate Warhol's happy marriage of photography and painting, the two media he could never choose between. As the 1960s screen tests maneuvered a place between still photography and moving picture, the commissioned portraits clearly originated as Polaroids, but the inapposite, clashing, eye-assaulting colors reinforce the canvas's identity as a painting. Color is the gloss—makeup, camouflage—that Andy places protectively or abusively over the vulnerable photographed face. He fulfills the pathetic sitter's desire to be rendered immortal, attractive, Warholian, but also lays waste to it by overpainting, by adding wrong color. The fame account of the sitter sinks; Andy gloats. The face vibrates, like a disco Rothko, between assertiveness and disappearance.

The most celebrated of his portraits, profoundly uncommissioned, were images of Mao, begun in 1972. In this series, he turned the revered Chairman into a fleshy, maternal Monroe,

the face an epitome of sated appetite, plump and colorful as a carnival balloon. He hung the Maos, in 1974, on Mao wallpaper. The choice of Mao as a subject resumed Andy's early allegiance to "Commonism"; he liked powerful star-presences that erased everybody's personality, but he also liked to level fame's distinctions, giving each citizen a morsel of renown. Mao's face was a flash card of the world's greatest star, but his cult signaled individualism's collapse; like the "Female Movie Star Composite" collage that Andy made in 1962—four ink-drawn slivers of the faces of Joan Crawford, Greta Garbo, Sophia Loren, and Marlene Dietrich, taped together, as if by Dr. Moreau, into one unrecognizable cyborg—Andy's Mao was a contemporary Jesus whose face, if you worshiped it, forgave (and decimated) individual idiosyncrasy.

Following the trail of the Maos, in 1976 Andy did silkscreens of hammers and sickles. His fondness for communist iconography may have been partly motivated by a desire to please European collectors and critics, who tended to read Marxist meanings into his work, but he had always favored images of private identity resisting (and succumbing to) mass culture's manic replications, and he had always sought the literal's face overruling the figurative. The hammers and sickles may be symbols, but Warhol made the images from photographs of real hammers and sickles that Ronnie Cutrone had bought at a hardware store.

In this period, Warhol's extraordinary range of subjects *is* his point: a performance of plurality, catholicity, sweep. In the 1970s, he did screenprints of Mao, but also of Jimmy Carter

and Mick Jagger, and black and Latino drag queens from the bars and piers of New York City ("Ladies and Gentlemen"); he did screenprints of hammers and sickles, but also of gems and grapes. He screened skulls; he screened self-portraits. Such promiscuity—such appetite for every category—should not prevent us from reading significance into his subjects: indeed, it matters that he chose Mao, and that he chose gems. But his larger interest was not in the meanings of a single object, but in the *proliferation* of different species, and each form's vulnerability to the blitzkrieg encroachments of neighboring appetites. Gems can't remain gems forever, if grapes are nearby; grapes grow gem-like, gems grow grape-like. Mao ceases to be wholly Mao after Andy renders him. For many viewers, Warhol's screen subsumes the real Chairman.

Andy had a fantasy: death didn't exist, and people at the ends of their lives simply vanished or floated away. This fairy-tale hypothesis came in handy when he needed to confront the deaths of family and friends. Edie Sedgwick died of a drug overdose in 1971. He didn't articulate the death's impact on him; leaving wounds unspoken was his custom. When his mother's health declined—drink and senility overtook her—and Andy found himself unable to care for her, he sent her back to Pittsburgh; she died the next year, 1972, at eighty. (That same year, he withdrew his 1960s films from circulation.) He didn't attend the funeral; he couldn't face it. A relative guilt-tripped him by sending him a picture of Julia in her coffin. He honored her with a portrait, in the style of his other commissioned works: on

her sturdy face—some would call it old-world peasant, though she oddly resembles Georgia O'Keeffe—he overlaid high-stress finger-painting, as if connecting his painting proclivity with Mother's early tutelage. He didn't tell most people about Julia's death. When they asked about her health, he'd say she'd gone shopping at Bloomingdale's. But he never stopped feeling guilty about her death: near the end of his life, he told his diary, "at Christmas time I really think about my mother and if I did the right thing sending her back to Pittsburgh. I still feel so guilty." Mrs. Warhola's last appearance on camera might be her cameo in a sequence of the *Factory Diaries*—brief, poignant footage of Andy and Julia watching TV together. Actually, Andy is invisible, behind the camera. We hear his voice, however. Mostly the camera trains its attention on the Warhola TV set—which shows men watching telemonitors of a moonwalk mission (early 1971). Everyone—Mom, Andy, moonwalkers, NASA—needs TV screens: televisions bring home the moon action, just as Andy's video camera brings home to him the domestic scene he is taking part in but also screening out. Julia lies on her side, in bed. Andy says, "Mom?" She looks up and says, "What?" Then the scene ends. This is their final recorded encounter: her last word to Andy, as far as his art knows, is "What?" My impression, from listening to his audiotapes, is that Andy frequently said "What?" in conversation, either because he didn't catch what the other person was saying, or because he sought confirmation, or because he liked repetition, and wanted to hear the same comment twice, with the hope that the second time around it might metamorphose into

something strange. I suspect that Andy said "What?" primarily because he had difficulty making sense of heard speech, and because he needed time to come up with a coherent response.

Andy may not initially have told anyone about Julia's death because he found it literally unspeakable. That he was ashamed of the death, or of his inability to talk about it, is clear from a statement in his diary, ostensibly about a more sensational case. "And Brigid was telling me about the boy on the news whose mother died and he didn't tell anybody, he just kept her in the house for eight months." Andy's reaction to the death of artist Man Ray, four years later, sheds further light on his bizarre nonresponse to Julia's. A segment of the *Factory Diaries* features Andy improvising a videotaped letter to Man Ray, after the latter's death. Andy, repetitiously, charmingly, describes his memory of meeting Man Ray and taking his picture, but he doesn't mention the fact that Man Ray is dead. Though transcription of this vocal epistle can't capture the sound of Andy's voice, it conveys a sense of the conversational style he used to evade death:

Nobody told me what to talk about. You mean write a letter to Man Ray? Oh. Man Ray was this wonderful person. . . . And he was really cute: he took a picture of me, and I took a picture of him, and then he took another picture of me, and I took another picture of him, and he took another picture of me, and I took another picture of him, and he took another picture of me, and I took another picture of him, and he took another picture of

me, and then I took one of him. . . . Dear Man Ray, I guess this is saying goodbye to you. I probably won't see you again. I have a picture of you, a Polaroid stuck in a little red book. . . . I spent a couple of hours sticking one in each page. . . . I guess we'll be taking our [Christmas] tree down, because it's going to be falling down soon. My dogs say hello to you. Archie and Amos. I don't know what else to say to you. I never really had much to say to you before. All I did was take pictures.

Here Andy admits—as openly as he ever will—that the practice of repeatedly making and taking pictures glues him to the dead and the living, people he loves but can't speak with or about, even after their passing. He can only do their portraits. Repetition was Julia's style, too; perhaps she imparted it to her son. In an interview, she discussed, with admiring delight, his addiction to likeness, and she floated a fey hypothesis about the homoerotics of repetition, of cloning: "I wouldn't mind if he would really get engaged and marry one of the boys . . . maybe he would get a little baby, I mean a little Andy. I would have all these little Andys, you know, Andys, Andys, Andys, Andys . . . wouldn't that be beautiful?"

While Julia was advancing into senility, Andy married one of the boys of whom she spoke so approvingly. His name was Jed Johnson; with his equally cute twin brother, Jay, he entered the Factory in 1968. With Jed, Andy had the most prolonged romance of his life, and, ultimately, the most painful; insiders speak of Jed as the second of Andy's three major loves (the

first was Charles Lisanby). Jed moved in with Andy, perhaps partly to help take care of Mrs. Warhola; eventually he redecorated the new home, at 57 East Sixty-sixth Street, where the "boys" moved two years after her death. Evidently Andy belittled Jed—withheld compliments, to lower the younger man's self-esteem. Pat Hackett told me that Andy didn't praise the masterful decorating job Jed did on the house until others had vociferously admired it. Jed directed a movie that Andy produced in 1976, *Bad,* written by Hackett (the film flopped, but it merits serious scrutiny, for it features startling—unintended?—echoes of Andy's home life); he was testy to Pat and Jed on the set of *Bad,* and these tensions may have led to Jed's decision, at the end of the decade, to leave him. More than any previous boyfriend, Jed performed the role of Victorian angel-in-the-house; as homemaker, he replaced Julia. His voice resembled Andy's, and Marilyn Monroe's. Soft-spoken, shy, recessive, Jed was the opposite of the dynamic, aggressive exhibitionists who usually screened Andy.

Warhol's home life remains a secret. He spent most of his time at the Factory, or at parties, dinners, and discos, and yet he slept at home, ate breakfast at home, kept beloved dogs at home (dogs had replaced his "pussies" of the 1950s), dyed his eyebrows at home, put on his wig at home, and brought his purchases back home. Home was where he glued himself back together: he used the word *glued* to describe his process of self-repair, which involved literally gluing the wig to his pate. Christmas Day 1976, for example, the diary says: "It started to snow a little. Said thanks and left to go home to get ready for

the Jaggers'. Got to East 66th and glued." Gluing aside, the days that seemed most solidly *home days* were Sundays—church time. On Sundays, Andy glued himself to God, Jed, and home. On Sundays, too, Andy glued himself back to art, which, he feared, his social whirl had overshadowed. So he seemed to spend many Sundays drawing at home. November 26, 1978: "I went to church, it was so beautiful and cold out. Then I worked. I drew earths and moons and watched TV." He was conscious that the critical establishment had largely given up on him in the 1970s, condescending to him as a mere society painter. In fact, he remained in this decade a complex, profligately productive artist, but Andy doubted his own commitment to his vocation, and home (a country, a symbolic refuge, a townhouse) became the imaginary place where he might do real work, real art, apart from the distractions of the limelight. On May 25, 1977, in Paris, visiting the Beaubourg, he told the diary: "Then we saw the Kienholz show and then the Paris/New York show opening next week and then the permanent collection. This took two hours and Bob [Colacello] was passing out but I had energy and wanted to just rush home and paint and stop doing society portraits."

The world of café society, which Andy plundered for art's sake, provided him a laboratory for his experiments in fame and identity: notorious because of Pop and the Silver Factory, he could now circulate among famous people as if among equals—Liz, Bianca Jagger, Liza Minnelli, Jackie Onassis, Lee Radziwill, Truman Capote, Halston, Paulette Goddard Chaplin Meredith Remarque (whose autobiography Andy attempted to

cowrite), Shirley MacLaine, Paloma Picasso, Henry Kissinger, Jimmy Carter, Yves St. Laurent, Martha Graham, Valentino, Lauren Bacall, Diana Ross, Dick Cavett, Ethel Merman, George Cukor, Candice Bergen, Federico Fellini, Pierre Cardin, Vladimir Horowitz, John Lennon, Ursula Andress, Engelbert Humperdinck. Indeed, he was more than equal to many of them in fame, and certainly in accomplishment; but because of his revenant appearance, and his ever-present camera and tape recorder, he maintained his difference, his distinction, not as one of them, but as conscience and rebuke, sycophant and vacuum. His role was not to mingle with the famous, but to ironize them; to draw attention, as if with italics, to their fame; to generalize them, so that each figure who stands next to Andy, and gets photographed with or by him, loses identity and becomes a Warhol theorem, a Warhol situation. The person's role is to verify Andy's arrival into high society, which he, with Brigid Polk and Bob Colacello, referred to as "up there," be it heaven or Park Avenue. Nothing more sacrilegious than for a fine artist to downgrade himself by going *up there,* where the rich and the cheaply famous flocked. Andy's trick—his deception—was to sneak art up there by making his ascent (or descent) an art act, and by taking photos of what he saw when he arrived. His ventures *up there* were also exercises in juxtaposition: he no longer needed to paint celebrities, as he had painted Liz and Elvis and Troy. Now he merely needed to stand next to them.

He incarnated these exercises in star juxtaposition—placing himself as incongruous sidebar to another star—in several books, for which, as usual, he enlisted collaborators. One of

these efforts was *Exposures* (originally, and more provocatively, titled *Social Disease*), a compilation of celebrity photos, ostensibly Warhol's, with Warholian text (supposedly in Andy's voice) running alongside. The book begins, "I have a Social Disease. I have to go out every night." Across from this introductory page is a photo of a public toilet with a sanitary paper slip around the bowl. The picture is apt: Andy was contaminating society by entering it, just as he was contaminating art by his adventures in society. These ventures, which dominated his life in the 1970s, occurred during a time of sexual license and invention among gay men in New York and elsewhere; Andy seemed not to have participated directly in the gay bacchanal, but his voracious assaults on high society, his experiments in admixture (dispensing a tincture of Andy into a party's pool is enough to contaminate it, to turn it into art), were their own kind of multipartnered sex.

His collaborators on *Exposures* were Bob Colacello and a young, elfin, cryptically handsome blond photographer named Christopher Makos, who shared with Andy an unselfconscious salaciousness: Chris and Andy were forthright about their sexual curiosities, and Chris's talents as photographer inspired Andy to devote himself to documentary snapshots (aided by the acquisition, in the mid-1970s, of a 35mm camera, moving Andy's repertoire beyond his erstwhile wife, the Polaroid). Makos's photographic memoir of Warhol, titled *Warhol* (1989), poses Andy next to cars, buildings, the Great Wall of China, Georgia O'Keeffe, and Aspen ski slopes, and thus continues Andy's own adventures in juxtaposition. He liked to place

himself next to non-Andy objects and people, so that his Andy-ness could *sign* the adjacent presence, make it Andyish. He hoped to turn the entire world into his theme park: to spread the doctrine of Andy, like McDonald's hamburgers, around the globe.

Along with Colacello and Makos, a collaborator of Boswell-ian centrality in this period was Pat Hackett, who began work-ing for Andy when she was an English major at Barnard, and became his trusted amanuensis and cowriter, producing first *The Philosophy of Andy Warhol* in 1975, then *POPism: The War-hol Sixties* in 1980, and, after his death, *The Andy Warhol Dia-ries*. Hackett had the uncanny knack of sounding like Warhol. To compose *The Philosophy,* she brought him a series of ques-tions—rigorous as a philosophy seminar—and led the mas-ter through meditations on work, space, time, and death. She served inquiries, and Andy lobbed back answers; sometimes she filled in the blanks. Andy once told her, after she'd come up with an arresting insight, "You should make that into my language, that's really great." Pat was the midwife—nay, the mother—of Andy's language. Their grand collaboration was the *Diaries,* which began in 1976 as a way for him to document expenses for the IRS. It evolved into a more personal account-ing. In daily phone calls to Pat, he told her the activities of the day before; she transcribed them, from memory and notes, retaining evidence of a mind—Warhol's—willing to be merci-less, especially to those who condescended to his art. (Their collaborative act reconstructed his voice but did not liter-ally reproduce it; thus the diary must be read critically, as a

complex, screened performance.) Yet the diary gives us a tender Andy that we would not otherwise see, and reveals that, despite his fame, he had a lifelong case of bruised feelings. Acutely he knew he'd been a prodigal traitor to the art world because of his visible homosexuality and commercialism. On March 18, 1977, he expressed these insecurities:

> Cabbed with Vincent down to Frank Stella's studio ($2.75), a party for Leo Castelli's twenty years in the art business. Fred said I'd have to go—just the kind of party I hate because they're all like me, so similar, and so peculiar, but they're being so artistic and I'm being so commercial that I feel funny. I guess if I thought I were really good I wouldn't feel funny seeing them all. All the artists I've known for years are with their second wives or girlfriends

If he thought he was good—or if, like the other artists in the Castelli world, he had a wife or a girlfriend—he'd feel more at ease. Note that Warhol doesn't pity himself or make a grand political point about gay rights. He simply acknowledges his difference.

As if to reclaim the high ground of depth, inferiority, and mystery, Warhol surprised his friends and enemies in the 1970s by turning to abstract art—not nostalgically or enviously to revisit terrain he'd already transcended and discarded, but to affirm his private conviction that sexual desire was an abstract

puzzle. Anything that interested or perplexed Andy was abstract, especially money and sex. He told the diary, "God, it's so incredible, to have that much money, it's so abstract." And, according to Bob Colacello, when Candy Darling was dying in the hospital, Andy called the event "abstract"; he also said, "Politics are so abstract," and, "Love is too abstract, Bob." In Colacello's informative memoir, *Holy Terror: Andy Warhol Close Up,* he recalls a night at the Eagle's Nest, a leather bar, when a man "urinated in an empty beer bottle and left it on the bar for someone to drink," and Andy commented, "It was so abstract." Colacello remembers Andy examining sexually explicit Polaroids: "He was holding the 'fist-fucking' shot up to his glasses, examining it as if it were some exotic new gem discovered in the jungles of Brazil. 'I mean, it's so, so . . . so abstraaaact.'" And he refers, amusingly, to Andy's "broken record, 'Sex Is So Abstract.'"

Warhol's most ambitious venture into abstraction was a monumental series of Shadow paintings (1978 and 1979). In them, he staged vision's disintegration. Baby Jane Holzer described, to documentary filmmaker David Bailey, the impression of sightlessness that Andy conveyed: "you really have the feeling that he might be blind, and that it's very hard for him to see . . . " Of the Shadow series, Warhol said:

Really it's one painting with 83 parts. Each part is 52 inches by 76 inches and they are all sort of the same except for the colors. I called them "Shadows" because they are based on a photo of a shadow in my office. It's

a silk screen that I mop over with paint. . . . Someone asked me if they were art and I said no. You see, the opening party had disco. I guess that makes them disco decor. This show will be like all the others. The review will be bad—my reviews always are. But the review of the party will be terrific.

Disco—the mechanized thump, bump, and eternal reverb of female supremacy (Donna Summer) with a phallic twist—was black music whitely rerouted and resynthesized, and Andy's shadows have a blast with blackness. Sometimes the shadow is a color against a black backdrop; sometimes the shadow is black against a colored backdrop; sometimes shadow and backdrop are both black. Andy never clarifies what ideal impediment casts the shadow; on one level, the shadow is Andy himself, who, after the 1968 shooting, felt substanceless—neither liquid nor solid, neither living nor dead. In his 1981 series of Myths screenprints, Andy portrayed himself as *The Shadow* (after the radio serial); in this self-portrait, he looks out at the viewer, while his shadow, in elongated profile, stares sideways. The shadow, like a photograph, is a trace of matter, once removed: but in the Shadow paintings we can never name this presence. The year they were first exhibited, Andy alluded in his diary to the genital treasures lurking in shadows. Describing *Equus,* he said: "The movie has the longest nudity. Usually when they photograph a cock they make it fall in the shadows and the shadows always fall where the cock is. But in this movie the cock always falls right where you can see it." Andy's Shadow

paintings are not sublimated cocks; they are EEGs of abstract thought—his efforts to concentrate on a category he wants to see but can't bring into focus. Though not directly erotic, the shadows continue the urge of his 1960s films, from *Sleep* to *Blue Movie*. The shadows, like the films, stake a claim to what is passing and has passed; they anxiously ferret out inscrutable phenomena (sex, sleep, breathing, eating), yet fear that the eye is inadequate to the task of befriending physical presences.

Ironically, abstraction, for this profoundly disembodied artist, was a method of confronting the body and its benign emissions. His Oxidation paintings, made in approximately 1978, find comic, gutter sorcery in the bladder's humdrum stream. Urine on white gessoed background created the artifacts known as "piss paintings," while the rest of the group—the ones properly called "oxidation" paintings—were made by pissing on a canvas treated with copper metallic paint; the urine oxidized to create abstract forms—clouds, drips, splatters, penumbra. Cutrone and Warhol did some of the pissing; other visitors to the office helped out, too. Cutrone remembers waiting to pee in the morning until he arrived at the office, so he could offer a full gift to his boss's tabula rasa. He told me that, like Andy, he was piss shy, but "we knew what we needed to do." Leave it to Andy to discover the beauty of the green-gold stains on the metal partitions separating urinals in public restrooms: in no other series did Warhol find such an efficient way of milking eroticism out of abstraction. Jackson Pollock's drips, which had a urinary or seminal reference, turn queer when Andy repeats them, as if he were laying a metaphoric hand on

his predecessor's "paintbrush," Warhol's and Cutrone's joking euphemism for the micturating genitals.

His "cock drawings" and films aside, no Warhol work probed more pruriently the male body than his Torso series (accompanied by a smaller and more explicit series known as Sex Parts), made in 1977; these images nearly gave up abstraction, though they still claimed, within their figurative boldness, a sternly metaphysical hauteur. The Torso pieces feature midsections, buttocks, groins (overwhelmingly men's, very few women's), cropped from the whole body. The origins of the silkscreens were the nude Polaroids Andy snapped of any Factory visitors he could cajole to drop their pants, and the hundreds of Polaroids he took of sex sessions, some in the back rooms of the Factory, but mostly taking place off-campus, at a loft on Lower Fifth Avenue. The star of the sessions was the loft's owner, Victor Hugo, a swarthy Venezuelan who, like Ondine in the 1960s, could act out extremes that Andy wouldn't dare perpetrate with his own body. Hugo appears in many of the Polaroids, which possess as much aesthetic substance as the silkscreened paintings and prints that Andy derived from them. The Polaroids are certainly more sexually graphic. And, beyond their explicitness, the Polaroids—like the silkscreens—reveal his wish to crop sexuality, to see how much or how little flesh can fit into the Big Shot camera's limited frame, and to observe how these spatial restrictions estrange and sunder the body. He never opts for a full body shot; he limits himself usually to a groin, chest, midsection, or rear. He particularly favored a cropping that isolated, as a unit, the groin, upper thighs, and

abdomen: the same compositional focus predominated in his 1950s nude drawings. Some 70 percent of the Polaroids, I'd estimate, are of rear ends: *Taylor Mead's Ass* redux. Andy considered his series abstract: he called them "landscapes." He told the diary on Tuesday, March 14, 1977: "Victor came down with a nude pose-er. I'm having boys come and model nude for photos for the new paintings I'm doing. But I shouldn't call them nudes. It should be something more artistic. Like 'Landscapes.' Landscapes." The term stuck. These were work, not play. What made them labor was Andy's desire to see the nude body as abstract antimatter, to allow the Polaroid's limited frame to place compositional stress upon the body, pressing it into a confinement alleviated only, at times, by an arty shadow on the wall. The men are unidentified. His commissioned portraits verified and lionized personal identity; the Torso series erases name but celebrates bodily quirk. Each man has a distinguishing trait. One man, for example, exposes a discolored penis head, which seemed to interest Andy, because he took so many Polaroids of it. The camouflage pattern on the penis—like a biomorphic form in an Arshile Gorky painting—uncannily recalls the blotches that mottled young Andy's complexion.

To halt his climacteric, and to flower into what a recent self-help book calls a "multi-orgasmic man," Warhol made a petite series of abstract works known as Come Paintings. He describes to the diary one controversy surrounding their creation: "I gave [Catherine Guinness] a painting with some of my come on it, but then Victor said it was *his* come, and then we had a fight about that, but now that I think about it,

it *could* have been Victor's." I haven't spoken to anyone who actually saw Andy make a "come painting." Perhaps he worked his private paintbrush at home, or in the Factory bathroom, where he'd retreat to have "an organza" when the Polaroid sessions grew too intense. The come paintings, like the piss paintings, flash sex but also veil it: the bodies that leave these fond, runny deposits remain outside the frame, screened from view—though not, this time, with the aid of silkscreens.

The come and piss paintings, and the Torso series, advanced Warhol's lifelong project of releasing the male body from its manacles. And yet, ironically, his own body was now entirely fettered—contained by corsets, and by physical pain. His scars and abdominal belts formed him a new torso, trim but bound. (The Torso paintings and prints were idealized shadows cast by his own ruptured trunk.) He silkscreened professional athletes (Dorothy Hamill, O. J. Simpson) in 1977, and trained his lens on sexual athletes like Victor Hugo, and made images of his face in 1978 (including self-portrait wallpaper, imitating the cows and the Maos), but his own body remained under wraps, restrained, yet bursting to reveal itself. It materialized in the thousands of photographs that Makos and Colacello and society photographers took of him; it telegraphed its presence every time he appeared at an opening, and every premiere was a public orifice into which his body could insinuate its pale demand. (He said, "I will go to the opening of anything, including a toilet seat." He should have added: *especially* a toilet seat.) And the appearance he finagled that would have made even Shirley Temple jealous was his cameo in an Elizabeth Taylor

film, *The Driver's Seat,* 1974. At last, he was truly *up there*—no longer merely a Liz fan, but her costar. Ever the closet patricide, Andy had one big line in the film: "The king is an idiot." Bob Colacello recounts in *Holy Terror* the extracurricular, off-screen, MGM-caliber moment in which Andy showed his own scarred torso to Elizabeth. After she told Andy, "Feel my back," so he could touch her "crushed vertebrae," he said, "'Now I'll have to show you my scars.' He loosened his tie and unbuttoned his shirt. He was wearing, as always, the medical girdle that had held him together since the shooting 'You poor baby,' said Elizabeth Taylor softly, 'you poor baby.'" Never say that Andy was shy or inhibited, despite his demeanor. In a *verismo* flash, he could reveal himself, bold as Salome or Sarah Bernhardt. Liz, queen of scars, was the ideal spectator for this most extroverted of his performances.

7. ENDANGERED SPECIES

IN EARLY DECEMBER 1980, Andy told the diary that his home life was "horrible": "the situation with Jed is getting worse every day." Boyfriend erosion, career erosion: endangerment on every shore. Jed was sleeping on a separate floor of the townhouse, away from Andy. Jed finally moved out on December 21, 1980; Andy told the diary, "I don't want to talk about it." The next day, hoping to initiate a new romance, he sent roses to Jon Gould, an executive at Paramount Pictures; Chris Makos had made the introduction.

That year, Jed sent to Andy, as a Christmas card, a reproduction of a watercolor, "An Old-Fashioned Xmas": Jed's choice of image, and his inscription, subtly rebuked Andy, the Studio 54 tart, for his cavalier furloughs from the home fort. Wedlock's collapse broke down Warhol's resistance to blue moods, which worked in him like a virus: he surrendered, and never recovered brightness.

Jon Gould was a rugged younger man, and he didn't treat

Andy well. An epitome of what the personals ads called "straight-acting," Jon was gay except where Andy was concerned: claiming straightness as alibi, he refused Andy's advances. The diary says: "It's confusing because Jon tries to keep a straight image, he tells me he's not gay, that he can't . . . but I mean . . ." Jon's hetero veneer attracted Andy: "I love going out with Jon because it's like being on a real date—he's tall and strong and I feel that he can take care of me. And it's exciting because he acts straight so I'm sure people think he *is*." Coincidentally, Jon, like Jed, had a twin named Jay. Perhaps because Jon, in the Paperbag system, counted as a "real man," Andy tolerated his new inamorato's callousness, and pretended to get a kick out of it. He told the diary, "Jon didn't remember my birthday which was great," and confessed in 1983, the year that Jon moved into Andy's townhouse, that he thought Jon was trying to kill him: "We were on a snowmobile and he pushed me over a cliff. I thought he did it on purpose."

Daily shopping stimulated and sustained Andy in the 1980s. He feared that his imagination had run dry; obsessively shopping, he could unearth new ideas, new categories. His obliging companion in this quest was the musician and retired business-man Stuart Pivar, who described Andy to me as "suicidally depressed." Among Andy's grievances was his failure to find a lover. Pivar said that Andy "had no sex life after Jed." The diary often sounds the forlorn note: in 1981 he admitted, "Went home lonely and despondent because nobody loves me and it's Easter, and I cried." Another ailment was the townhouse's disar-ray. Since Jed had moved out, it had become an uninhabitable

warehouse, the resourcefully decorated rooms now blockaded with plunder from antique stores. Andy couldn't invite people home; his hoarding had upstaged those erotic tendencies that Walt Whitman called "adhesive." Andy, tired of adhering only to things, confessed to the diary, "I'm so sick of the way I live, of all this junk, and always dragging more home. Just white walls and a clean floor, that's all I want. The only chic thing is to have nothing." Further spurs to his gloom, Pivar asserted, were Fred Hughes's jibes: he'd make sport of Andy's gaffes. Andy had hysterical angry fits on the phone with Stuart about Hughes's condescensions. This anointed "boss" was to have relieved Andy of problems; instead—spat after spat, the umbilical cord torn with the teeth. Depression also stemmed from the U.S. artistic establishment's critical rejection of his post-1960s work. According to Ronald Feldman, a dealer who worked with Warhol on several major series of screenprints, he was considered a "has-been" when they began collaborating in 1980. Andy took every rejection personally. He had a habit of carrying around issues of *Interview* when shopping, to give out gratis. From the diary: "And when people on the street turn me down when I offer them a free *Interview,* it just gets me right in the gut." In his intestines he felt the defeats, and this *inside* he couldn't hide, for, ever since Pop days, he'd extrojected his interior: by now, vulnerability to attack had become his public face. He realized, "I'm going to have a hard time now not getting put down," and after a show of prints called *Reigning Queens,* in June 1985, he surmised that he had reached his nadir: "And I've hit rock bottom. This show, I have sunk to the bottom of

the gutter. The rock bottom of the skids of the end of the line."
He may have been comfortable at the bottom: afraid of motion
(and promotion is a form of motion), he discovered a back-
wards bliss in imagining that his career had skidded to a stop.

The deepest irritant was poor health. He needed gall-
bladder surgery but, phobic about hospitals, postponed it
for years. One of his major art assistants in the 1980s, Benja-
min Liu (his drag persona "Ming Vauze," he was a protégé of
Halston and Victor Hugo), told me that on strolls with Andy, it
was understood that they could never pass Cabrini Hospital,
and that when they walked by Bloomingdale's, Andy said that
his mother was inside, shopping. Rituals gave byzantine for-
mality to his gavotte with disease. Afraid of germs, he avoided
touching handles and doorknobs and didn't like other people
to open his lunch packages from Brownie's health food store;
afraid of fire, he moved ashtrays into the middle of the room.
He trafficked in magical thinking, superstitiously imagining
that petty misdemeanors sabotaged his health: he told the
diary, "I'm sure I got sick the other day as punishment because
I yelled at that lady." Pursuing therapies we gingerly call alter-
native, he saw a chiropractor, who gave him crystals, which
he put in the water he boiled for oatmeal. No precautions were
too preposterous: a second chiropractor tested the phone
numbers in his pockets for black magic. He was consoled to
discover that crystals were not antipathetic to Christ.

The advent of AIDS made health a complicated matter for
any gay man in the 1980s. Although Andy is not considered
an artist who responded aesthetically or politically to the

epidemic, it colored his work and conduct. He understood that he was endangered, as was the renaissance—gay culture—from which he had always kept an ironic distance ("It was too gay for me, it drove me crazy," he told the diary in 1986). Rather than responding altruistically, he reacted in fear: AIDS was another of the traumas—near-death experiences—that were his shadow brides. His first mention of AIDS ("gay cancer") in the diary, on May 11, 1982, notes his worry "that I could get it by drinking out of the same glass or just being around these kids who go to the Baths." Misconceptions about modes of HIV transmission were rampant, and not unique to Andy. In 1983 he noted that at a supermarket "a gay guy there made my sandwiches and so I couldn't eat them," and in 1984 he expressed dislike of shaking hands at church after mass. In 1987 he avoided sitting with Robert Mapplethorpe at an art opening because the photographer had AIDS. Warhol's friend Zoli, who managed a modeling agency for which Andy did gigs as a mannequin, died of "gay cancer" in November 1982. Jon Gould was hospitalized with pneumonia in February 1984; starting then, Andy told his housekeepers to wash his clothes and dishes separately from Jon's. Gould died on September 18, 1986, at the age of thirty-three: he denied that the cause was AIDS. After Rock Hudson died to make AIDS decent, his effects were auctioned, and Andy went to the preview, commenting: "And the whole thing was so nelly, not one good thing. You'd like to think that a big brute movie star would have had great fifties stuff, like maybe big rugged Knoll pieces, but it was just comfortable nelly junk from his New York apartment." Nelly

versus brute: thus Warhol mapped masculinity's north and south poles. In the art of his final decade, Andy, like Rock Hudson, shuttled between the antipodes.

Warhol's paintings and prints from the 1980s have not received anything near the critical attention or approbation that now greets his 1960s productions (even if, at the time, the response to the Pop work was often negative). The tendency to "put down" Warhol comes with the territory: his work pretends to oversimplify and reduce, and, with his up-front love of money and advertisement, he makes an easy target. However, the sheer quantity of art he produced in the 1980s, and its iconographic inventiveness (performing a survey of every kind of image that plausibly interests him or that has even a glancing relation to his own stable of concerns), will eventually cause critics to knuckle down and start praising its significance, beauty, political finesse, and art-historical sophistication. To comprehend the motley species of Andy's 1980s productions, I must resort to manic list-making, for his late art, too, strove to list, to compile an exhausting roll call of auction-worthy collectibles, which the critic, like Sotheby's, must posthumously organize into categories. Warhol's final work constructed an amulet against sickness and death; he rushed to summarize all the species before his time was up.

His principal subject was group behavior. Although his commissioned portraits showed separate individuals (and, occasionally, couples, such as Keith Haring and Juan DuBose), Warhol preferred his subjects to gather in sororities. In 1982,

for example, he made paintings of grouped eggs, based on Polaroids—the prettiest canvases multicolored, like Easter treats. The eggs clustered together—some abutting, others isolated as wallflowers or elective mutes. Gathered yet scattered, balancing centripetal and centrifugal urges, the grouped eggs (like the camouflage cliques) reflected his own conflict between asociality and amiability. This desire to accrete images—dinner guests or loony residents huddled in an SRO hotel lobby—climaxed in a series of Retrospective paintings of 1979, in which he recycled his own signature forms (Marilyns, Campbell soup cans, Maos, electric chairs), combining them in single paintings, as if he were inviting his own images to a "mixer," giving them a chance to mingle, to blend into hydra-headed unity. Meanwhile, the Reversal paintings of 1979 took the further, sinister step of reversing these trademark icons, turning them into photographic negatives; white Marilyn wore blackface. By resuming his own images, he exercised a protective, maternal custodianship, believing them, like the "kids" at the Factory, in need of new boxes, new jobs, new lovers.

As if he were taking "sex lessons" again, in his late art he strained to figure out how solitudes behaved together. His 1981 paintings of crosses, a dozen crucifixes lined up in rows, seem instances of seriality (the same figure, repeated), but they actually depict plural bodies interacting, trying to socialize. Some crosses touch one another, each leaning into the next: they seem to be holding hands, or joining limbs, one arm merging with the neighbor's. That is how Warhol defines interpersonality: objects coldly greeting each other, alliances freaked with

hostility. Wanting to combine individuals, to sew them into a simulacrum of comity or civility, he stitched together groups (mostly foursomes) of identical photographs and showed them at the Robert Miller Gallery in January 1987. (The idea for the stitching was Chris Makos's.) The thread-joined images resemble flaps of Andy's own skin, surgically sewn after his shooting, but they also express likenesses befriending one another and congregating into a single multichambered body. When Andy amassed forms, identical or not, he let each give the adjacent image a "feel"; each cell gropes its likeness. Even his flower silkscreens, of the 1960s, grouped four flowers (sometimes called pansies) together in one frame, two of the buds furtively—clumsily—touching petals, playing footsie.

Andy feared group death: indeed, this artist supposedly without social conscience spent the last years of his life fervently enumerating categories in danger of disappearing. Nostalgia for deceased idols fueled the enterprise, but so did his prurient urge to pinpoint the borderline between presence and obliteration (that flicker of a second when the object is still before his eyes, not yet gone), and his consciousness that anything he loved was in danger of forever evaporating. Jed, Julia, Edie, Candy—gone. Gone, too, Jon Gould, and, as the 1980s progressed, a gay multitude. Appropriately, he began the decade by honoring another threatened minority, the Jews: his silkscreen prints of Jewish geniuses, as he called them, included Stein, Einstein, and Freud. Anything that Warhol respected, or regarded as a dominating presence above his own downgraded self, paradoxically qualified as an endangered species, whose

extinction he prophetically elegized. He worried about beach erosion, for, though never comfortable in the sun, he had a house—or houses—in Montauk, at the tip of Long Island's South Fork; and he worried about star erosion. His series of myth screenprints, including himself as "The Shadow" and Greta Garbo as "The Star," declares that the structure of identity on which he depended—the star system—was eroding, and that his studios, indiscriminately manufacturing fame, had sped up its depreciation.

Andy seemed to care as much about animals—and bugs—as about people. Killing a roach was, for him, "a very big trauma." Affectionate depictions of animals go back to his 1950–51 Christmas card designs of Chinese horses, his 1955 fashion-show backdrop of lion and giraffe, and his "Happy Bug Day" print of 1954. Later, he identified with the dead denizens of the Museum of Natural History's reptile room, where his show of *Endangered Species* prints opened in 1983. Among the victim species he pictured were the African elephant, the bald eagle, the bighorn ram, and the San Francisco silverspot butterfly. (Rams are brute; butterflies, especially from San Francisco, are nelly.) Few critics have paid attention to his Endangered Species series—deeming it Warhol at his most bathetic—but, on the contrary, it gravely portrays his own bodily and emotional endangerment, as well as a sexual minority's panic in the face of epidemic. All of his work, even before AIDS, falls under the rubric "Endangered Species": his Chelsea Girls, or his "Thirteen Most Beautiful Boys" (a group of screen tests), or his Torso series of men unveiling their wares, or his

doomed-to-be-consumed soup cans (poisoned with botulism?), or his 1963 *Tunafish Disaster* painting (from a newspaper article about tainted cans killing two Detroit housewives), picture entities under threat of disappearance. Among the vanishing populations he cataloged were the American Indians, in a 1986 series of prints called Cowboys and Indians; images of a Northwest Coast Indian mask and a Plains Indian shield, in this series, represent Warhol's interests as a collector, but also his conception of art as camouflage, protecting his pale skin, his resewn interior, and his nelly tribe from the imperial crucifier.

Andy kidded himself that he was in Christ's position: he, too, wanted to disappear while remaining a static image, to make his eroded body an emblem. He gave grandiose form to his Christ identification in his Last Supper paintings of 1985–86, based on cheap reproductions of Leonardo. In January 1987, Warhol audaciously exhibited twenty of them in Milan—right across the street from the real McCoy. Andy's Last Suppers are predictive accounts of his own upcoming death, as well as paranoid portraits of Factory behavior, in which Warhol as Christ is surrounded by disciples and a lurking betrayer (Valerie Solanas, and other, nonviolent defectors). Andy dared to do a flaming pink Last Supper: nelly spirituality. As crystals were compatible, he declared, with Christianity, so could he reconcile conventional images of Christ with a homoerotic iconography; in *The Last Supper (The Big C)*, in tandem with Christ at the final Passover meal is a blue motorcycle (recalling the motorcycle in his film *Bike Boy*, itself an homage to Kenneth Anger's *Scorpio Rising*, the definitive gay ode to the motorcycle); the words

The Big C, emblazoned large in the bottom middle of the canvas, suggest that Warhol has finally moved beyond *A* and *B* (his two preoccupying letters) to a third term, *C,* perhaps the *C* of the copyright logo (Andy always eroticized trademarks), or the *C* of Christ, or simply the *C* that is the terminus beyond *A* and *B*'s stichomythia. In another Last Supper painting, he juxtaposed Christ with the image of a bodybuilder, captioned "Be a SOMEBODY with a *BODY.*" Jesus was a superstar—a guy with a body worth displaying; Jesus represented the ideal compromise between a mortified, failing body and a body that had the masculine fortitude to stick around forever.

Was Christ nelly or brute? In Warhol's eyes, both: art, like mysticism, wisely quarries the in-between. His Camouflage paintings of 1986, for example, exploit brutality's nelliness: as camouflage allows a soldier, reptile-like, to survive by blending into the forest or the sand, so the paintings insinuate a nelly theme (soldier sexiness) under the cover of a brute style (abstraction). On the purely brute side, in 1981 he made paintings and prints of guns and knives, a sequel to the hammers and sickles. He had wanted to exhibit the guns and knives in conjunction with his dollar signs, to stress affinities between money, masculinity, and weaponry, but the dollars, to their detriment, were shown separately. On the nelly side, Andy made paintings and prints of shoes, the artifacts' surfaces covered with a substance called diamond dust. Shoes returned him to his roots—the I. Miller ad campaign and the feet drawings of the 1950s—but overlaid the decorative homage to nelly taste with a murderous finish: for Warhol seemed amused by the fact

that diamond dust was a lethal weapon. He told the diary: "Diamond dust can kill you. It's a good way to murder somebody." (So, Andy would have noticed, was semen.) He splayed the shoes randomly across the painting's field, like thrown dice, or corpses post-massacre.

The strongest case to be made for the aesthetic and ethical value of Warhol's late work is its commitment to an arctically rigorous process of self-examination. Sometimes the self-portraits were direct: images of famous Andy's face. The several most haunting, shown in London in 1986, feature the artist wearing a fright wig, strands of hair sticking straight up, as if his head were hanging in air, like a chandelier, or like John the Baptist in the Gustave Moreau painting *The Apparition (Dance of Salome)*. Over Andy's face lies a scrim of camouflage pattern; he'd treated the face of artist Joseph Beuys the same way in portraits, for camouflage—honor, not stigma—signified a face worth protecting.

Other late Warhol images committed self-portraiture by veil and proxy. A 1985 series of prints and paintings of an erupting Vesuvius may seem a touristy image, but it actually depicts his own aesthetic "flow," or the type of atomic explosiveness that he idealized in others (Ondine's verbal torrent, for example), a disastrous eruption that thrills the remote spectator but endangers the locals. The image of Vesuvius shows Andy adoring disaster, marveling at the ability of comic-book-style line drawing to capture excess. The stream of lava resembles the "Puff" of air that Superman blows in the 1960 painting: Vesuvius is a Pop superhero. So were Frederick the Great,

Beethoven, Lenin, and Goethe (Warhol never stinted in his praise of famous men): he made images of them in the 1980s, as well as prints of reigning queens (Queen Beatrix of the Netherlands, Queen Ntombi Twala of Swaziland, Queen Elizabeth II) that were conscious ventures into campy self-portraiture. The reigning queens show represented, in Warhol's eyes, his "rock bottom": behind his fantasy of ruling as a queen lay the reality of coup d'état and guillotine. Warhol understood that his reign was not stable, and that his monarchy demanded reiterative advertisement: he made a series of ad screen-prints in 1985, including a Paramount logo that alluded to Jon Gould, and a Blackgama-clad Judy Garland, whose Stonewall-initiating corpse he'd waited in line (with Ondine and Candy Darling) to see at the Frank E. Campbell Funeral Chapel in 1969. (While waiting, they'd begun to compose—via tape recorder—a novel, *b,* the unfinished sequel to *a.*)

Other self-portraits were more gastric, for Andy dimly knew that his internal organs were in trouble. Several paintings featured intestines—an anatomical site that, ever since his father's "stomach poisoning" and his mother's colostomy, unsettled the Paperbag imagination. A 1985 painting, *Physiological Diagram,* shows a map of the interior of a man's body, including the intestines, rendered externally, like Mrs. Warhola's. And when he made Rorschach paintings, the blots resembled shadowy X-rays of his body's infrastructure: skeleton, rib cage, lungs, spine. Perhaps he engineered the symmetrical ink clouds to be camouflage, to pose as psychiatric invitations, sounding boards for the spectator; but they depict his own body's maternally

enmeshed innards, and thus are Janus-faced elegies, looking back to Julia's death and forward to his own. Indeed, Warhol's entire oeuvre—even the late work, which seems, except for the self-portraits, to be especially impersonal—may be interpreted as an externalization, crisply distanced and disembodied, of his abject internal circuitry.

Warhol understood that every mind worked by surgically cutting, cropping, cleaving, copying, threading, and grafting the world's rough evidence into comprehensible shapes; and so the late work, like the early, heuristically unpieces the whole body into its fragments—egg, lip, intestine, skull. In the 1980s he made a series of paintings called Philip's Skull—images of Philip S. Niarchos, who'd commissioned a portrait, and asked that the X-ray of his skull be used, instead of a Polaroid of his face, as the art-work's basis. Similarly decapitating were the pieces Warhol made from details of prior men's paintings (Paolo Ucello, Edvard Munch, Giorgio De Chirico). Though these fragmented appropriations may represent human faces (Botticelli's Venus, for example), their effect is ghoulish. Rather than adding a Warholian touch to past masters, resuscitating them, he seems instead to be killing them, embalming their iconographies. When he makes paintings from ads or commodities, the effect is, in contrast, humanizing: he renders the Coke bottle, for example, as if it were a living idol or his own mutant twin. In a print of a spilled Coke, executed sometime in the 1980s, Warhol seemed to be narrating Coke's death—its mortal liability, as a liquid, to leak; as a bottle, to crack; and as a product, to flop.

Coke is not a person, but Andy thought otherwise. His art is a bill of rights for inanimate objects, giving them suffrage and thus granting his own robotic self the liberty to pursue happiness. In the 1980s, he attempted technologically to produce an Andy Warhol robot that could give lectures and interviews, and in many of his late paintings and prints he seemed to be sweeping actual people aside, clearing space for emptiness, inanition, anhedonia. His least human work, or the work most devoted to the inhumane, is a series entitled Zeitgeist (1982), paintings of German monuments—perhaps his first public-architectural intervention since his ill-fated mural for the 1964 World's Fair. This sequence contemplates unpeopled spaces, and, with a bleakness atypical of Warhol, suggests that bodies obliterated by totalitarianism are twice-erased—first, from the earth, and second, from the rescue of artistic rendering. Another German project, equally unpopulated and untactile, without even the horned warmth of the Endangered Species rhinoceros, was his 1986 sequence of commissioned portraits of Mercedes-Benz cars and automotive parts. We've come a long way from gorgeous Gerry-Pie's torture in *Vinyl:* while sexual sadism at least offered a whip-and-wax mimesis of human touch, the Mercedes motor purrs at the furthest remove from the mortal organism. (Even a Brillo box implies the presence of the comestible, since a Brillo pad removes stuck traces of foodstuffs.) And the toys in the miniature paintings he made for his dealer Bruno Bischofberger in 1983 (Bruno's son Magnus was Andy's godchild) were unliving if not unmoving contraptions— a robot, a clockwork panda drummer, a clockwork motorcycle

with sidecar, and various artificial or mechanical animals (frog, parrot, terrier, monkey, mouse). He hung the paintings at child's-eye-level on *Fish* wallpaper, echoing his *Cow* wallpaper, and suggesting Jesuitical conversions, as well as the fetishist's and fisherman's pleasure. We assume the fish, like all toys, are dead. If alive, they qualify as pets.

Andy's pets, in the 1980s, were young artists, whose careers he advanced, even as, Drella-style, he sucked nutrients from them. These friendships—advocacies—included Francesco Clemente, Keith Haring, and Jean-Michel Basquiat. For Basquiat, Warhol felt something nearly like love; together, they produced *Ten Punching Bags,* which represent interracial battle gone amorous. Boxing interested Basquiat, and *boxing* (in the sense of the Brillo boxes, the time capsules) was the core of Warhol's artistic method. The logo of the punching bags, *GENE-SPORT,* pictures a white and a black figure boxing; the word *GENE* is in black letters, the word *SPORT* in white. (The bags themselves are white, with black paint.) Warhol and Basquiat might have wished to make sport of their "genes," the word itself a cornerstone of racial categories; the purpose of the "bag" in Andy's life, whether the colostomy bag or the moniker Andy Paperbag, was to replace the body, to hide it by wrapping or enclosing it, and also, with shy exhibitionism, to expose (or indecently "flash") his practice of fabricating enclosures. The punching bags represent Andy's own tendency to see himself and his art as "put down" by others—rejected, targeted, punched. Christ's face is imprinted on the punching bag: Christ was the star whom oppressors put down but who had, like the

bag, the temerity and resilience to rise again. The beauty of a punching bag is that it doesn't feel the pain of the assault, and that it bounces back. Basquiat didn't bounce back—he died of an overdose, despite Warhol's efforts to get him off drugs. And Warhol himself would not bounce back, despite his multiple comebacks and his feline, nine-lived knack for self-reinvention.

Andy had begun to rebuild his distressed body; the last years of his life were a series of attempts to make art of his failing organism. He worked with a trainer; he tried, as his weight-lifter painting advertised, to be somebody with a body. He'd never quite had one before, and even with the workouts, he remained, said Stuart Pivar, "in terrible shape." Chris Makos took a photo of Andy getting a massage: here, for our astonished gaze, lies Andy, his flabby, pale flesh at rest, ministered to, receiving solicitude from human fingers.

Finally he found the confidence to put his own figure forward—a futility (no one needed his torso, it served no cause) and a long-delayed gratification. In 1985, at a nightclub, Area, he created an "Invisible Sculpture" by standing on a pedestal beside the label ANDY WARHOL, and, more rambunctiously, in 1981, he posed in drag, with a series of inventive wigs and anti-naturalistic modes of maquillage, for Polaroid self-portraits; Chris Makos, too, photographed him in drag, and called it *Altered Image*. The drag self-portraits tour the girlie categories, though none is named; each faked, anonymous visage suggests a vocation (teacher, star, surgeon, char), and his face—camouflaged by womanliness—becomes a Blue Guide to

the joke of gender. Andy has never seemed more variously him-self: the drag portraits send him home to Lana, to Julia, to Judy, to Candy, to all the ladies he has been the near-miss mirror for. He vaguely worried that the drag photos would ruin his reputa-tion, and yet for years he'd been altering his complexion with collagen and astringents; his dermatological regimens were strict, exacting, and involved dozens of products, the collec-tion of them (of course he saved his face-repair creams) now functioning, posthumously, in their cardboard carton in the Warhol Archives, as yet another artwork. He wanted to look not like himself but like the punk-pop-group Blondie's lead singer, Debbie Harry, the most architecturally beautiful face in the history of rock, her cheekbones high and pedimental.

Harry was a regular on Andy's TV shows, of which he con-cocted several, with the collaboration of Vincent Fremont and Don Munroe. "TV" is shorthand for "transvestite," and trans-vestism always haunts Andy's love of television, a medium that permits out-of-body travel within the private home. The highlight of *Fashion* (a TV series of ten segments, including episodes on male models, Halston, designer Betsey John-son, and makeup), was a conversation between Diana Vree-land and Henry Geldzahler, in which she waxes enthusiastic about the boys who skateboard in front of the Metropolitan Museum, whose Costume Institute felt her high hand. Andy also produced the cable TV show *Andy Warhol's T.V.* and, for MTV, *Andy Warhol's Fifteen Minutes.* "Good TV means a lot," he told the diary; good TV was good reception, and open-ended receptivity was half of his TV pleasure. Making television, he

could actively transmit his body, an ephemeral, wave-based sculpture to which he was devoting intense reconstructive and reinterpretive labor, trying to imagine it as beautiful, trying to wedge its bizarreness defiantly in the path of put-down.

Warhol fulfilled modeling assignments for Zoli and later for the Ford agency; in the Frederick Wiseman documentary *Model,* Warhol interviewed naked male models (he aspired to join their ranks) in a New York hotel room. Cuddling Robert Rauschenberg at a Leo Castelli bash in 1982, Andy was delighted to discover that his former rival and role model had "a bad body." Though Warhol felt, looking at video footage of himself, that he was a freak ("I can't change it. I'm too unusual"), he appeared, as freak, as himself, on episodes of *The Love Boat* and *Saturday Night Live;* he considered running, in *Artforum,* a fold-out ad for his modeling career. Fred Hughes and others condescended to Andy's modeling ambitions, but he felt righteous and rigorous about his new passion, this attempt to "get a good body": he told the diary that he wished he'd started exercising when he was young so he could have had a good body all his life. He was pleased to report that "I think I finally look like people want Andy Warhol to look again."

In 1986 he visited cadaver dissections at an art school: he was investigating possibilities for sculpture casts as an alternative to painted portraiture. Despite the renovations to his body during the 1980s, incarnation—living as an empty box or bag—demoralized him. He still marveled at other people's bodies (he made affectionate nude portraits of the art dealer Pat Hearn in 1985, in which she resembles a young Katharine Hepburn); and

yet his *Diaries,* from which I draw this paragraph's account of Andy's inner life, declare his sense that someone else was living within his skin's hotel, his organs a disintegrating network now vulnerable to hackers and hijackers, vandals and assailants. If the body is armor, resistance to the diseased, arrowed world, then his shield had flaws. Even his breathing felt wrong: he said his lungs were "still funny from being shot." Someone noxious had walked into his body: "It happens if you're having this trauma or if you're sick or something. And you know, when I was little I remember I was really sick and didn't like school and had to be dragged there and then one day I changed—after that I loved school and everything, so I think somebody may have walked into me then. . . . I'm not clear on who the walk-ins are. Souls. And I'm not clear on where they come from." Entered by a foreign spirit, Andy's body developed into a ruptured thing, not his property; and it—the space where Andrew Warhola used to be—was visited by thoughts of invaders. He dreamed in April 1981 that Billy Name and others wearing "colorful costumes" invaded his house and took over his life. After the Factory's open-door policy, he may have feared that visitors would never leave. Billy Name was a beloved touchstone of Andy's past, and yet when Billy started calling him in 1987, suggesting a Factory reunion, Andy had severe reservations. "I'm going to just have to tell Billy that I can't face the past. And I'd walked into the house and didn't look where I stepped and so I was talking to him with dog poop all over my shoes."

Another invasion, however, was not a dream, and its traumatic intensity rivaled the departure of Jed and the death of

Jon Gould: a woman—a stranger—pulled off his wig while he was autographing copies of his book *America* at the Rizzoli store in SoHo on October 30, 1985. Andy didn't stop signing; pretending that he didn't care, he pulled his jacket's hood over his head. But the trespass cut him. He said: "It hurt. Physically. And it hurt that nobody had warned me." He'd hoped his crystal could have prevented the assault; his chiropractor told him, a few days later, that the crystal "had been invaded," and he remarked, "I think what invaded was the girl." The girl seemed a second Valerie Solanas: "It was like getting shot again, it wasn't real. I was just the comedian there, pleasing the people." Home that evening, he fixed himself Campbell's dry soup; soup, his oldest friend, consoled. Andy's wig was his name tag, as well as his shield against humiliation; when this "girl" pulled it off, his personality lost scaffolding. Later, she dared to call the office to talk to Warhol—as Valerie had continued to pester him after the shooting.

A few days after the Rizzoli disaster, he worried that AIDS would lead authorities to incarcerate gays in concentration camps: "All the fags will have to get married so they won't have to go away to camps. It'll be like for a green card." The prospect of sick "fags" sent away to camps may have recalled, for him, the time he reluctantly sent his senile mother, at the end of her life, back to Pittsburgh: four days after the wig trauma, he told the diary, "My mother was the age I am now, when she came to New York. And at the time I thought she was really old. But then she didn't die until she was eighty. And she had a lot of energy." The next Easter, when Andy served food to the

homeless at the Church of the Heavenly Rest, he noticed that many of the women resembled his mother.

Andy made his reputation as an artist specializing in repetitions, and so it is no surprise that repetitions—hauntings—offered him a ledger for accounting intimate terrors. Repeated again and again was the event of being "put down," invaded, and humiliated. He loved when commodities or countenances repeated, but not when shame recurred: he told the diary in May 1986, "I wish I were twenty and could go through all this again but I never want to go through anything or anybody again in my whole life." He wanted to avoid the revival of miserable unspeakables—wounds, holes, distensions; stretchmarks of his pre-fame, cramped embodiment. These moments of repetition he described as "walk-ins": breaches, when another spirit, a double from somewhere unknown, walked into his body, replacing his own personality, which vanished in a propitiatory, shielding instant. All of his painted, drawn, and filmed images of doubles try to represent his experience of being walked in on, ceding to an out-of-towner, friend or stranger—surrendering to Edie, to Julia, to Viva, to Nico, to a stalker, or to any attractive man he'd rather be. Andy dwelled on the figure of the double because he himself was two people: the invader who walked in, and the exile who walked out. One reason why he filled his days and nights with personalities, and why he cluttered his house with collectibles, and why he exerted himself past exhaustion to stuff the world with paintings and prints and photographs and tapes and films and videos and magazines, was to *open the door* to

walk-ins, to tell potential intruders that his body was a salon, a public terminal, a machine, not a person with the usual limits and blinders. Becoming automated, or identifying with automatons, allowed Warhol to admit walk-ins during a trauma, to go vacant so that other people—squatters—could overtake his rooms. Becoming a machine inoculated him against traumatic emptiness but also recirculated the vacancy, this time as anesthesia. Opposed to these icy interludes was his favorite drug, overstimulation—antidote to blankness, to the experience of willpower deserting him, like Jed walking out of the collection-crammed dollhouse.

Here are a few events of the 1970s and 1980s that repeated the "put-down," "walk-in," out-of-body, twinned experience: sending his mother away to Pittsburgh; her death; Jed's rejection; Jon's rejection, and then his death; the AIDS epidemic, and the bodily fears it instilled; the memory of Valerie, and the wounds she left behind. Any insult or humiliation (especially the wig episode) recalled her assault; even the departure and death of Mrs. Warhola, soon after the shooting, recapitulated it. Many gay men had reason to be terrified of viral invasion in the 1980s; Andy feared viruses but also the invasions and damages committed, in fact or imagination, by "the girl"—the girl who taunted him on his first day of school, then Valerie, then the wig despoiler. And there must have been others, walking in. I wonder if his mother was one of those "girls" who walked in, and whether the dream of Billy Name—moving into Andy's house, living under the stairs, wearing "colorful" costumes— reflects his long co-residence with Julia; in the 1950s she

invaded his nelly New York sphere, even if her steady presence abetted—fed soup to—his renegade impulses.

It may seem odd, so late in Andy's life, to be talking about his mother, but Andy, in this true story, is now going to die, and the world of death, hospitals, and old bodies was, for him, the old country, Julia's country, to which she'd departed nearly sixteen years before he joined her there. We are sad to be leaving Andy, but it is time for him to go. He walked out of his body quickly, without preparation (unless we consider the Last Supper paintings to be last rites).

Andy had needed gallbladder surgery since 1973, but he avoided it because he was afraid of hospitals. He associated them with the disaster of his own near-death in 1968, but also with the disaster of birth. He wrote in *The Philosophy*: "Being born is like being kidnapped. And then sold into slavery." In his 1963 silkscreen painting *Hospital,* a doctor holds upside down a newborn infant, though a nurse-nun, face surgically masked, a forbidding cross around her neck, dominates the composition; the religious nurse summarized terror for Warhol, and she would return at the very end.

He only agreed to enter the hospital for surgery when his doctor, Denton Cox, as well as other specialists whom Warhol consulted, told him that he'd die if he didn't: the gallbladder— his bag—was in imminent danger of rupturing, flooding his body with toxins, like the Vesuvian lava he'd painted two years earlier. White, weak, he did a final modeling gig (with Miles Davis) at a club called the Tunnel, and on Friday, February 20, 1987, he checked himself into New York Hospital. He brought

two books with him: Kitty Kelley's biography of Frank Sinatra, and a volume of Jean Cocteau's diaries. Checking in, Andy chose the pseudonym "Bob Roberts" only after he was forbidden his first choice, "Barbara"; he knew his health insurance ID numbers by heart, although he forgot his own home telephone number after the surgery was successfully completed (his hernia repaired, too, a bonus, so he'd never again need to wear an abdominal harness). He kept on his wig throughout the operation. The nurse, Min Cho, whose English was imperfect, and who didn't know her patient was a famous artist, kept watch over him, though she may have heeded more closely the Bible she was reading. In the early morning, Min Cho realized that Andy had suffered cardiac arrest, perhaps from a fear-related surge of adrenaline. She called in other staff, and after they spent an hour trying to revive him, he was pronounced dead at 6:31 A.M. He was only fifty-eight years old. According to Paul Alexander, in his book *Death and Disaster,* the nurse then cleaned Andy's dead body, washed off the blood, and "gathered up two garbage bags full of soiled material."

I wonder about Andy's last thoughts and last words; no one transcribed them. The night before, he called his housekeepers. He refused a pain shot from the dull nurse. And then he turned off the hospital-room television.

The funeral was held in Pittsburgh on February 26, 1987; he was buried in Saint John the Baptist Byzantine Cemetery, beside Julia and Andrej Warhola. One of Andy's confidantes, Paige Powell, tossed a flask of scent (Estée Lauder) and copies

of *Interview* in the open grave. A memorial service took place in New York City, at Saint Patrick's Cathedral, on April Fools' Day. A pianist played a passage from Mozart's *Magic Flute*—the entrance of the high priest, Sarastro, who understood the clandestine unity of antitheses. Brigid Berlin read aloud from the Book of Wisdom.

After an investigation, the New York State Department of Health alleged lapses in Warhol's postoperative care. His estate lodged a wrongful death suit; the case was settled, and the hospital paid the estate three million dollars. Thus began the posthumous tedium, full and empty as any Pop box— accounting, haggling, buying and selling, institutionalizing. An auction of his collections, held at Sotheby's from April 23 to May 3, 1988, brought $25,333,368. The Museum of Modern Art, which ignored him during his lifetime, gave him a retrospective in 1989. The Andy Warhol Museum in Pittsburgh opened in 1994. Andy is anywhere, everywhere, embodied in critics, curators, dealers; The Andy Warhol Foundation for the Visual Arts; The Andy Warhol Film Project; tchotchkes, T-shirts, appropriations. Through these emissaries, the Factory lives on—a belated Internationale of a thousand faithful, who handle, disperse, restore, catalog, and explain his treasure chest, and ensure that it continues to bear fractious fruit.

Like Ingrid Superstar, Andy disappeared. Someone walked into his body, and he walked out. His death, a vanishing act, defied the auguries; it left a vacuum that we may enjoy and not strive to fill. He practiced the art of making nothing happen ("I can tell when one of them is glad to see me walk in the door,

because something's happening, and they can't wait for me to make nothing happen"): now that he is gone, we are free to confront the substantial nothingness he left behind. For Warhol had "a mind of winter," his hair wintry, too, like the snow man in the Wallace Stevens poem: "nothing himself," he "beholds/ Nothing that is not there and the nothing that is."

It is false to say that Andy Warhol left nothing behind. He left behind his own example, the gestures and actions of a comic, heroic life; he'd rather have been called a heroine, but he was less Lois Lane and more Superman, transforming his alien self into a costumed, metropolitan ubiquity. As well known for his odd verbal style as for his art, he stands before us as a formalist, an abstract thinker who reformed the way we see concepts, names, species, and categories. He was an organization man: interested in organisms, in originality, in organs, and in how the mind organizes cognition and memory. By collecting and socializing, by making amused cameo appearances, by producing abundant sculptures, paintings, prints, drawings, films, photographs, videos, time capsules, and books, Andy organized and boxed the world into digestible units, modular perceptual containers that can be stacked, repeated, and counted, and that might last forever. Above all, he was a maker, in love with productivity: without apparent self-consciousness or inhibition, he produced, ceaselessly. The seed of great art is impulse, not restraint. Andy wanted art to be easy, but only so that he could make more of it, and more quickly. Easy Street, easy art: he wanted to ease—to lubricate—the wheels of production, to make fabrication a more accessible, democratic,

and openhearted realm of conduct. Enough of war, of rivalry; Warhol's practice suggests that art can be as direct, pacifying, and clarifying as a cool glass of water—what Ed Hood, in *My Hustler,* calls a "water cocktail." It is not heroic to deprive the world of the artifacts one has the ability to make. Warhol did not hold back his largesse. He could have truly retired from painting. He could have fired all the kids in the Factory and closed it down. He could have moved to a tropical island and paid for the company of boys. He could have hired bodyguards and become a recluse. Instead, he stayed in New York, walked its streets, and worked. In a time of artistic meanness, when creators stint posterity by refusing to produce, and by masquerading their drought as good manners, Warhol threw away decorum and worked. He was one of the most magnanimous producers of the twentieth century, putting art forward again and again, working to salvage *work*—his favorite category— and to teach us, in a deathless didactic act, that incarnation is hard labor, with no time left over for love.

SOURCES

I NEVER MET ANDY WARHOL, but I interviewed people who
worked with him, fought with him, painted for him, performed
for him, partied with him, photographed him, fed him, wrote for
him, shopped with him, posed for him, lighted him, designed
for him, transcribed him, flew with him, slept with him, imper-
sonated him, protected him, observed him, analyzed him, and
sacrificed for him. The experience of interviewing his friends
illuminated mysteries of Warhol's temperament. Even when I
didn't incorporate their words, their points of view informed
my thinking, and I am profoundly grateful to each of them: Mary
Boone, Randy Bourscheidt, Stephen Bruce, John Cheim, Bob
Colacello, Ronnie Cutrone, Ronald Feldman, Vincent Fremont,
Vito Giallo, John Giorno, Nathan Gluck, Sam Green, Pat Hack-
ett, Pat Hearn, Madalen Warhola Hoover, Benjamin Liu, Gerard
Malanga, Christopher Makos, Taylor Mead, Allen Midgette, Syl-
via Miles, Paul Morrissey, Billy Name, Robert Pincus-Witten,

SOURCES

Stuart Pivar, Robert Rosenblum, Stephen Shore, Holly Solomon, John Wallowitch.

Conversations with curators and critics helped me understand Warhol's work. Callie Angell, adjunct curator of the Andy Warhol Film Project at the Whitney Museum of American Art, elucidated unseen aspects of Warhol's cinema. The Andy Warhol Museum was an essential resource: I spent days at the archive, looking through time capsules and files, with the help of John Smith, archivist. Thomas Sokolowski, director of the Andy Warhol Museum, answered many questions and read a draft of this book. At the museum, Geralyn Huxley and Greg Pierce showed me films, and Margery Smith explained paintings and drawings. At the Andy Warhol Foundation for the Visual Arts, Sally King-Nero gave guidance and advice. The staff at the Museum of Modern Art Film Study Program—Charles Silver, Ron Magliosi, and John Harris—permitted me to spend hour after hour watching Warhol films. Nicholas Baume at the Wadsworth Atheneum invited me to speak at a symposium, and we traded reflections on Warhol. Peter Halley provided many leads. Reva Wolf gave me ideas and facts. Steven Watson generously supported my project with insight and information. Years of conversations with Bruce Hainley are intrinsic to this book's fabric; he began writing about Warhol before I did, and his bold work is always my model.

While researching this book, I had the good fortune of teaching a seminar on Warhol at the Graduate Center of the City University of New York. I learned much from my students, and from the essays they wrote: I want to acknowledge the work

of Melissa Anderson on Candy Darling, Paul Battiato on Julia Warhola, Jennifer Brown on *Lonesome Cowboys,* Delphine Daniels on the commissioned portraits, Jennifer Farrell on the self-portraits, Jason Frank on the photographs, Tim Heck on the Torsos and Sexparts series, Akira Hongo on Truman Capote, Christine Pichini on Brigid Berlin, and Michael Angelo Tata on Donyale Luna and Dorothy Dean. I also benefited from reading Neil Printz's Ph.D. dissertation, *"Other Voices, Other Rooms": Between Andy Warhol and Truman Capote.*

The process of writing, revising, and publishing this book was warmly facilitated by my splendid trio of editors, James Atlas, Jesse Cohen, and Carolyn Carlson, and by my literary agent, Faith Hamlin.

Andy Warhol's books are a fundamental resource for the biographer and critic. Especially useful are *The Andy Warhol Diaries* (1989), edited by Pat Hackett; *POPism: The Warhol '60s* (1980), cowritten by Hackett; *The Philosophy of Andy Warhol (From A to B and Back Again)* (1975); *Andy Warhol's Exposures* (1979); and *a: a novel* (1968). Of interest, too, are *Andy Warhol's Index (Book)* (1967), *America* (1985), and *Andy Warhol's Party Book* (1988), the latter cowritten by Hackett. Several of the 1950s presentation books have been issued in facsimile editions, including *Wild Raspberries* (1959), with Suzy Frankfurt; *25 Cats Name Sam and One Blue Pussy* (1955), with Charles Lisanby; and *Holy Cats by Andy Warhols' mother* (1957).

There are two major biographies of Warhol, on which I have necessarily relied for facts. Both are delightful and

informative, and I recommend them: Victor Bockris's *Warhol* (1989; the British edition, reprinted by Da Capo in 1997, is preferable), and David Bourdon's *Warhol* (1989). A third biography, Fred Lawrence Guiles's *Loner at the Ball: The Life of Andy Warhol* (1989), contains fascinating details. Paul Alexander provides a full account of Warhol's death in *Death and Disaster: The Rise of the Warhol Empire and the Race for Andy's Millions* (1994). Margia Kramer, in *Andy Warhol et al: The FBI File on Andy Warhol* (1988), offers a quirky, disturbing addendum.

Some of the most exciting information about Warhol occurs in his own interviews, uncollected, scattered across magazines and newspapers. More easily found are the interviews given by his associates. Crucial documentary resources are Patrick S. Smith's interviews with Warhol's colleagues, collected in Smith's two books, *Andy Warhol's Art and Films* (1986) and *Warhol: Conversations about the Artist* (1988). Revealing interviews with Warhol 1960s cohorts appear in John Wilcock's *The Autobiography and Sex Life of Andy Warhol* (1971), and in *Andy Warhol: Transcript of David Bailey's ATV Documentary* (1972). Another fascinating compilation of interviews with Warhol's friends is John O'Connor and Benjamin Liu's *Unseen Warhol* (1996). Though the focus of Jean Stein's (and George Plimpton's) *Edie: American Girl* (1982) is the life of Edie Sedgwick, the book includes many valuable interviews about Warhol's practice and personality.

Warhol's Silver Factory was documented by photographers, whose works have been collected in book form. Billy

Name's legendary images appear in *Andy Warhol's Factory Photos* (1996) and *All Tomorrows Parties: Billy Name's Photographs of Andy Warhol's Factory* (1997). Stephen Shore's definitive images are gathered in *The Velvet Years: Warhol's Factory, 1965–67* (1997), with incisive text by Lynne Tillman, as well as interviews with Factory regulars. A rare book, worth looking for, is the catalog for the 1968 Warhol retrospective at Stockholm's Moderna Museet, *Andy Warhol;* it includes photos by Shore and Name. Nat Finkelstein has collected his photos in *Andy Warhol: The Factory Years 1964–1967* (1989). Christopher Makos provides candid text and photos in *Warhol: A Personal Photographic Memoir* (1988).

Firsthand accounts of life with Warhol abound. The best is Bob Colacello's *Holy Terror: Andy Warhol Close Up* (1990). Mary Woronov's *Swimming Underground: My Years in the Warhol Factory* (1995) is evocative and concise. John Giorno includes an intimate essay, "Andy Warhol's Movie 'Sleep,'" in his collection, *You've Got to Burn to Shine: New and Selected Writings* (1994). Ultra Violet's *Famous for 15 Minutes: My Years with Andy Warhol* (1988) and Holly Woodlawn's (with Jeff Copeland) *A Low Life in High Heels: The Holly Woodlawn Story* (1991) are entertaining. Viva's roman à clef, *Superstar* (1970), is good smutty fun. Michael Ferguson's *Little Joe: Superstar—The Films of Joe Dallesandro* (1998) gives all the facts; and I adore Candy Darling's diaries, a selection of which are published in *My Face for the World to See* (1997). A sympathetic guide to the artwork of Warhol's associates is Debra Miller's *Out of the Shadow: Artists of the Warhol Circle, Then and Now* (1996).

There are many critical studies on Warhol. Good introductions to the subject are Carter Ratcliff's *Warhol* (1983), and the compendium of reviews and essays in *The Critical Response to Andy Warhol,* edited by Alan R. Pratt (1997). A classic account of Warhol's cinema is Stephen Koch's *Stargazer: The Life, World & Films of Andy Warhol* (1973; revised edition, 1991); though not always accurate, it is beautifully written—a serious, lasting contribution to the study of film. A fine early monograph is John Coplans's *Andy Warhol* (1970). A valuable monograph, Rainer Crone's *Andy Warhol: The Early Work 1942–1962* (1987) includes astonishing reproductions (among them *A Gold Book* and *In the Bottom of My Garden*). Jesse Kornbluth's *Pre-Pop Warhol* (1988) is sharply informative. Sophisticated analyses are collected in three anthologies: *Who Is Andy Warhol?* (1997), edited by Colin McCabe with Mark Francis and Peter Wollen; *The Work of Andy Warhol* (1989), edited by Gary Garrels; and *Andy Warhol Film Factory* (1989), edited by Michael O'Pray. (The last includes Gretchen Berg's 1967 interview with Warhol, and seminal essays by Jonas Mekas, Ronald Tavel, Parker Tyler, and Gregory Battcock.) Three recent books offer new approaches to Warhol's work: *Pop Out: Queer Warhol* (1996), edited by Jennifer Doyle, Jonathan Flatley, and José Esteban Muñoz; Jane Daggett Dillenberger's *The Religious Art of Andy Warhol* (1998); and Reva Wolf's intrepid analysis of Warhol's poetic affiliations, *Andy Warhol, Poetry, and Gossip in the 1960s* (1997), an epitome of scrupulous scholarship. An early, nuanced appreciation is Peter Gidal's *Andy Warhol Films and Paintings: The Factory Years* (1971). Poet John Yau's *In the Realm of Appearances: The Art*

of Andy Warhol (1993) pursues an idiosyncratic interrogation. Influential analyses of Warhol's art occur in Arthur C. Danto's *Beyond the Brillo Box: The Visual Arts in Post-Historical Perspective* (1992) and Hal Foster's *The Return of the Real* (1996). (Foster discusses Warhol's "traumatic realism.") Two accounts of Warhol's gay or queer iconography are Juan Suárez's *Bike Boys, Drag Queens, and Superstars: Avant-Garde, Mass Culture, and Gay Identities in the 1960s Underground Cinema* (1996) and Richard Meyer's essay, "Warhol's Clones," in the *Yale Journal of Criticism* (7, vol. 1 [Spring 1994]).

There are dozens and dozens of exhibition catalogs. Some I have depended on: *The Warhol Look: Glamour Style Fashion* (The Andy Warhol Museum), edited by Mark Francis and Margery King, with essays by Hilton Als, Richard Martin, Bruce Hainley, and others; *Andy Warhol: Portraits of the Seventies and Eighties* (1993), with essays by Henry Geldzahler and Robert Rosenblum, and a recollection by Vincent Fremont; *The Andy Warhol Museum* catalog (1994), including a CD of Warhol's voice, and a chronology by Margery King; the Museum of Modern Art's catalog, edited by Kynaston McShine, *Andy Warhol: A Retrospective* (1989); *Andy Warhol Prints: A Catalogue Raisonné 1962–1987* (1997, 3rd ed.), edited by Frayda Feldman and Jörg Schellmann, revised and expanded by Feldman and Claudia Defendi; *The Films of Andy Warhol (Part II)* (1994), from the Andy Warhol Film Project, with text by Callie Angell; *Something Secret: Portraiture in Warhol's Films* (1994), from the Museum of Contemporary Art in Sydney, Australia, with an essay by Angell. Two sumptuous new catalogs are

Andy Warhol Photography (1999), produced by the Warhol Museum and the Kunsthalle in Hamburg; and *Nadar Warhol: Paris New York* (1999), by the Getty Museum, with an essay by Judith Keller. A historically significant catalog is *Raid the Icebox I (with Andy Warhol): An Exhibition Selected from the Storage Vaults of the Museum of Art, Rhode Island School of Design* (1969), with an essay by David Bourdon. An assortment of other recent catalogs whose images and essays I have found illuminating: *Andy Warhol Nudes* (1995), edited by John Cheim, with an essay by Linda Nochlin; *About Face: Andy Warhol Portraits* (1999), from the Wadsworth Atheneum, with essays by Nicholas Baume, Douglas Crimp, and Richard Meyer; *The Films of Andy Warhol: An Introduction* (1988), from the Whitney Museum; *Andy Warhol's Video and Television* (1991), from the Whitney; *Andy Warhol Camouflage* (1999), from Larry Gagosian Gallery, with essays by Brenda Richardson and Bob Colacello; *"Success is a job in New York . . . ": The Early Art and Business of Andy Warhol* (1989), from the Grey Art Gallery and the Carnegie Museum of Art, edited by Donna M. DWeSalvo, with texts by Trevor Fairbrother, Ellen Lupton, and J. Abbott Miller; *Andy Warhol: Philip's Skull* (1999), from Gagosian, with an essay by Robert Rosenblum; *Andy Warhol: Death and Disasters* (1989), from the Menil Collection, with an essay by Neil Printz; *Andy Warhol: Oxidation Paintings/Piss Paintings* (1998), from Galerie Daniel Blau in Munich; *Warhol: Shadows* (1987), from the Menil Collection; *Andy Warhol Crosses* (1999), from the Diözesanmuseum, Cologne, with essays by Rosenblum and Joachim M. Plotzek; *Andy Warhol Photographs*

(1986), from Robert Miller Gallery, edited by John Cheim, with an essay by Stephen Koch; *Eggs by Andy Warhol* (1997), from the Jablonka Galerie, Cologne, with texts by Rosenblum and Vincent Fremont. This list could be expanded, as could any list regarding Andy Warhol.

ABOUT THE AUTHOR

Wayne Koestenbaum has published over a dozen books on such subjects as hotels, Harpo Marx, humiliation, Jackie Onassis, and opera. His latest book of prose is *My 1980s & Other Essays* (2013); his latest book of poetry is *Blue Stranger with Mosaic Background* (2012). Koestenbaum's first solo exhibition of paintings took place at White Columns gallery in New York during the fall of 2012. He is a distinguished professor of English at the Graduate Center of the City University of New York.

OPEN ROAD
INTEGRATED MEDIA

Open Road Integrated Media is a digital publisher and multimedia content company. Open Road creates connections between authors and their audiences by marketing its ebooks through a new proprietary online platform, which uses premium video content and social media.